NATIONAL MUSEUM OF ANTHROPOLOGY
MEXICO CITY

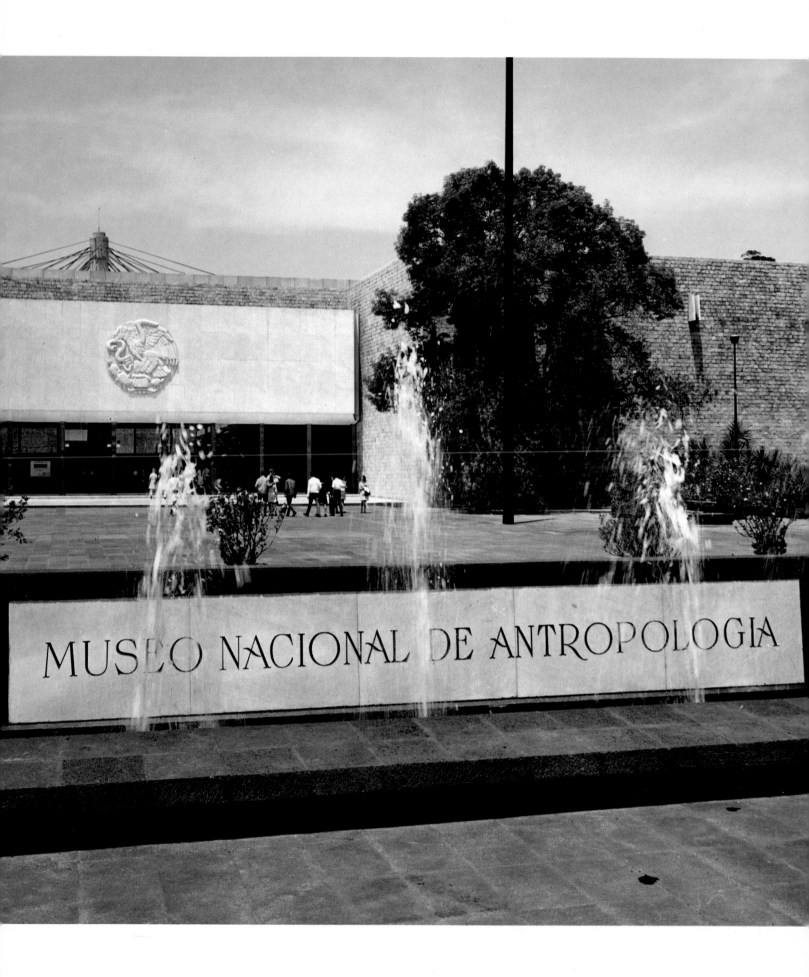

NATIONAL MUSEUM OF ANTHROPOLOGY
MEXICO CITY

Paul Hamlyn LONDON·NEW YORK·SYDNEY·TORONTO

GREAT MUSEUMS OF THE WORLD

Editorial Director: Carlo Ludovico Ragghianti
Assistant: Giuliana Nannicini
Translation and Editing: Editors of Art News

Texts of this volume by Carlo Ludovico Ragghianti and
Licia Ragghianti Collobi
Design by Fiorenzo Giorgi

Originally published in Italian by
Arnoldo Mondadori Editore, Milan
© 1970 Arnoldo Mondadori Editore – CEAM – Milan
© 1970 Photographs copyright by Kodansha Ltd. – Tokyo
This edition © copyright The Hamlyn Publishing Group Limited 1971
Feltham, Middlesex, England
All rights reserved
ISBN 0 600 79315 X
Printed and bound by Officine Grafiche Arnoldo Mondadori, Verona

INTRODUCTION

ARTHUR ROMANO
Director

The formation of the Mexican National Museum of Anthropology was the result of a centuries-long process of social, economic and cultural evolution on the part of the Mexican people. Indeed, to carry out so vast and demanding an enterprise required the best efforts of the country's intellectual elite and the enlightened support of the federal government.

The original impetus for a museum sprang from the need to exhibit, in the clearest and simplest way, the far-reaching and ancient roots of Mexican civilization. A museum would serve the important function of illustrating the cultures of the various peoples responsible for the progress achieved by the pre-Hispanic civilization that today constitutes Mexico. The conception and organization of the new museum dates from the Spanish Conquest, at the beginning of the third decade of the sixteenth century. At that time, the colonists, spurred by the desire to dominate and exploit the recently subjugated peoples, began to collect documents that would help them understand the spirit of the natives. This activity gave rise, in turn, to a form of collecting directed toward studies which — though still primitive — may be described as anthropological. The Italian scholar Lorenzo Boturini, who arrived in

9

Mexico in 1736, was the first to collect documents for study and research. Although his aim was to write a history of the American peoples, his intentions were misunderstood, and all the manuscripts and codices he had transcribed were seized and moved, by order of the Viceroy Don Antonio Bucareli, to the Royal and Pontifical University. This institution was the actual basis for this as well as other museums.

From the middle of the eighteenth century, the pace of collecting increased rapidly. A new and important phase in the development of the museum came in 1790, when the Conde de Revillagigedo ordered that all the objects found during the paving of the Plaza Mayor be preserved at the University, along with the Boturini collection. An exception was the great Sun Stone, which was set into the west wall of the Cathedral, then in the process of construction.

In 1823 the historian and political leader, Don Lucas Alamán, organized the Museum of Antiquities and Natural History. Two years later — on March 1, 1825 — with the approval of the first constitutional president of the Republic of Mexico, Don Guadalupe Victoria, it was legally established under the name of the National Museum. By

that time, the collections included a large amount of material from pre-Hispanic times and the vice-regal period, and a particularly extensive collection of natural history exhibits. The space at the University soon proved inadequate to meet the growing public demand for enlarging the collections. On December 4, 1865, the Archduke Maximilian issued a decree by which the fine old Mint (*Casa de la Moneda*) became the new home of the National Museum. This Baroque structure, with elegant façades on the exterior as well as on the large courtyard, had been built between 1731 and 1734, and was situated between the street named after the Mint (*Moneda*) and the avenue called Correo Mayor.

Fourteen years after the inauguration of the museum in its new form, the building was equipped with gas light, permitting scholars to continue their studies after dark. The museum was opened to the public on Tuesday, Thursday and Sunday afternoons. In addition to eight exhibition rooms, the building also contained a botany and minerology laboratory. In 1877 the first issue of the museum's publication, *Anales del Museo Nacional*, was brought out.

In 1910 the natural science collections were removed to the new

National Museum of Natural History. At the same time, the old museum was renamed National Museum of Archaeology, History and Ethnography. In 1939, Don Lázaro Cárdenas, President of the Republic, assigned it the present name of National Museum of Anthropology. He also provided for the establishment of the National History Museum in Chapultepec Castle. The old Mint remained the home of the museum, by then devoted exclusively to the pre-Hispanic civilizations of Mexico, until 1964.

The organization and exhibition of the collections was altered in 1947. It may be said that after these improvements Mexico became one of the leading countries in the field of museum study. Prior to the renovation, the old rooms had resembled warehouses, with no logical order for displaying the extensive pre-Hispanic material. In the modernization of the museum, the entire building was supplied with electricity, a convenience that previously had been confined to the offices. A selection of the most characteristic pieces of each culture, archaeological site and geographical area was chosen for exhibition, and the remaining material was stored. With the renovation of the lighting system and the modernization of the shelves and display cases, the museum succeeded in reviving the public's interest in the rich cultural legacy of the past. Still,

the displays left a great deal to be desired, as did the building itself, which had not been conceived as a museum and was situated in the traffic-choked center of the city.

All these practical considerations, as well as a number of cultural problems, led members of the government, anthropologists, artists, literary men, teachers and humanists to promote the formation of a new Museum of Anthropology which was to open in Mexico City in 1964. The complex design for the new building was the object of numerous lengthy studies. Pedro Ramirez Vazquez was chosen as the architect. After the construction was authorized, it was agreed that the site would have to be within the area of Chapultepec Park, the most suitable place because of its historical associations, its role as a gathering place on Sundays for people of every social level and its good communications with the rest of the city. Finally, a site was chosen opposite Chapultepec Lake, between the streets called La Milla and the Paseo de la Reforma.

Those in charge of the construction had the responsibility of devising solutions for numerous interdependent needs. The first requirements

were space and convenience, both for visitors and staff, but these had to be supplied in such a way as to appear to the public closely connected with the contents of the exhibition rooms. It was considered indispensable that not only pre-Hispanic but also ethnographic material be exhibited. Such artifacts bear witness to the variety of customs and cultures of the numerous indigenous groups that in the past inhabited the coasts, highlands and mountains of Mexico. Since the old museum's collection of this material was mediocre, it was necessary to increase the collections in order to include the pre-colonial periods as well as modern ethnography. For this purpose, expeditions were organized to obtain material directly, while large quantities were also acquired from private collectors. Hundreds of objects were collected, of which a part are now displayed in the various rooms of the museum, while the rest is kept in the reserves until it can be restored, classified and catalogued.

The present National Museum of Anthropology, with its new building and its novel, contemporary features, is the product of the continuous efforts, over 226 years, of intellectuals and government officials of the most diversified backgrounds. Not all of those years were as fruitful as

the last ten, which belong to the peaceful phase of the Mexican revolution. It is hoped that the different peoples of the earth will take up the modest but sincere message of a nation as young as Mexico, which has always sought to share in the difficult task of bringing peace to a world constantly in turmoil.

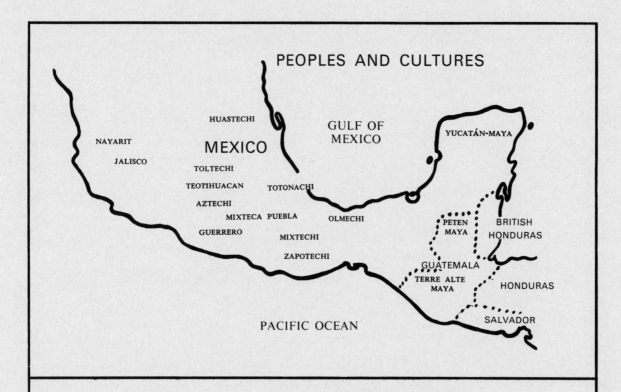

PEOPLES AND CULTURES

NAYARIT

JALISCO

HUASTECHI

MEXICO

GULF OF MEXICO

YUCATÁN-MAYA

TOLTECHI

TEOTIHUACAN

TOTONACHI

AZTECHI

MIXTECA PUEBLA

OLMECHI

PETEN MAYA

BRITISH HONDURAS

GUERRERO

MIXTECHI

ZAPOTECHI

GUATEMALA

TERRE ALTE MAYA

HONDURAS

SALVADOR

PACIFIC OCEAN

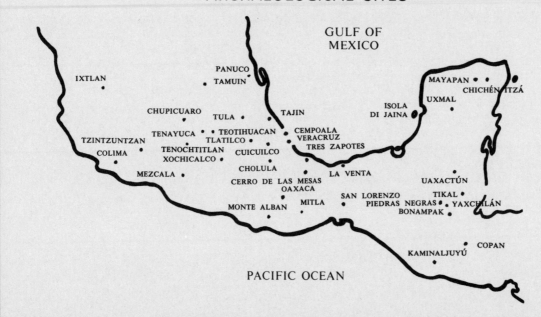

ARCHAEOLOGICAL SITES

GULF OF MEXICO

IXTLAN

PANUCO

TAMUIN

MAYAPAN

CHICHÉN ITZÁ

CHUPICUARO

TULA

TAJIN

ISOLA DI JAINA

UXMAL

TENAYUCA

TEOTIHUACAN

TLATILCO

CEMPOALA

VERACRUZ

TZINTZUNTZAN

TENOCHTITLAN

XOCHICALCO

CUICUILCO

TRES ZAPOTES

COLIMA

CHOLULA

LA VENTA

MEZCALA

CERRO DE LAS MESAS

OAXACA

UAXACTÚN

SAN LORENZO

TIKAL

MONTE ALBAN

MITLA

PIEDRAS NEGRAS

BONAMPAK

YAXCHILÁN

COPAN

KAMINALJUYÚ

PACIFIC OCEAN

In describing the arts and artifacts of ancient Mexico, the authors have adopted a strictly chronological framework, instead of giving separate developments in time for each culture and civilization. This arrangement points up the differences in works generally considered homogeneous because they were produced by the same ethnic group, and differences among the various groups — as well as similarities and related elements in neighboring or distant territories and chronological phases.

Where archaeological finds documenting a given territory or period are not represented in the museum, the authors have attempted to cover these issues in the text.

1100 B.C.—A.D. 200
TLATILCO CULTURE
OLMEC CULTURE
ZAPOTEC CULTURE

KNEELING WOMAN KISSING A DOG.

The earliest remains of representational art in the Valley of Mexico and all of Central America have been found in Tlatilco, El Arbolillo and Zacatenco. The most ancient may date from 1500 B.C., when the local populations were already established in centers and engaged in agriculture, hunting and fishing. This first period in middle or Meso-American art is variously described as Archaic, Formative or Pre-Classic. There are still many unknowns in this "Pre-Classical horizon." Since its origins are obscure, scholars have ascribed various dating and chronological schemes. The entire pre-Christian epoch is usually divided into three periods: Lower, 1500–1100 or 1350–850; Middle, 1100–600 or 850–450; and Upper Pre-Classic, 600–100 or 450–150.

The most abundant Pre-Classic figured handiwork, in addition to terracotta vases, consists of small modeled representations of human beings and animals. Since vases and figures have been found in large numbers in the tombs of Tlatilco, scholars have concluded that they were funerary offerings, probably symbolic of fertility in humans and crops. They were simply and rapidly made, by modeling a handful of wet clay. Sometimes, segments or pellets of other materials were added to articulate the limbs or define the features and headdresses. The clay was smoothed with a polished stone, dried in the sun, painted and then baked in a kiln.

Unlike the terracottas of other civilizations, including the European ones, each of the sculptured finds from Tlatilco is a unique, original work.. The production as a whole shows a number of predominant themes, with subjects from daily life prevailing. There are also formal models like the steatopygous female figures, and common stylistic devices such as the almost mask-like high foreheads and raised, spreading eyebrows, as in this example. It is clear that each artist worked with the greatest freedom while also adhering to a number of traditional basic features. The result is a surprising variety and richness of detail, composition, rhythm and invention. Only a small number of these works seem conventional and perhaps traditional. The current scholarly interpretation is that they represent a somewhat childlike, carefree "naturalism." Some see them as ingenuous reproductions of reality executed with primitive means. Certainly the reality they suggest is free of suffering and drama, and appears serene, witty, affectionate and warm. At the same time, the plastic composition is not casual or improvised but carefully planned for symmetry, balanced harmony and lively but subtle modeling.

The *Kneeling Woman Kissing a Dog* is one of the masterpieces of Tlatilco sculpture. It is one of the most original creations of the period — full-bloodedly bucolic and depicting a powerful personal interpretation of a happy, sunlit world. The figure — disposed in two directions and balanced on one knee — reveals a sophisticated knowledge of composition. There is an extraordinary grasp of fleeting movement in the rendering of the affection between the leaping dog and the kneeling woman.

18

Kneeling Woman Kissing a Dog
Circa 1100–500 B.C.
Modeled terracotta, with traces
of polychromy;
height 3 1/8".
From Tlatilco.

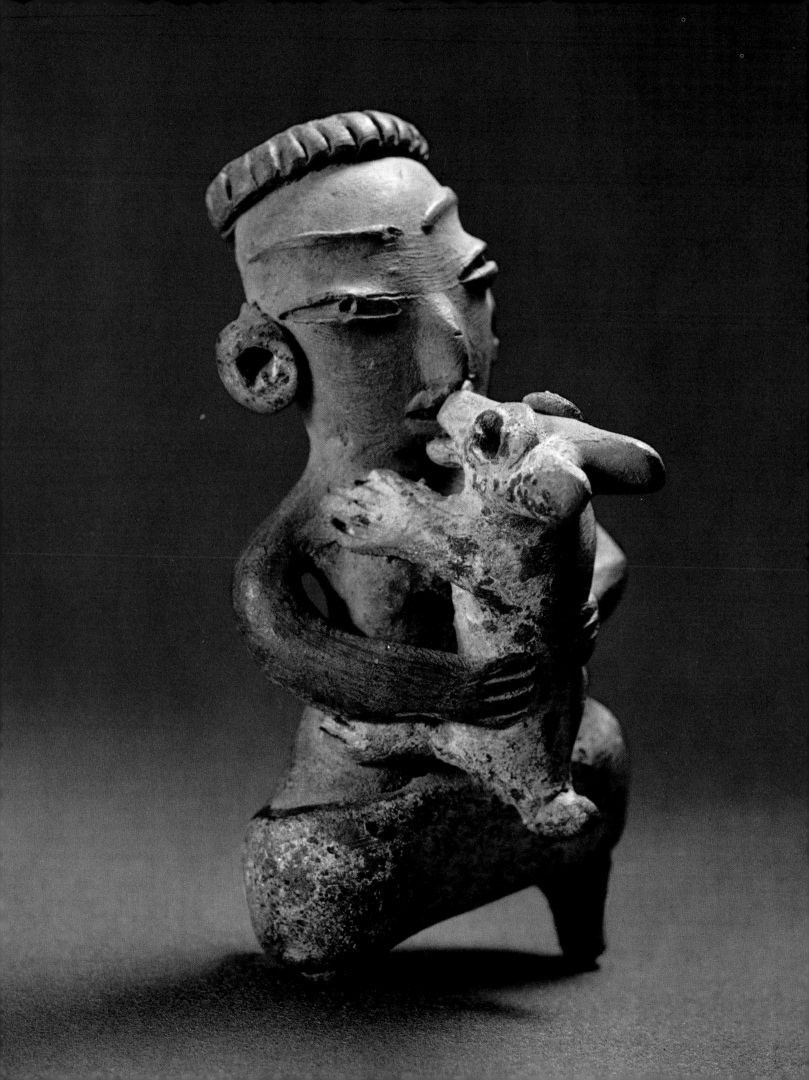

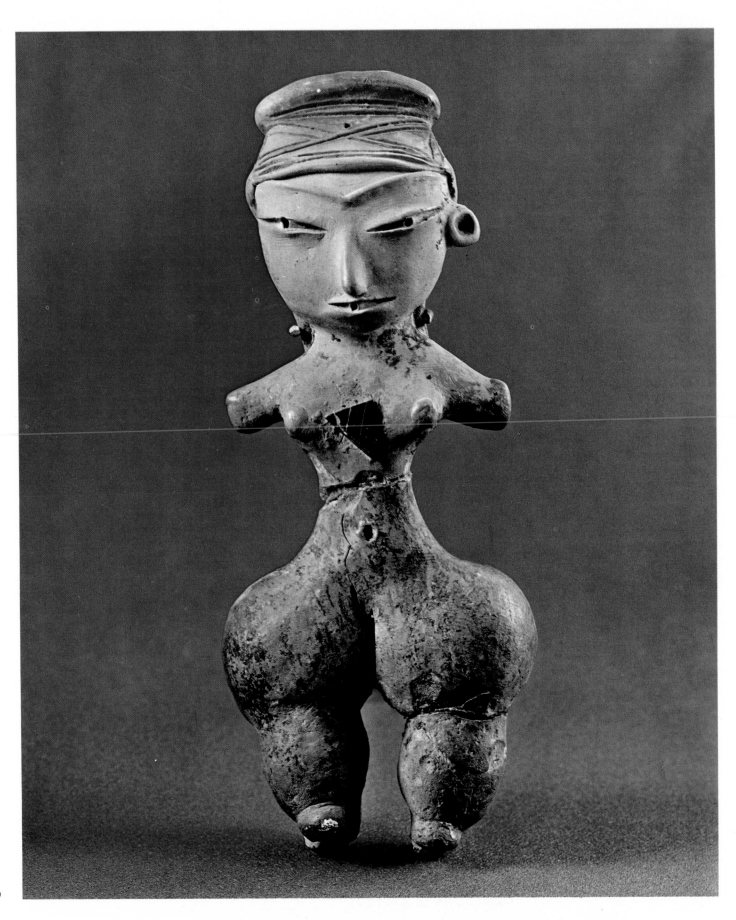

Nude Woman with Diadem and Pendants
and *Nude Two-Headed Woman*
1100–500 B.C.
Terracotta with traces of polychromy;
height 2 3/8".
Modeled terracotta with traces of white
paint; height 4 1/2".
From Tlatilco.

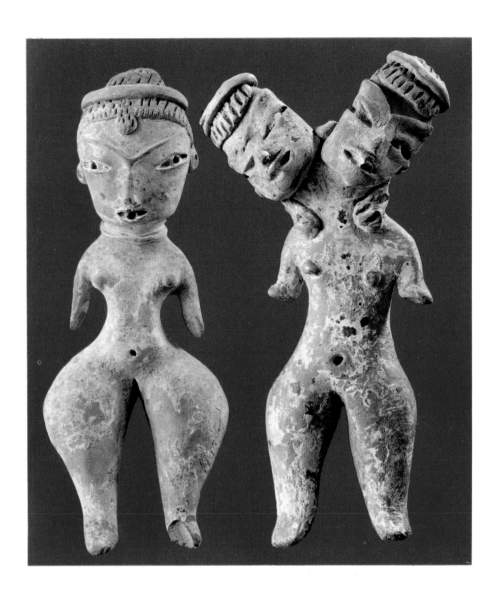

Nude Woman with Turban
Circa 1100–500 B.C.
Modeled clay with additions and traces of
polychromy; height 4 2/5".
This statuette and those on the following
pages, examples of the oldest known art
form in Central America, clearly show how
erroneous is the notion that "archaic" cul-
tures always begin with geometrical or at
least symmetrical forms. These sophisticated
figures, with their "intentional abstraction,"
are akin to the highest expressions of Cy-
cladic art. Adapted by various cultures, they
continued to be made throughout the two
thousand years of Pre-Columbian art. The
Jaina terracotas — the celebrated "Tanagra"
figurines of Maya art in the seventh and
ninth centuries — are particularly outstand-
ing.
From Tlatilco.

NUDE WOMAN WITH TURBAN.

In this highly original figure, the artist revealed his deliberately anti-natural-
istic intent by contracting the extremities, enclosing the composition in
recurrent oval forms and balancing the size of the head, body and legs.
With the aid of an agile and assured modeling stick, the artist defined the
clear crisscross motif of the headdress. He used the point of the modeling
stick to perforate the pupils of the eyes and the center of the mouth. The
figure's eyes and breasts form a single compositional motif which is re-
peated below, with the belly button as the center. This extremely straight-
forward compositional scheme is also found in other works, such as those
above, and may be typical of a particular artist or school.

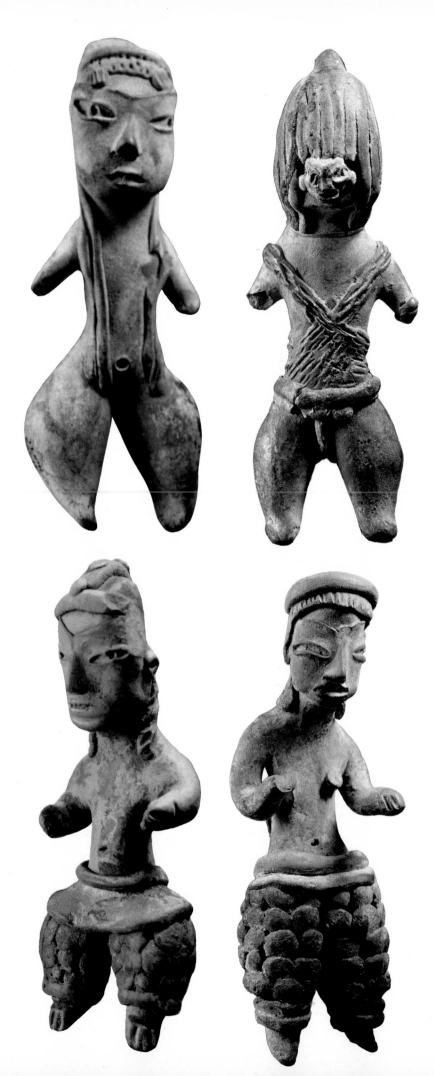

Female Figure with Headdress and Long Hair and *Male Figure with Long Hair and Mask*
Modeled polychromed terracotta; heights 5 1/4″ and 4 3/4″.
From Tlatilco.

Figure with Short Skirt and Pantalets and *Figure with Pantaloons*
1100–500 B.C.
Modeled polychromed terracotta; height of both 3 15/16″.
From Tlatilco.

NUDE WOMAN WITH DIADEM AND PENDANTS, AND NUDE TWO-HEADED WOMAN.

p. 21

The frequent representation of female figures in Tlatilco sculpture has led scholars to suppose that women, as child bearers and thus as symbols of fertility in nature, had a dominant social position. These two examples are among the most typical statues of women. The *Nude Woman with Diadem and Pendants* shows restraint in the composition of the upper part; below, there is a greater rhythmic impetus within the bilateral symmetry. The bicephalism of the *Nude Two-Headed Woman* is interpreted by scholars as symbolic of the principle of duality, one of the roots of Meso-American religious philosophy. It is commonly found on figures thought to be pro-pitiatory in nature, in the form of two heads on one body, two faces on the same head or two different halves of one face. The composition of this statue has the form of a somewhat splayed double X. The modeling is more impressionistic than in other figures, and the play of light on the heads is strongly accentuated by the "negative" device of hollows that catch shadows.

FEMALE FIGURE WITH HEADDRESS AND LONG HAIR, AND MALE FIGURE WITH LONG HAIR AND MASK.

The female figure is akin to the *Nude Woman with Diadem and Pendants* (page 21), but the composition is less severe and the modeling is freer and livelier. The elaborately costumed male figure is thought to be a ritual dancer. Under the tall, probably feathered headdress, the face is covered with a human mask that resembles later mummified heads. The radiating and converging composition, similar to that of the female figurine, is emphasized here by the crossed vestments.

FIGURE WITH SHORT SKIRT AND PANTALETS, AND FIGURE WITH PANTALOONS.

Some scholars believe that these figurines represent dancers. Their head-dresses and hair styles seem to have a ritual meaning. The pants and the bell-shaped garment at the hips are rendered by means of a series of pressed clay pellets. Although dealing with the same subject, the artist has differ-entiated the gestures, movements and features of the two figures.

VASE IN THE SHAPE OF A CONTORTIONIST OR ACROBAT.
Another aspect of Tlatilco expression and stylization is revealed by this unusual vase. The cap of hair incised with a stick, the strongly individualized head and the careful modeling recall the works described above. But the compactness and accentuation of the volumes in this work reveal a more explicitly architectonic type of composition. These new features in Tlatilco sculpture are related to the art of the Olmecs, who spread along the Gulf Coast and the central part of Mexico around 1000 B.C. The human- and animal-shaped Olmec vases were used in the magic rites that invoked favorable agricultural conditions. Feasts with dancing, shows, sleight-of-hand performances, acrobatic and contortionist exhibitions were held in honor of the rain-god. According to scholars, this and the vase on page 26 are typical products of the superimposition of the Olmec civilization on the more ancient culture of Tlatilco.

VASE IN THE SHAPE OF AN ARMADILLO. *p. 26*
Tlatilco culture continued to produce its own stylistic expressions up to the eve of the Classic age. This magnificent zoömorphic vase in black terracotta shows all the common motifs of Tlatilco art in decoration, materials, color and technique. Typical also is the representation of only a single part — here the lower portion — of the animal.

"TIGER-FACE" FUNERARY MASK. *p. 27*
The accomplished work of an Olmec artist, this mask dates from the period of the greatest cultural and political expansion of "The-People-from-the-Land-of-Rubber," whose origins and early history have remained unknown. In the second half of the millennium preceding the Christian era, important Olmec settlements and religious centers were established near Tlatilco,

24

Vase in the Shape of a
Contortionist or Acrobat
Circa 1100–500 B.C.
Olive-colored polished terracotta;
height 9 4/5".
From Tlatilco.

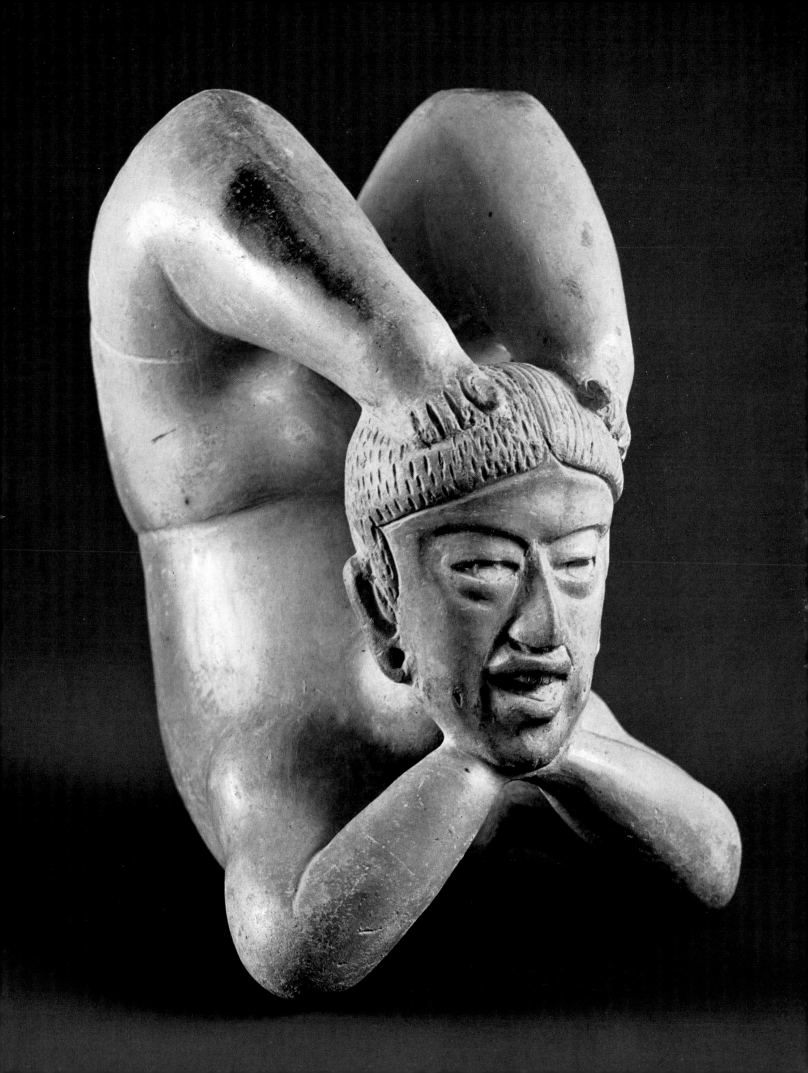

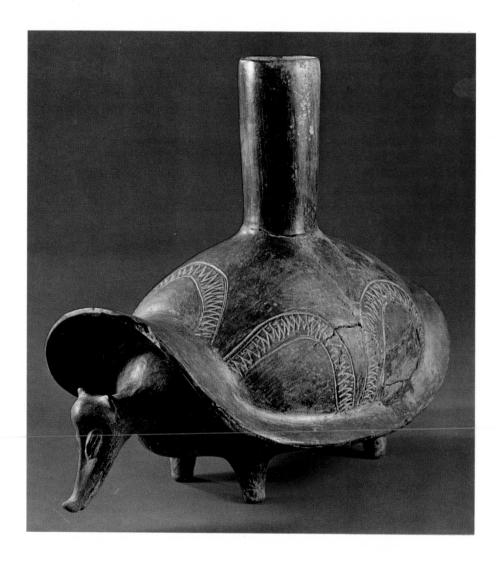

in the central part of the country; further south toward the Pacific, in the state of Oaxaca; and — with completely independent cultural features — in a limited area near the Atlantic, at La Venta, San Lorenzo, Tres Zapotes and Cerro de las Mesas.

The highly original Olmec art is the outstanding cultural phenomenon of the Middle Pre-Classic period, circa 850–450 B.C., and it assumed an influence in Mexico comparable to that of Hellenic art in the Mediterranean. It contributed substantially to the formation of the flourishing Zapotec, Mayan, Tajìn and Teotihuacan cultures throughout the first millennium after Christ. Although it is a reasonable supposition that the Olmecs produced an advanced architecture on a par with their sculpture, no examples have come to light.

It is assumed that this funerary mask comes from the territory around La Venta. Although the artist has imbued the sculpture with a striking and almost aggressive vitality, stylistic discipline is also apparent. The mask tends toward a geometrical abstraction analagous to that seen in some periods of Egyptian art. There are no chance effects in the contour or interior arrangement; the emphasis is on the elliptical rhythm and symmet-

Vase in the Shape of an Armadillo
1000–500 B.C.
Black terracotta with engraved decoration; height 5 7/8".
From Tlatilco.

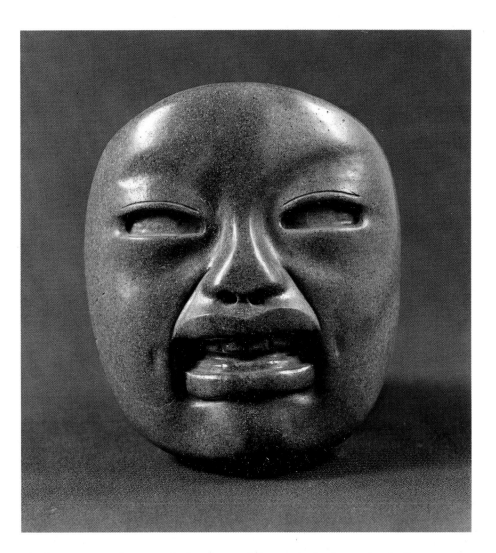

rical correspondences of the form. The typical rictus is similar to the "archaic smile" seen in Mediterranean art. Archaeologists have named the mask "Tiger-Face" and describe its distinctive feature as a jaguar mouth on the assumption that it resembles the animal's savage and frightening appearance. This motif was often utilized to render a maximum of movement within a contained, architectonic framework.

PECTORAL WITH A FELINE HUMAN HEAD AND REPRESENTATIONS REFERRING TO JAGUARS. *p. 28*

This unusual piece at first seems puzzling because the stone is carved to different depths and has engraved parts that suggest a palimpsest. Further observation shows that there are in fact five masks in profile. On the largest, to the left, another has been grafted which looks upward. A profile mask with the same mouth, parallel to the largest, comes down from the eye of the mask above. Two more profiles are turned in the opposite direction: one is surmounted by finger-like elements; the other is engraved on the cheek of the largest and has a similar helmet. Engraving, along with carving, is often seen in other Olmec sculpture. It is possible that the multiple profiles in this work were done as a "study" piece to try out various compositional devices.

"Tiger-Face" Funerary Mask
Circa 1000 B.C.
Green stone;
height 3 15/16"; width 3 1/2".
The break in the left cheek was repaired in Pre-Columbian times.
Provenance unknown.

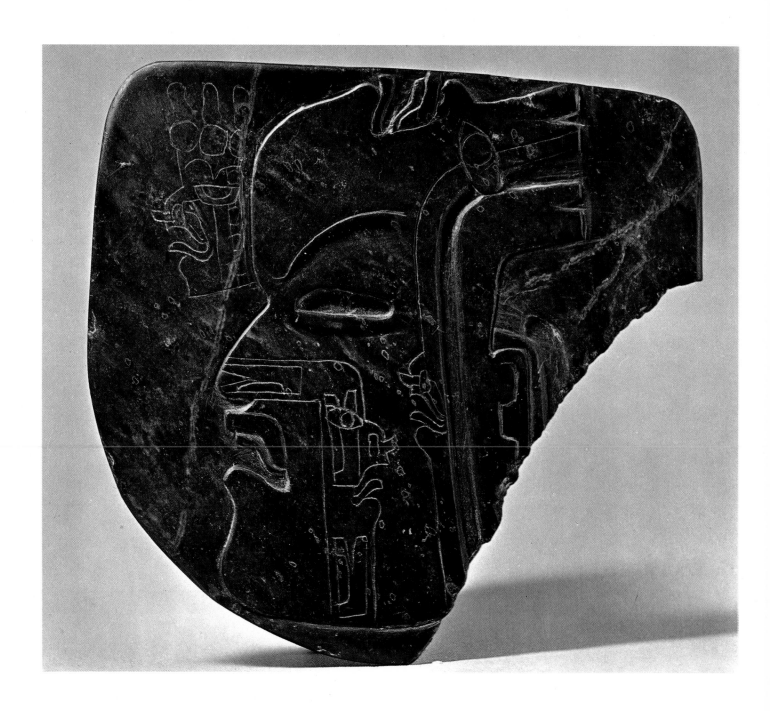

HEAD WITH CAP.

Probably a fragment of a statue, this head is one of the masterpieces of Olmec art. Archaeologists point out the feline mouth and the deformed skull, but these features may be seen more simply as an ethnic trait (with Far Eastern analogies) and the result of a custom also known among other peoples. The sculpture is reminiscent of the subtly executed lifelike works of the Amarna period in Egypt. It is a composition in pure volumetrics on a modular framework, skillfully dissimulated in the corresponding convexities above and below the slit eyes, and in the relationship between the other spherical forms seen frontally and in profile.

Pectoral with Feline Human Head and Representations Referring to Jaguars
Circa 850–150 B.C.
Fragment.
Engraved and carved green serpentine;
5 7/8″ × 6 1/5″.
Provenance unknown.

Head with Cap
850–150 B.C.
Jade; 8 5/8″ × 3 15/16″.
Fragment of a statue from
Tenango del Valle.

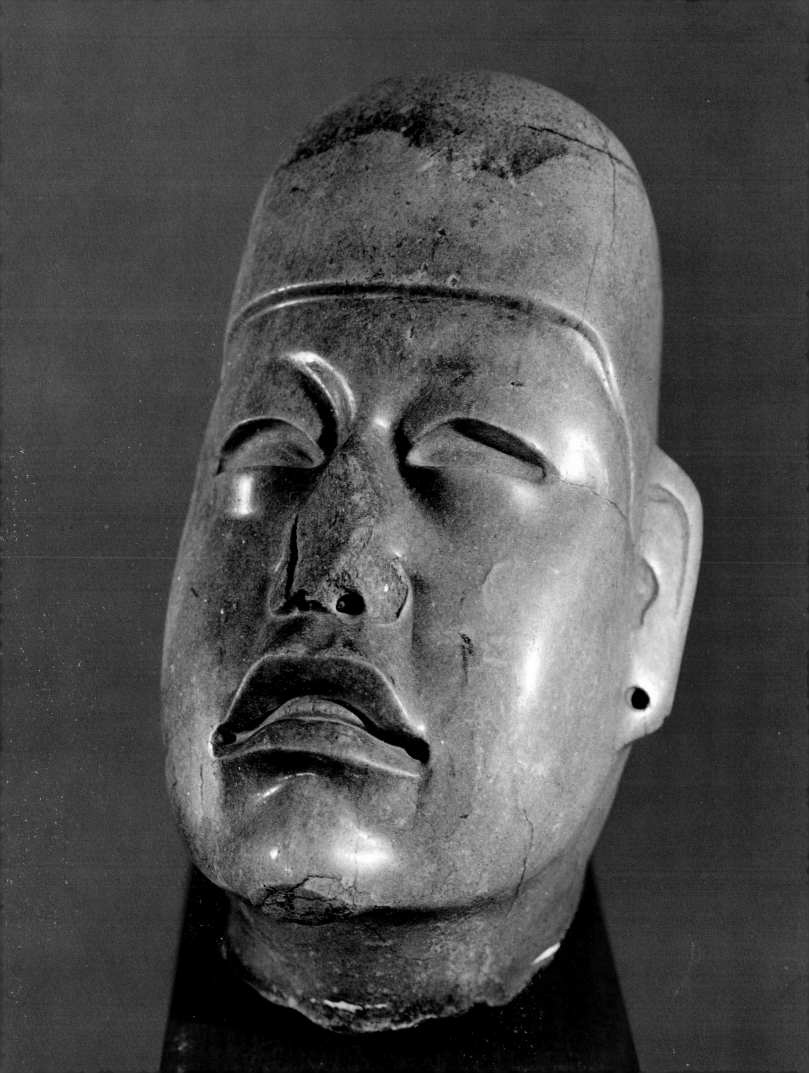

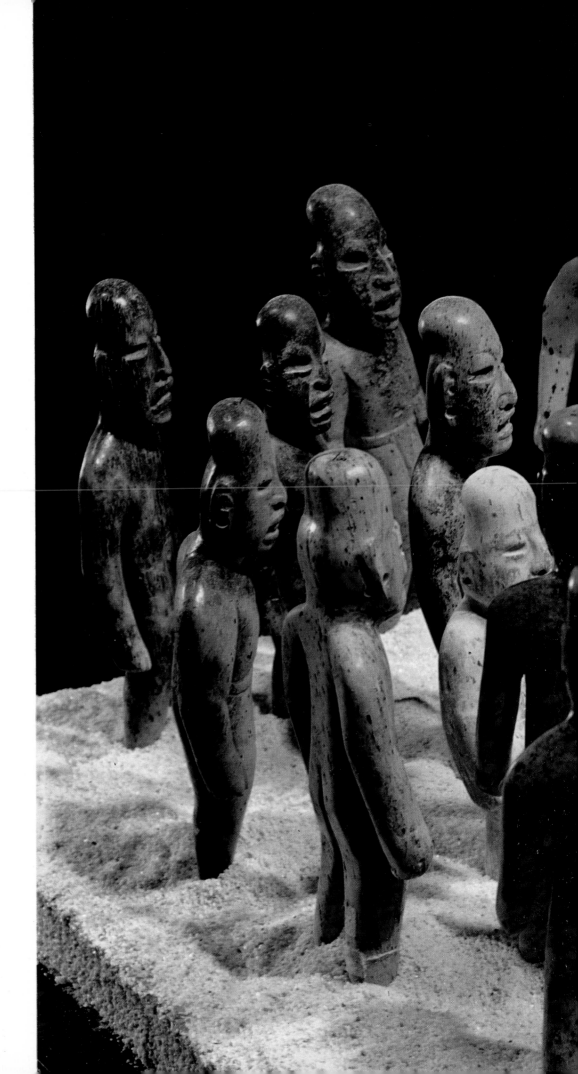

Group of Figures
850–150 B.C.
Light green and white jade;
heights vary from 6″ to 9 7/8″.
30 From La Venta.

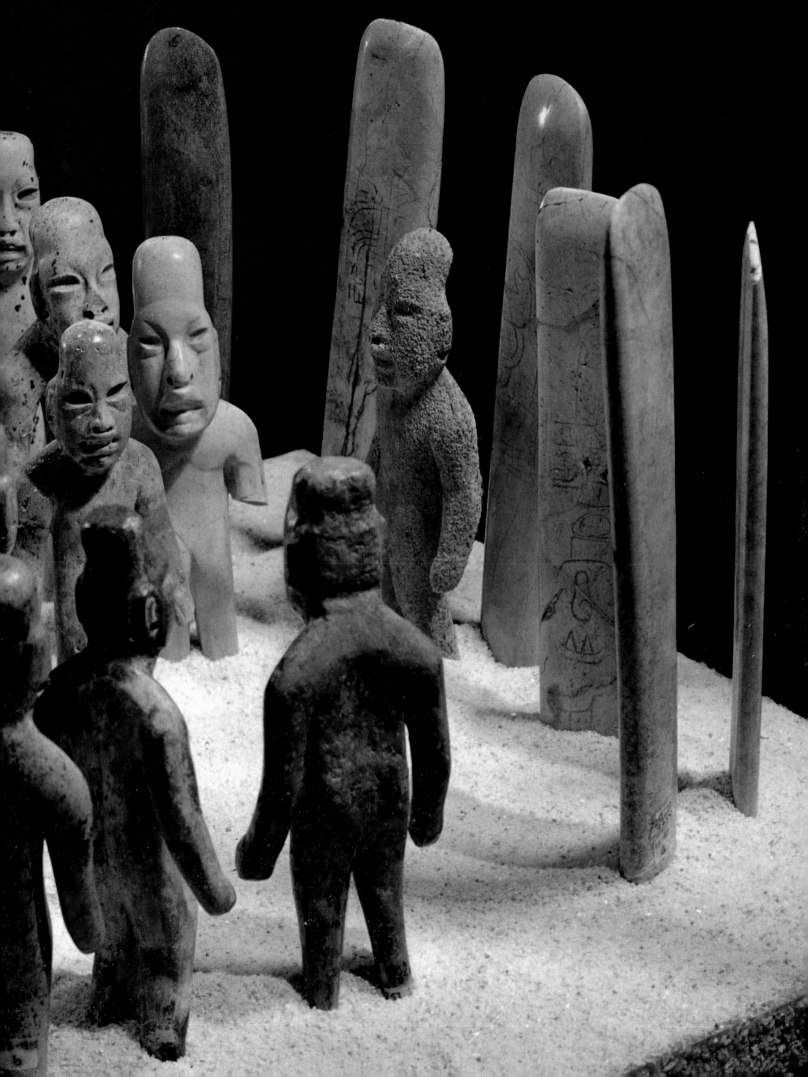

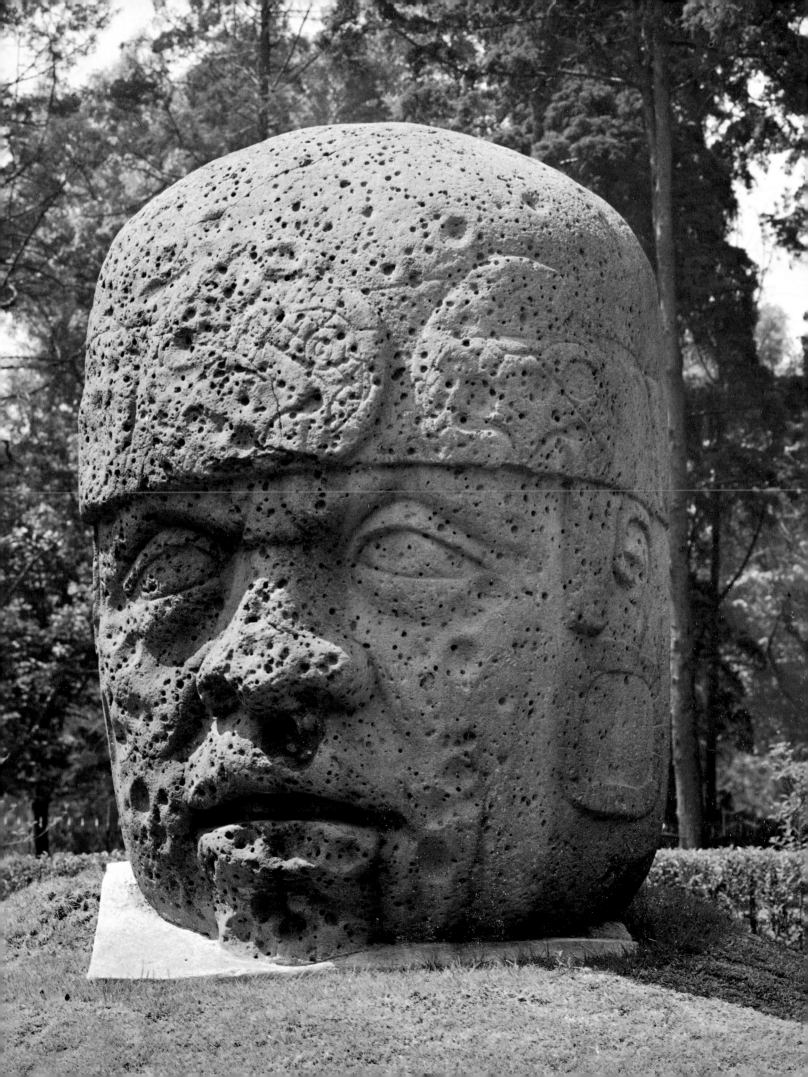

Colossal Head
Circa 850–150 B.C.
Basalt; 12'1 7/8" × 6'2".
Discovered in 1945 by Stirling, it remained in the jungle of San Lorenzo Tenochtitlan (Veracruz) until 1963, when it was brought to the museum by James Johnson Sweeney on the occasion of the exhibition of Olmec sculpture organized by the Houston museum.

GROUP OF FIGURES. *pp. 30–31*

Composed of sixteen standing male statuettes — three of which are copies — and six steles with engraved designs, this sculpture group was found three feet below the surface of the ground. Although its meaning has not been deciphered, it seems that it did not have a religious or funerary purpose. Exploiting the lightness and transparency of the green and white jade, the Olmec artist created, through the use of a continuous play of light and shade, a scene of exceptional impressiveness.

COLOSSAL HEAD.

Colossal stone heads — eighteen have been discovered to date — were originally set on low bases having the form of a truncated pyramid. Pre-

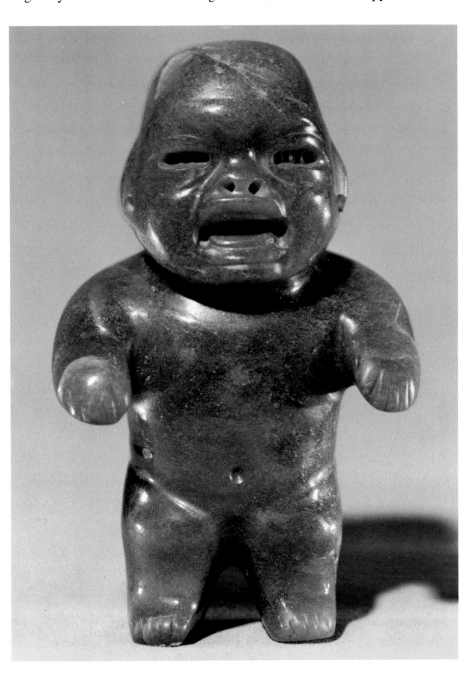

Weeping Child (or Dwarf)
850–150 B.C.
Gray-green jade; height 4 3/4".
From Cerro de las Mesas.

sumably they represented the severed heads of the losers in pelota. The game, which was reserved for the nobility, had religious significance. The pelota, or ball, was a symbol of the sun, and the sacrifice of the loser was seen as a means of attaining divinity. As in this example, such grandiose sculptures show a decidedly architectonic aspect of Olmec art — in the composition of the volumes, the monolithic synthesis that is unaffected by anatomical and decorative details, and the severe purity of the multiple points of view.

WEEPING CHILD (OR DWARF). *p. 33*

This *Weeping Child* reveals the Olmec artist's broad range of imagination. Here the rhythmic composition of the volumes has been rendered more flexibly. The whole work is animated by the mimicry of the expression, and gives an impression of intensified life.

FEMALE FIGURINE WITH HIGH HEADDRESS.

A typical example of the little figures found in the state of Guerrero, in western Mexico, this statue shows pronounced deformations, especially of the skull. The features, dress and decorations are incised in lines and dots on the clay. "San Jeronimo" is the name given to this type of sculpture, which was produced by a population that settled along the banks of the Mezcala river, had close connections with Olmec culture, and flourished from 600 B.C. to A.D. 400. The "San Jeronimo" terracottas also have a direct affinity with the older Tlatilco art, before the major period of Olmec influence.

TRIPOD VASE. *p. 36*

One of many similar artifacts from the Valley of Mexico, this vase has bulbous feet and painted decoration. The modeling of the supports recalls the forms produced by the Tlatilco culture.

FIRE-GOD. *p. 36*

Huehueteotl, the ancient god of fire, was often represented in central Mexico with a brazier on his back — an allusion to volcanos. According to archaeologists, this work, which was found at Cuicuilco, refers to the little volcano of Xitle, whose lava covers the entire surrounding region. This figure belongs to a culture that flourished in the region of Cuicuilco and was contemporary with the last phase of Tlatilco art, with which it has close affinities.

PLANT-FORM VASE. *p. 37*

Protuberances in the form of fruit often occur, along with other vegetable forms, in the production of figurines and ceramics from the fertile rural region of Chupicuaro. Color was used extensively and with great imagination, as is seen in the traces commonly found on the surviving works. This vase, datable between 600 and 200 B.C., was produced in the phase of Chupicuaro culture contemporary with the last stage of Tlatilco civiliza-

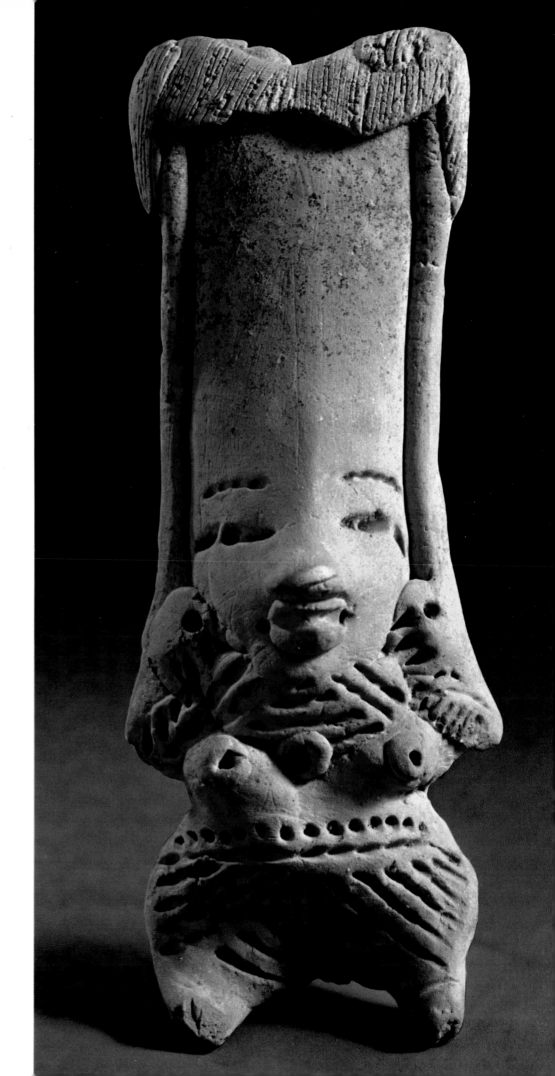

Female Figurine with
High Headdress
Circa 600 B.C.
Modeled and incised terracotta;
height 6 1/2″.
From the state of Guerrero.

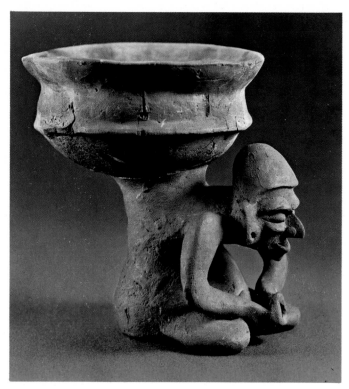

tion. It shows a similar taste for spontaneous modeling on pure underlying volumes, in which the light brings out an expansive animation.

SEMI-CUBIC VASE.
Datable around 300 B.C., this vase has an unusual semi-cubic form, with a round mouth decorated with a braided border. In the limpid form of the vase, the artist showed the preference for pure volumetrics that is also seen in the zoömorphic sculpture and the ceramics of the Tlatilco Lower and Middle Pre-Classic periods.

SEATED FIGURE. *p. 38*
This figure dates from the oldest period of the Chupicuaro culture, which archaeologists place in the so-called Upper Pre-Classic. The artist followed a rigorously fundamental compositional scheme that is apparent in the symmetry and parallels; however, the modeling of the sculpture is freehand, with platelets, threads and pellets of clay worked with comb and stick. The whole is animated with touches of color, and captures an impression of intense and transitory life. Like the preceding terracottas, this work was part of the furnishing of a tomb.

FOOT OF A VASE IN THE FORM OF A
VERTEBRAL COLUMN. *p. 39*
The great religious and cultural center of Monte Alban, a city built on terraced mountain peaks in the state of Oaxaca, has given its name to the various approximate periods into which archaeologists divide the Zapotec culture: Monte Alban I (650–200 B.C.); Monte Alban II (200 B.C.–

Above, left:
Tripod Vase
Circa 600 B.C.
Yellow and red terracotta;
6 11/16″ × 9 1/2″.
Provenance unknown.

Above, right:
Fire-God
Circa 600 B.C.
Terracotta; 4 3/4″ × 2 3/4″.
From Cuicuilco.

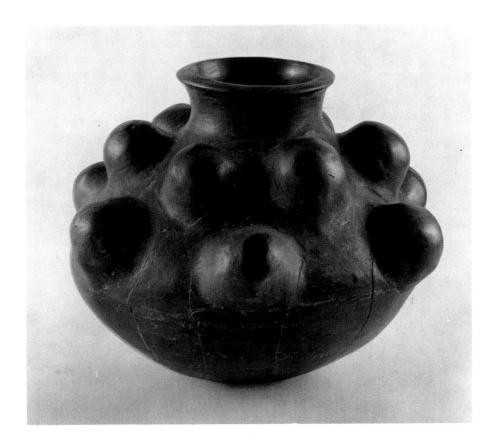

Plant-Form Vase
600–200 B.C.
Brown-black terracotta;
height 8 1/16".
From Chupìcuaro (Guanajuato).

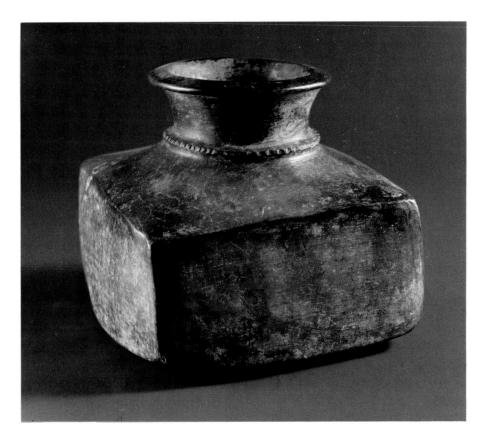

Semi-Cubic Vase
Circa 300 B.C.
Steel-gray terracotta;
6 5/8" × 7 1/2".
From Chupìcuaro.

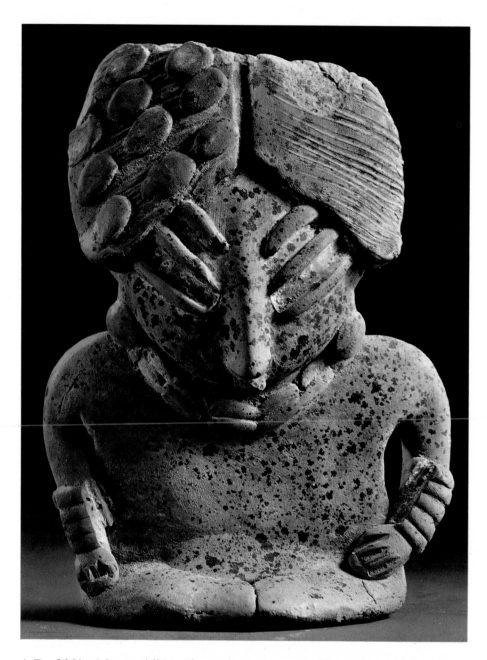

Seated Figure
Circa 200 B.C.
Terracotta with green and
blue decorations;
height 4 3/4".
From Chupìcuaro.

A.D. 200); Monte Alban "loma larga" or transition phase (200–350); Monte Alban IIIA (350–600); Monte Alban IIIB (600–1000); Monte Alban IV (1000–1300); and Monte Alban V (1300–1521). It is certain that the ritual center was already flourishing around 500 B.C., and that it continued in its religious and cultural functions throughout Pre-Columbian history. The Zapotecs, who came from other regions and apparently had been in contact with the Olmecs and Mayans, overwhelmed an earlier culture that has left traces as far back as 2000 B.C.

Comparison with the numerous works that have survived from the first two "periods" of Zapotec culture would seem to confirm the proposed dating of this unusual piece between 200 B.C. and A.D. 200. In form, this work shows affinities with those works. Its theme is believed to have been inspired by the vertebral column.

*Foot of a Vase in the Form of
a Vertebral Column*
200 B.C.–A.D. 200
Polychromed terracotta;
height 16 1/2".
From Monte Alban (Oxaca).

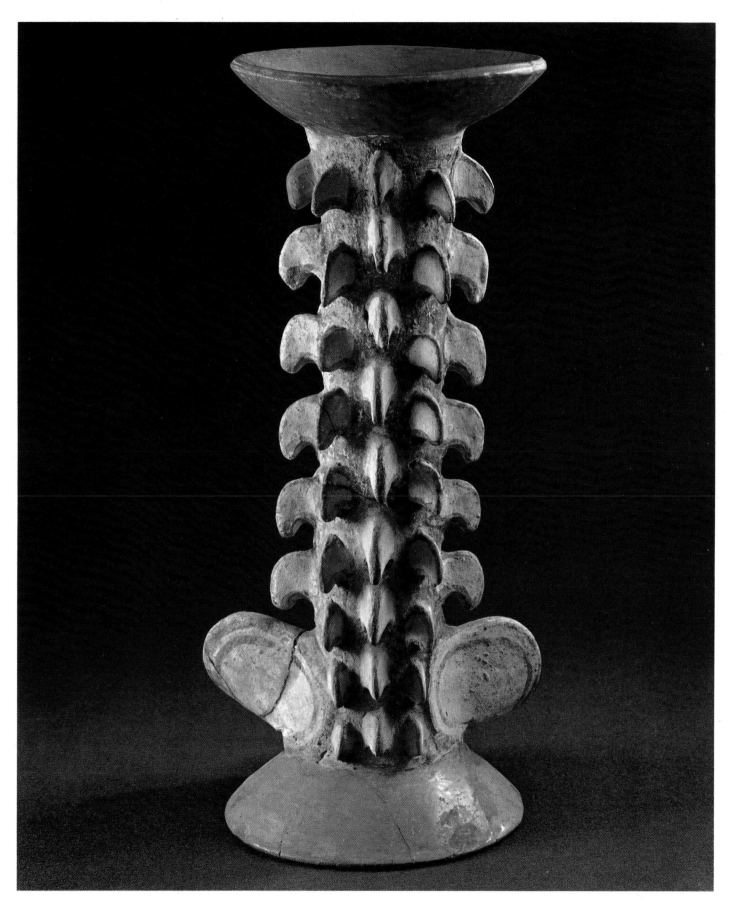

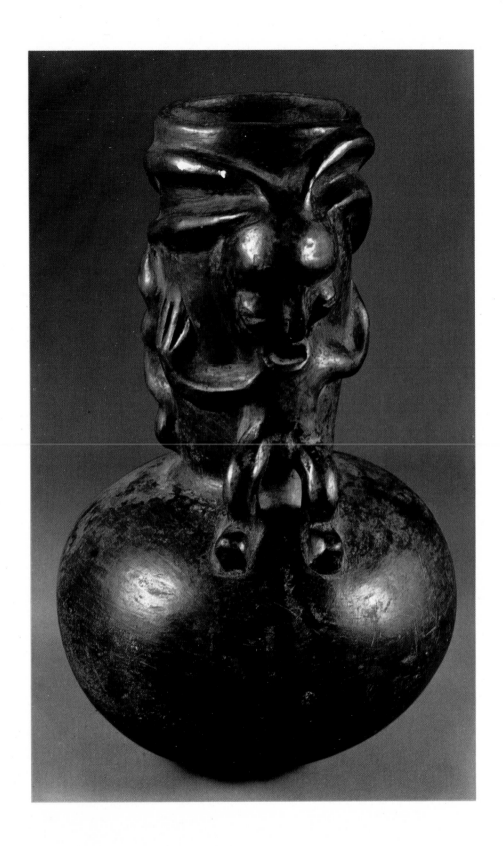

FLASK WITH ANTHROPOMORPHIC FIGURE.

This flask was found in one of the three tombs discovered within the **40** Pyramid of Tlapacoya, on the central plateau. The Pyramid is believed to

Flask with Anthropomorphic Figure
Circa 200 B.C.
Black terracotta; height 9 7/8″.
From Tlapacoya.

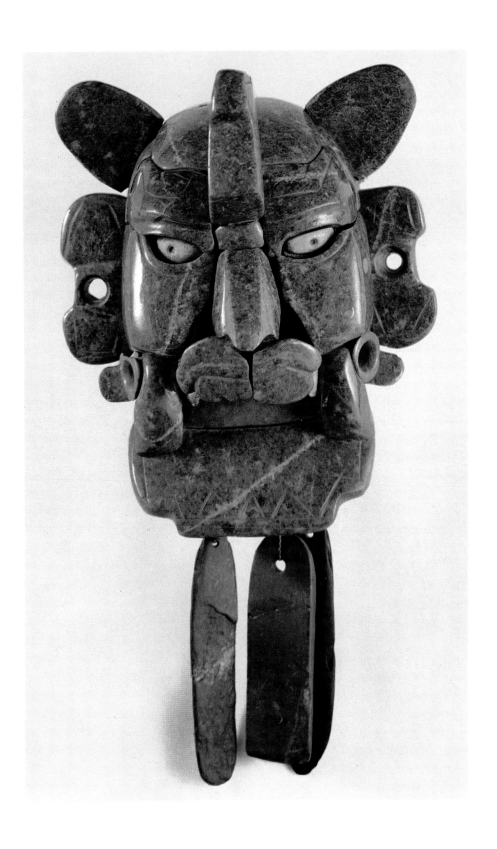

Mask of the God Murcielago
200 B.C.–A.D. 200
Blue-green jade, composed of a number
of sections with metal links; height 10 1/4".
From Monte Alban.

have provided the precedent, on a smaller scale, for the Pyramid of the
Sun at Teotihuacan, and was thus certainly constructed before 200 B.C.

Like Tlatilco, Tlapacoya was an "independent" and ancient culture that was active all through the millennium before Christ. The artifacts found in its three tombs show exceptional imagination in the variety of forms and the diversity of their decoration. The artists evidently absorbed a great deal of their expressive means from the neighboring and contemporary cultures of the Zapotecs, Teotihuacan, Oaxaca and, of course, the Olmecs.

In this monochrome bottle, the anthropomorphic figure probably refers to Cocijo, the god of rain, who was highly venerated by the Zapotecs. The pure volumes, combined with improvised surface effects, recall the works of Tlatilco and Chupicuaro, as well as some of the surviving Zapotec vases of the Monte Alban I period.

MASK OF THE GOD MURCIELAGO. p. 41

Murcielago, or the bat-god, is associated with ideas of darkness, night and death. This is a rare example of the technical mastery of a Zapotec artist of the Monte Alban II period. Each part of the mask is separate, which makes the whole somewhat mobile, like an automaton. Similar devices are seen in many other ancient civilizations.

JAGUAR WITH A COLLAR.

This funerary urn or canopic jar in the form of a jaguar wearing a collar is decorated with various colors in fresco on a thin chalk ground. It symbolizes, according to archaeologists, the earth and death. It is the work of a Zapotec artist who was strongly connected to Olmec culture of the Monte Alban II period. This is revealed by the careful balance of the forms and their geometrical and volumetric stylization. There is a savage potency in the rigid, almost hieratic pose of the figure.

Jaguar with a Collar
200 B.C.–A.D. 200
Clay with plaster coating and traces of polychromy; height 33 1/2".
From Monte Alban.

WRESTLER OR PELOTA PLAYER. p. 44

With other similar sculptures from La Venta, such as the *Seated Man*, and figures from Laguna de los Cerros and Papajàn, Veracruz, this figure is one of the highest achievements of Olmec art. The *Wrestler* is rigorously composed in terms of volumes. No part of the body extends beyond the limits of an imaginary polyhedron, and the carving of the body is polished and clean, with no marginal or incidental effects. It is not certain whether the figure represents a wrestler or a pelota player. The game of pelota was already being played by the Olmecs around 500 B.C., and subsequently it spread as far as Arizona and Nicaragua. It is thought to have represented the struggle of the cosmic elements, and to have been utilized by the priests as a divinatory rite. The player was allowed to touch the pelota — a hard rubber ball — only with his hip, arm or right leg. The goal was a ring set at a height of fifteen feet in the wall of a rectangular court. Pelota was a dangerous sport, for losers were sacrificed.

On page 44:
Wrestler or Pelota Player
Circa 200 B.C.–A.D. 200
Porous green stone; height 26".
From Minatitlan (Veracruz).

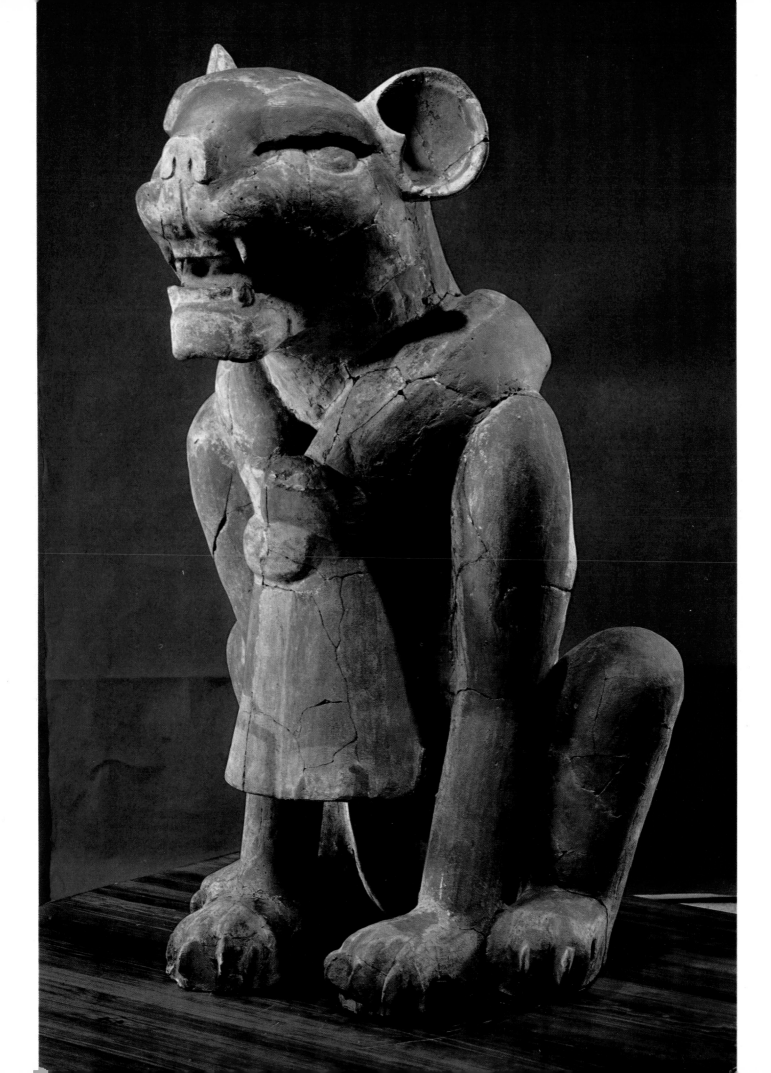

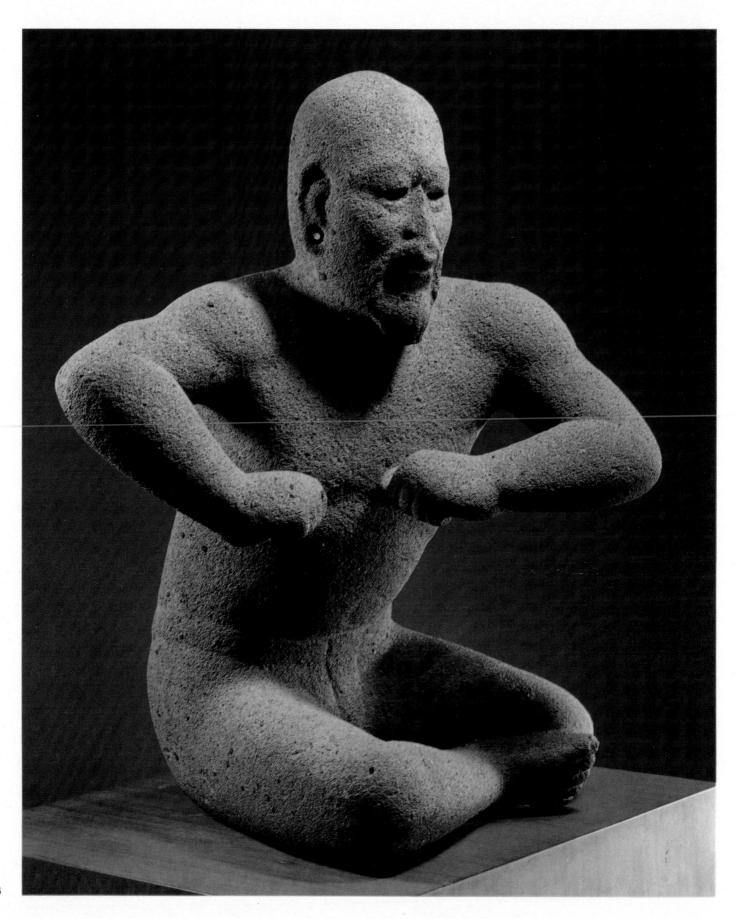

44

A.D. 200 — 600
TOTONAC CULTURE
TEOTIHUACAN CULTURE
COLIMA CULTURE
NAYARIT CULTURE
ZAPOTEC CULTURE

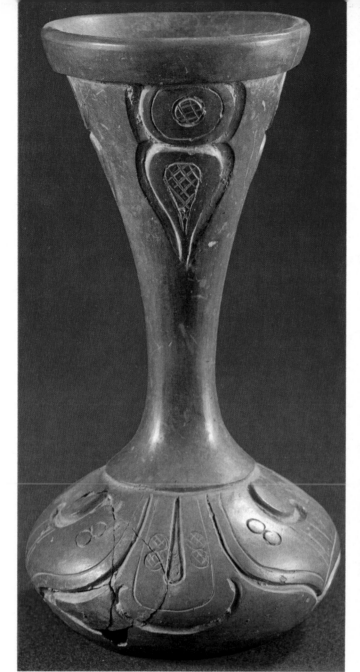

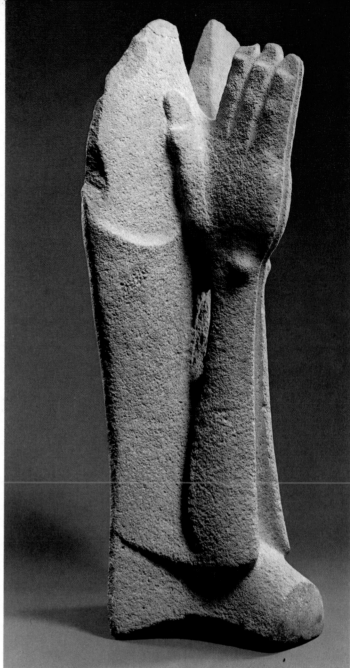

VASE WITH FLORAL DECORATIONS.

This vase is a splendid example of the ceramics produced by the so-called Totonac culture. The carving is similar to that seen in Totonac stone reliefs, while the ornamental decorations are typical of the Proto-Classic period of the Veracruz culture, when Olmec traditions were still strong. Thus it may have been produced before A.D. 200, the date usually assigned to it by archaeologists.

The Totonac ethnic group occupied the vast territory that is now the state of Veracruz; they still constitute the major population of the state, preserving their own language and traditions, which are distinct from those of neighboring areas. The lively Totonac or Veracruz culture was oriented predominantly toward the Olmecs in the Pre-Classic and later periods. Subsequently it was influenced by Teotihuacan, the Maya, Huastecs, Toltecs and finally the Aztecs, by whom they were conquered. Thus, Totonac art is a composite formation, but also shows expressions of originality.

Above, left:
Vase with Floral Decorations
A.D. 200
Gray-black terracotta,
with decorations
in low relief and traces of red paint;
height 7 1/2".
From Cerro de las Mesas.

Above, right:
Palma with Hands Joined in Prayer
A.D. 400–600
Mutilated stone; height 16 1/8".
From Veracruz.

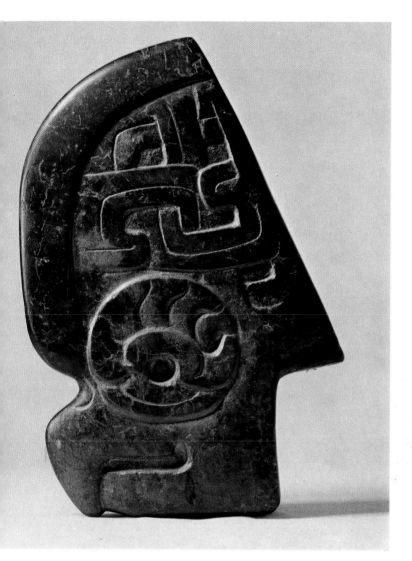

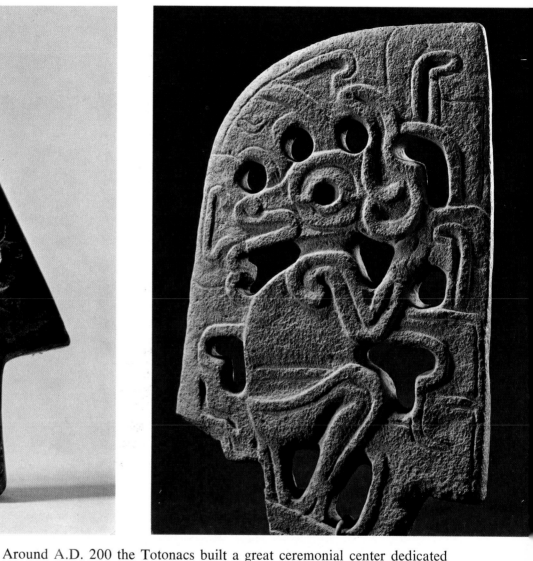

Above:
Head of a Macaw (Guacamaya)
Circa A.D. 600
Diorite; height 13".
From Veracruz.

Above, right:
Funerary Ax
Circa A.D. 600
Andesite; 18 1/2" × 9 7/8".
From the coast of the
Gulf of Mexico (Veracruz).

Around A.D. 200 the Totonacs built a great ceremonial center dedicated to el Tajin, the rain-god. Its most prominent building, the Pyramid of the 365 Niches, has provided a point of departure for the dating of three periods in Totonac art: I (A.D. 200–650), II (650–1000), III (1000–1250). The earlier chronology is established on the basis of terracotta figures called *Remojadas,* and this name is used also for the Classic period — Remojadas II — up to 800. The following period, up to 1250, takes its name from the Isla de Sacrificios. There is, accordingly, a double division that seems occasionally to correspond to two distinct directions in art: with Olmec influences on Remojadas, and influences from Teotihuacan, the Toltecs and the Maya on el Tajin.

PALMA WITH HANDS JOINED IN PRAYER.

The *palma* represents the chest protector worn by the pelota players; the so-called "yokes" are representations of the wide belts worn by the players. Hands joined in prayer are one of the typical themes used in these **47**

objects. Others are arrows, animals, and human and divine beings. These *palmas* were utilized in funeral ceremonies. Reminiscences of Olmec art are apparent in the pure polished forms of the volumes and the elimination of naturalistic accidentals.

HEAD OF A MACAW (GUACAMAYA). *p. 47*

Carved for funerary uses, this ceremonial ax symbolizes the victory of a pelota player. The typical flashing eye, called solar eye, was a reference to the cult of the sun. Effects of contrasting light and dark were constantly sought after by Totonac artists. In architecture, there is the example of the celebrated empty niches of the Pyramid of el Tajin; here, there is a delicate combination of motifs in relief and pierced work. Such stone axes were also used as architectural elements, fixed into the walls of temples and civil buildings.

FUNERARY AX. *p. 47*

The forms and symbols of axes and yokes were sculpted on the walls around the platforms devoted to the game of pelota at the ceremonial center of el Tajin. Such motifs are also represented in the celebrated stones of Aparicio, where the pelota players are shown decapitated, with their blood spouting out in serpentine patterns. This work represents a seated personage with a roe-buck mask and glyph, symbols of vegetation. The plastic elements and the dark hollows are distributed along the surface in an imaginative pattern brought to life by the light. In Totonac culture different art forms coexisted between A.D. 300 and 800: the terracottas that refer back to Olmec art, and the relief sculpture — exemplified by both this and the preceding ax — which are related to Teotihuacan and Mayan culture.

MUTILATED STATUETTE (OF XIPE-TOTEC?).

This statuette may represent Xipe-Totec, "Our-Lord-Who-Was-Flayed," one of the favorite divinities in the polytheistic religion of Veracruz, Monte Alban, Oaxaca and the cultures along the coast of the Gulf of Mexico. The missing arms of this little statue must have been movable, as in the "smiling" figurines (see pages 54–55). Stylistically, the figure appears to be related to the phase of Veracruz culture datable around A.D. 500. Later, there were highly complicated and ornate representations of the god from Monte Alban, which show strong analogies to this work in the treatment of the face and the flayed skin. The realistic and horrible aspects of the subject of this statue are less significant than the serenity of the pure forms and delicate rhythm of the mask, which achieves the stylistic refinement of Olmec sculpture.

DANCING WOMAN. *p. 50*

An unusual Totonac work, this little figure of a dancing woman, with its color and lively pictorial qualities, has affinities with the Teotihuacan and Nayarit statuary of A.D. 500. It may be related to the sculpture depicting domestic themes that was common in the Pre-Classic period.

Mutilated Statuette (of Xipe-Totec?)
Circa A.D. 500
Mutilated terracotta.
From Veracruz.

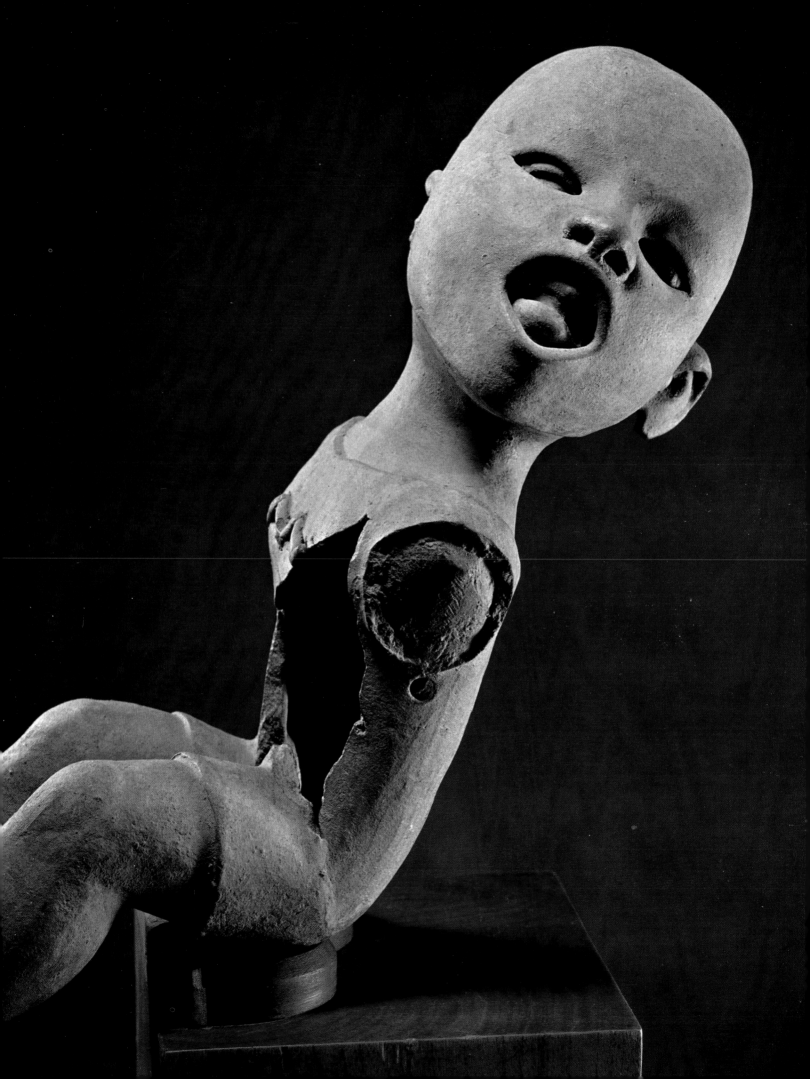

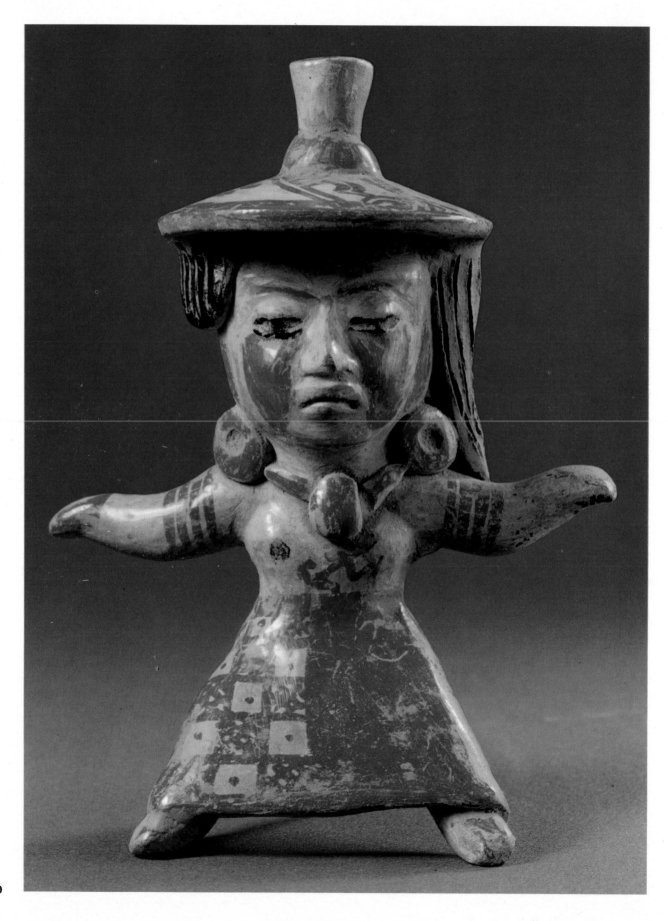

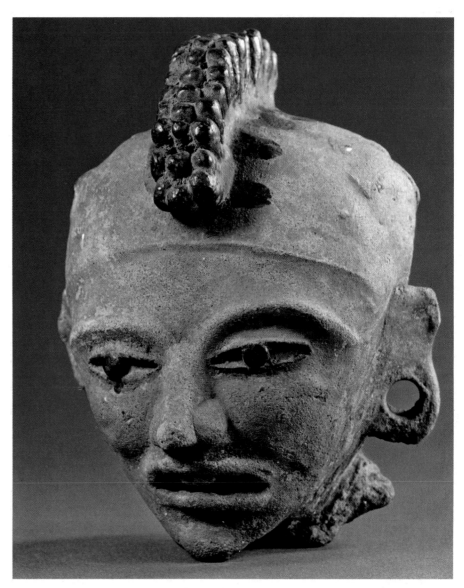

HEAD WITH ORNAMENTAL CREST.

Totonac artists were not restricted to established ritualistic forms in executing heads, as they were in the *palmas,* yokes and axes. This work is an example of their interest in vigorous plastic contrasts, fluent play of light and the rendering of expressions from nature. Painting with bitumen, as in the crest and pupils of the eyes in this head, was used in Veracruz production from Remojadas I, before A.D. 300. Some scholars maintain that this head must have been executed after 650, but evidence for this dating is inadequate.

SEATED WOMAN. *pp. 52–53*

Chalchiuchihuatl, goddess of nourishment and fertility, was always shown as a young woman, seated cross-legged, with her hands on her knees. The perforations in the head and ears served for the insertion of offerings of rare birds' feathers. In the coordination of front and sides, and the balanced rhythm of all the parts, the artist has created a figure of sovereign authority. On this firm, architectonic base, he has sensitively modeled the surfaces,

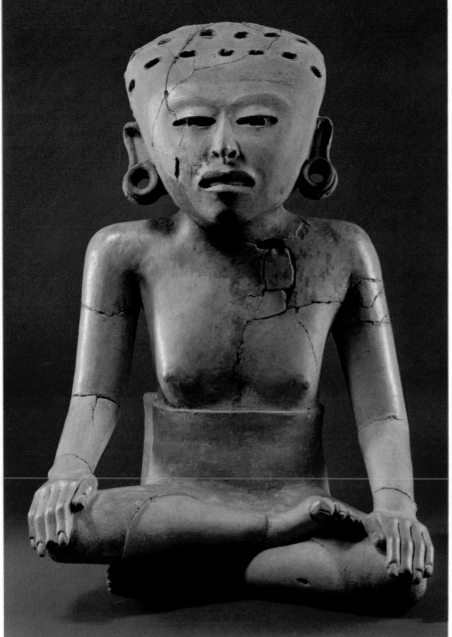

Seated Woman
A.D. 500–800
Terracotta; height 17 3/4″.
From Veracruz.
Right: detail.

giving them a sensual, palpitating play of light and shade. The rigorous frontal and pyramidal composition of this magnificent sculpture indicates the influence of high Olmec art.

SMILING MALE FIGURE. *pp. 54–55*

Frequent and memorable products of the center of Veracruz, smiling or grinning figures such as this one were the work of several "studios." They are usually assigned to the Remojadas II period. Often, these figures represent Xochipilli, god of music, dancing, procreation and the new corn. Although this example has movable arms with fixed legs, some of the figures also have movable legs. The connection with earlier sculpture is evident in the rhythms and the composition of the volumes. In addition to referring to Olmec art, the Totonac artist also seems to have derived inspiration from the Middle Pre-Classic period of Tlatilco, in which the grin was an expression of exuberant vitality. The concentrated "realism" of the face has an aggressive, almost feral quality, with no concessions to prettiness. Its explosive impact is highlighted by contrast with the calm control of the rest of the work.

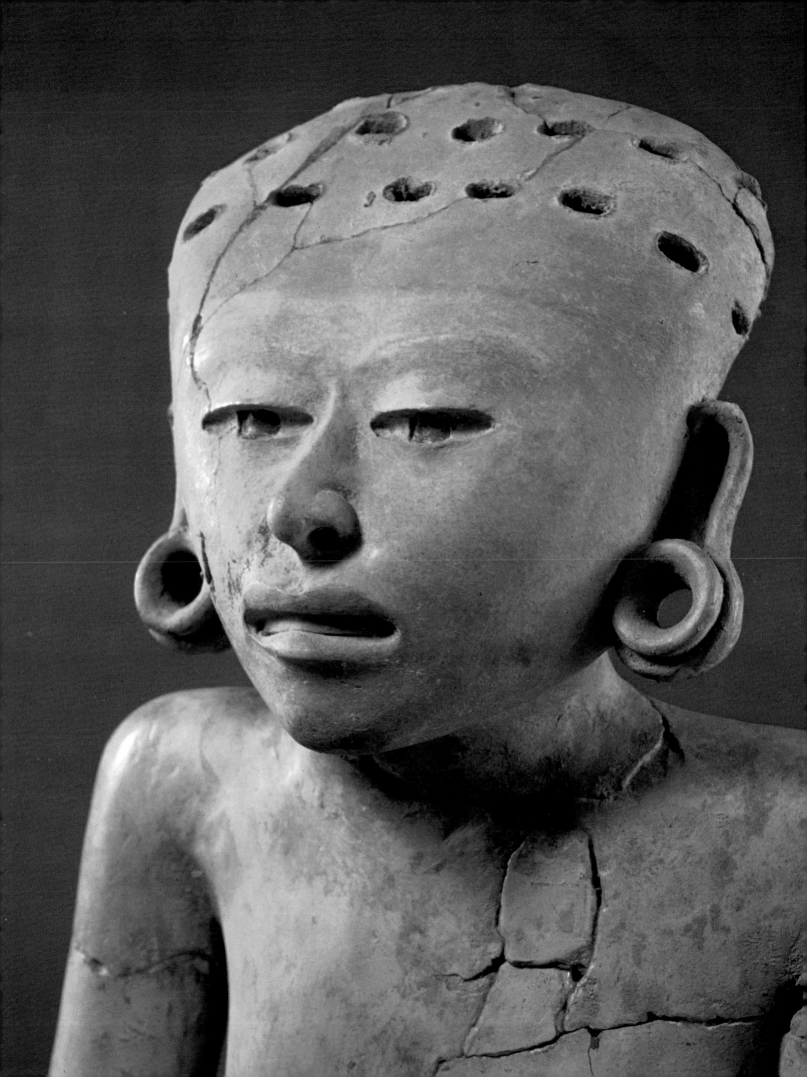

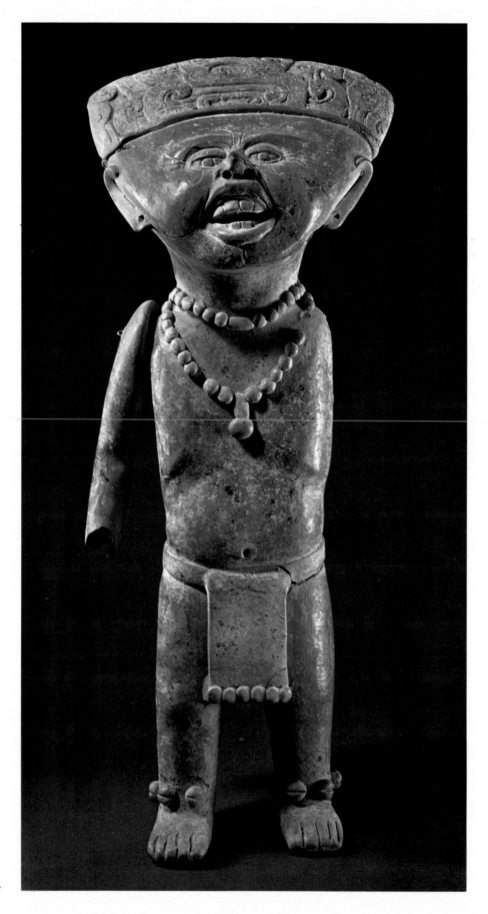

Smiling Male Figure
A.D. 300–800
Terracotta; height 11 3/4".
One arm is missing.
From Veracruz.
Right: detail.

54

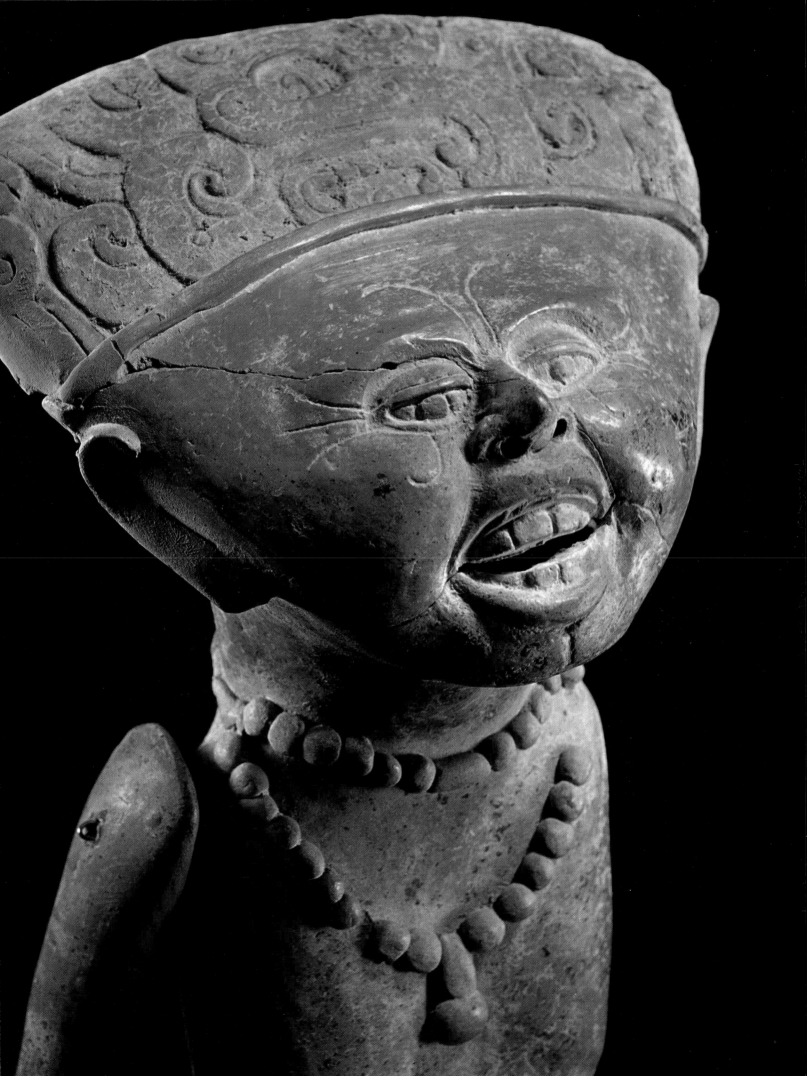

PAINTED VASE.

This simple and austere cylindrical vessel, with its appropriate geometrical friezes, belongs to the oldest phase of Teotihuacan civilization when, in addition to the simple figural expressions of groups derived from the east, there was also a tradition of pure geometricizing form. Probably the capital of a theocratic empire, Teotihuacan was unquestionably the largest city in Meso-America and a major religious and cultural center. First established between 200 B.C. and A.D. 150, its initial phase was followed by a period of relations with the neighboring peoples as far away as Oaxaca and the Gulf Coast, resulting in the flowering of a distinctive art that reached its peak in the middle of the millennium.

THE GODDESS CHALCHIUTLICUE.

This monumental monolith represents Chalchiutlicue, "Our-Lady-of-the-Jade-Skirt," the water-goddess who was companion to the rain-god Tlaloc. It was found in the plaza in front of the Pyramid of the Moon, and its imposing blocky forms are in keeping with the massive architecture of the pyramid. It is dated in the beginning of the Teotihuacan III period be-

56

Painted Vase
Circa A.D. 100
Terracotta painted in white on a red ground; height 14 1/2".
From Teotihuacan.

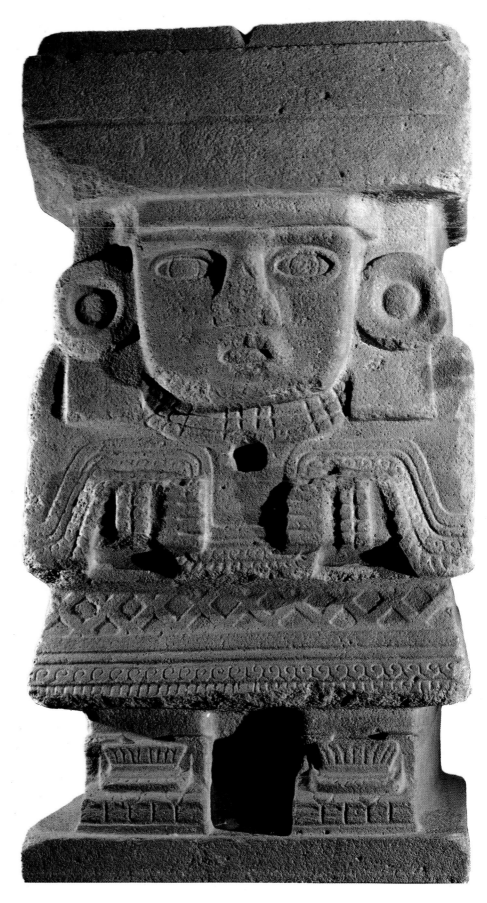

The Goddess Chalchiutlicue
A.D. 300–400
Carved and engraved andesite;
height 10'6".
From Teotihuacan.

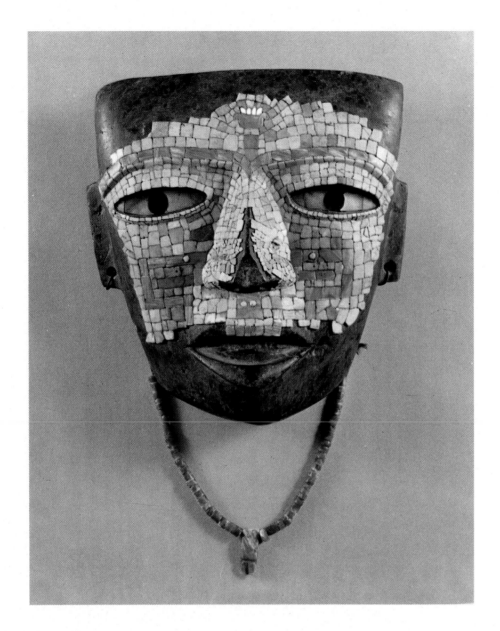

Funerary Mask in Mosaic
A.D. 400–600
Ophite covered with a mosaic of turquoise
and red shells and eyes incrusted with
mother-of-pearl and obsidian; height 9 1/2".
From the state of Guerrero.

cause of its affinities with the stylized and linear character of architectural
"ornaments" found at Teotihuacan. The symmetrical and decorative dis-
position of the frontal high relief makes an impressive combination with the
simplified geometrical structure.

FUNERARY MASK IN MOSAIC.
The plastic stylization of this mask is obviously derived from Olmec art.
The vivid mosaic incrustation is also stylized geometrically, as in the tatoo-
ing and body painting. The mask comes from the state of Guerrero, and is
in the "Mezcala style," which combined forms from Olmec art and domi-
nant contemporary elements from Teotihuacan.

Funerary Mask
A.D. 400–600
Veined onyx; height 7 7/8".
From Teotihuacan.

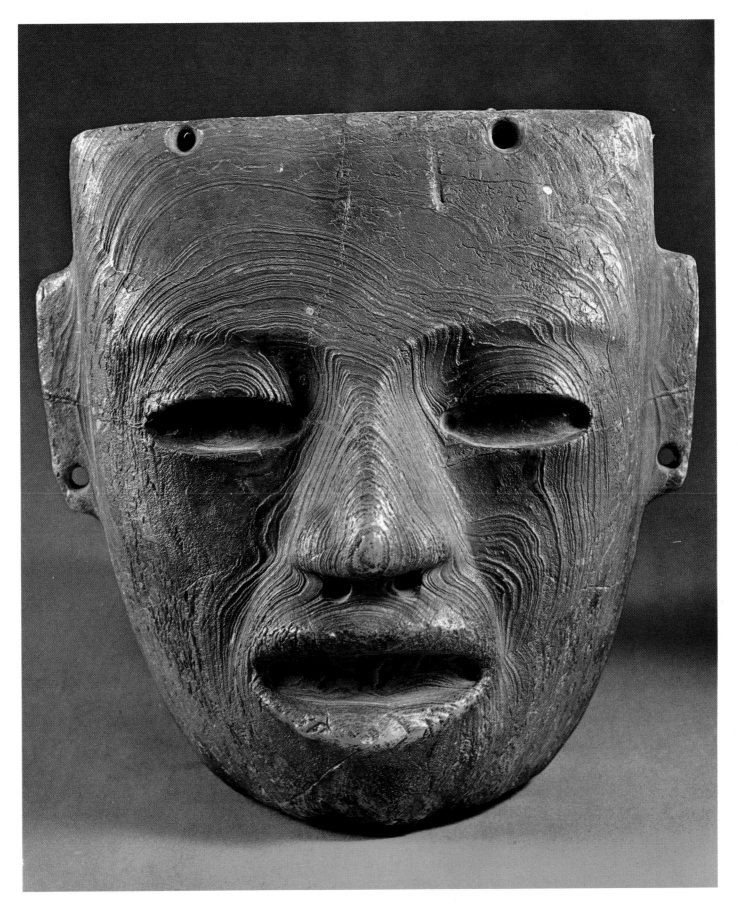

FUNERARY MASK.

p. 59

Although this mask may have been meant to receive a mosaic decoration, there are numerous other examples of smooth stone objects. The artist has exploited the possibilities of the natural layers and veinings of the onyx in creating his bilaterally symmetrical image. The rhythms of the material and the plastic movement of the work coincide impressively, as seen in the eye sockets, the nose and the mouth.

ARMED MERCHANT.

Armed with sword, shield and darts, this figure represents one of the Teotihuacan merchants who carried on trade with distant and dangerous areas. Like the following examples, the painting comes from a temple or a priest's dwelling, whose walls were generally covered with frescoes by Teotihuacan artists and their assistants. Paintings that are stylistically similar have also been found in tombs at Monte Alban.

The drawing was laid out on a coat of plaster, then the plaster was wetted down in successive areas to which the colors were progressively applied. In the final phase of the painting, a black or dark red line was brushed in along the preliminary drawing, which often shows later corrections. Besides the fresco technique, the artists sometimes painted *a secco,* using some medium other than water to fix the colors.

Unfortunately, almost all of the great picture cycles of this period have survived only in copies that are far from faithful to the originals. Of those that remain, the closest to the *Armed Merchant* is the line of priests and warriors in profile in the Casa de los Barrios at Teotihuacan-Teopancalco. In geometricized form, unrealistic color and total lack of depth, these paintings are related to the frontal sculptures that were used as architectural decorations. The stylization in drawing and color is rendered with freshness and spontaneity in the star-shaped "hieroglyphic" composition.

PRIEST OF THE GOD TLALOC.

p. 62

Tlaloc, god of the rain, was widely venerated by the Teotihuacan peoples. He received the most worthy of the dead in his heaven, and made wheat and all forms of human nourishment prosper. This painting represents a priest of the god, with a basket of fruit on his back and a flowering spike in his hand to symbolize the fertility of nature. His face is covered with a mask of Tlaloc, which has the typical forked snake's tongue and protruding teeth.

The preceding *Armed Merchant* accentuated rhythmic control, while this painting shows greater drama and inventive fantasy. The rendering is more improvised and does not follow a symmetrical composition, but approaches the splendid disorder of the magnificent *Earthly Paradise* of Teotihuacan-Tepantitla.

Armed Merchant
A.D. 400–600
Fresco; 21 5/8″ × 33 7/8″.
Fragment of wall painting
from Teotihuacan.

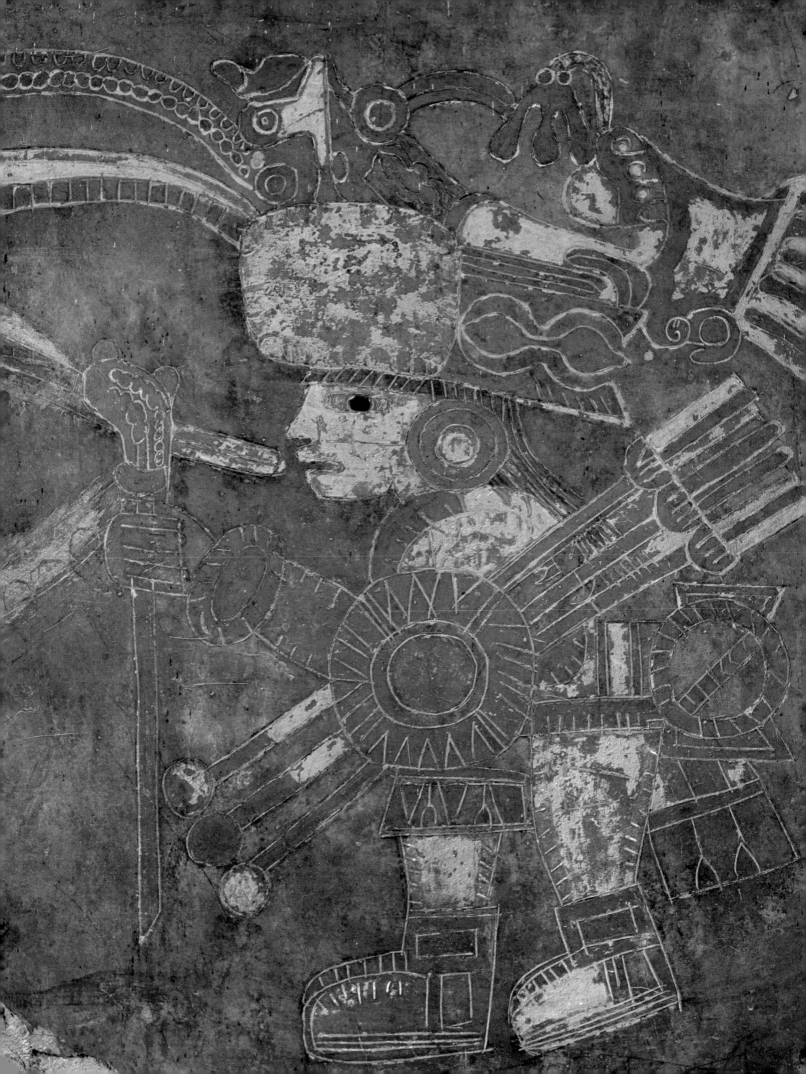

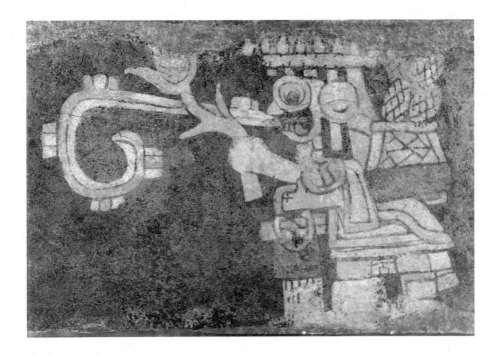

Priest of the God Tlaloc
A.D. 400–600
Fresco; 22″ × 15 7/8″.
Fragment of mural painting
from Teotihuacan.

THE GOD TLALOC.

The god of rain, wrapped in a cloud of water and stars, pours down the beneficent water that will nourish the crops. His face is covered with a mask, and from his open mouth emerges a volute or "comma" motif, which symbolizes song. Attributed to the same painter as the preceding work, this fragment is much closer in color and decorative motifs to the *Earthly Paradise*. The same bold imagination, with its innocence and refinement, is seen in this single figure.

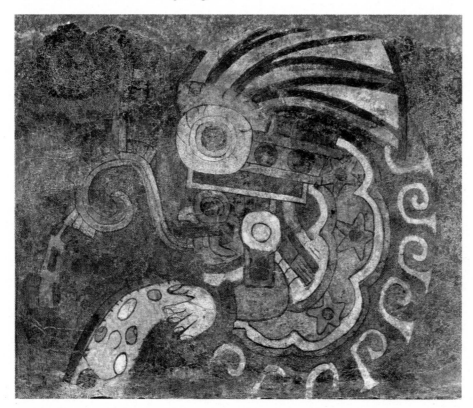

The God Tlaloc
A.D. 400–600
Fresco; 31 7/8″ × 57 1/2″.
Fragment of mural painting
from Teotihuacan.

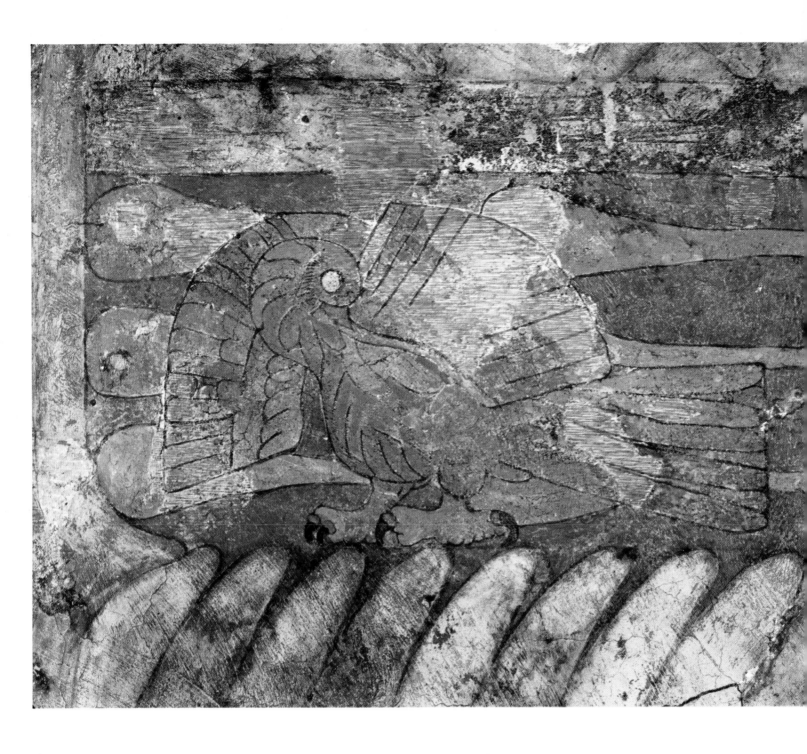

Fresco Called "The Animal Paradise"
A.D. 400–600
Detail.
Fresco; 9 7/8″ × 5 1/2″.
From Teotihuacan.

FRESCO CALLED "THE ANIMAL PARADISE."

A parrot (or perhaps another of the many birds that played an important part in the religion and beliefs of the Teotihuacan people) is represented on this small fragment from what was probably a long row of animals. It belonged to an "architectural" composition of varying vertical divisions. Although different in theme, it resembles another unusual example of Teotihuacan painting: the fresco in the Temple of Agriculture, in which bands of stylized, schematic motifs alternate with representations of flowers, fruit and shells. The crisp profiles, with clear and unrealistic colors filling the contours, are seen again in this fantastic, heraldic bird.

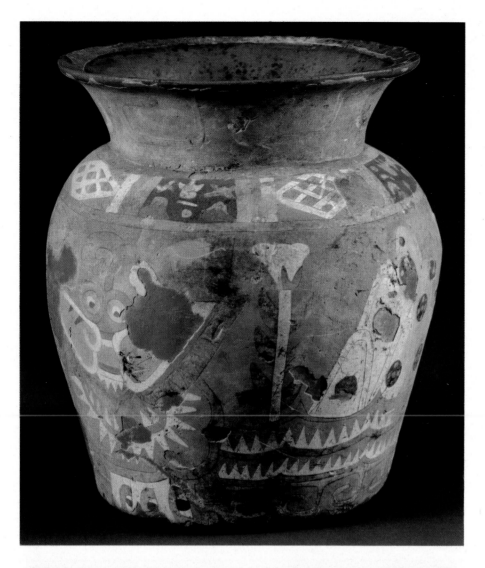

Jar with Fresco Decoration
A.D. 400–600
Painted terracotta; height 11″.
From Teotihuacan.

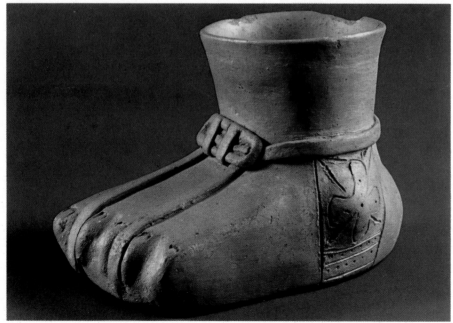

Vase in the Shape of a Human Foot
A.D. 400–600
Terracotta; 3″ × 4 1/2″.
From Teotihuacan.

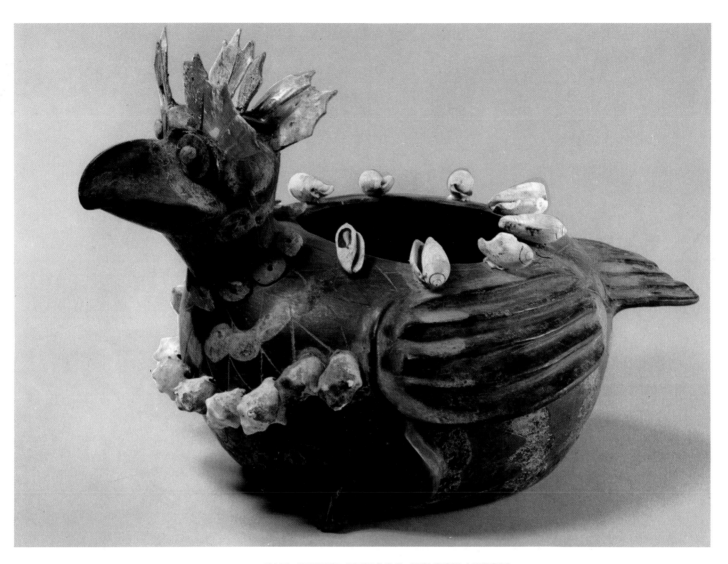

JAR WITH FRESCO DECORATION.
The style and technique of fresco painting is also found in Teotihuacan ceramics. In fact, the ceramics are closer to mural decoration than to the painting in the codices. With a stylus or hard thorn, the design is drawn on a thin coat of plaster, the colors are brushed in while the plaster is still wet, and the contours are then outlined in black. The form of this vase, although apparently simple, shows great facility with the material, and the painted frieze is developed in a slow rhythm around the plastically rotund shape.

VASE IN THE SHAPE OF A HUMAN FOOT.
At the time of their culture's greatest expansion, the Teotihuacan potters produced the ceramic ware called *anaranjado delgado* or "Thin Orange." These represented human beings or, as in this case, parts of the human body. The great demand for this kind of pottery led to the use of molds, so that the vases could be mass produced; yet, even such handicraft repetitions retained the excellent design of the original model.

Vase in the Form of a Turkey
A.D. 400–600
Dark terracotta; 9 7/8″ × 14 3/8″.
From Teotihuacan.

VASE IN THE FORM OF A TURKEY.
This vase is a typical example of the polished dark ware of the early cen-

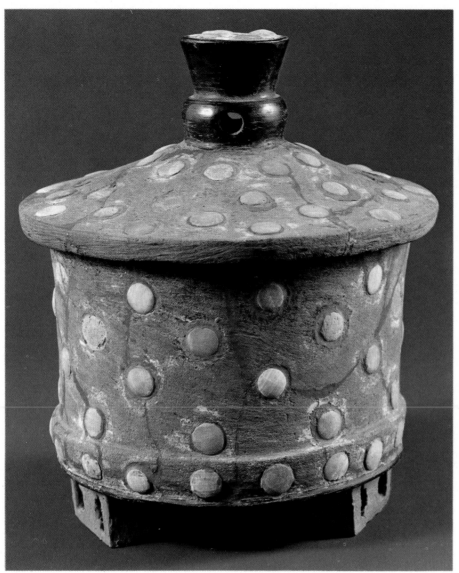

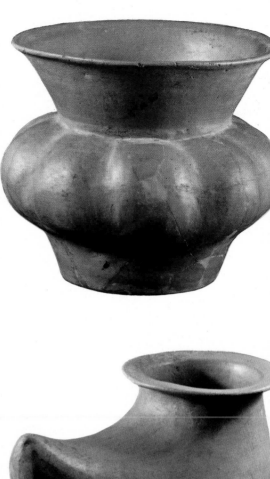

turies of Teotihuacan ceramic production. It is not unlikely that the decorative feathers, shells, mica disks and other details are later additions to the original vase. The world of domestic animals often provided artists with opportunities for coloring their interpretations with a smiling irony.

VASE DECORATED WITH STARS.
A tripod vase with a lid, this unusual work has a painted knob and applied white paste decorations with traces of cinabar. It is a typical example of the trade ware used by the Teotihuacans in their exchanges with Guatemala, where such vases, or local imitations of them, have been found.

VASE IN THE SHAPE OF A PUMPKIN.
Another example of "Thin Orange" ware, this vase was inspired by the swelling curves of the pumpkin, one of the oldest Mexican plants. Potters,

Above, left:
Vase Decorated with Stars
A.D. 400–600
Painted terracotta; height 6 3/4″.
From Teotihuacan.

Above, top:
Vase in the Shape of a Pumpkin
A.D. 400–600
Terracotta; height 6 3/4″.
From Teotihuacan.

Above, bottom:
Small Vase in the Shape of a Clog
A.D. 400–600
Terracotta; height 5 1/8″.
From Teotihuacan.

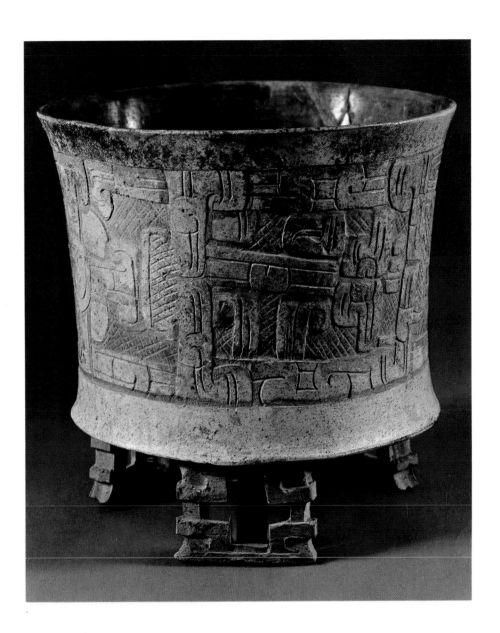

especially of Teotihuacan, often adopted the geometric and plastic rhythms of such vegetables for the forms of their mass-produced ceramics.

SMALL VASE IN THE SHAPE OF A CLOG.
Another example of "Thin Orange" ware, this is a typical product of Teotihuacan trade. It shows that the artists' predilection for forms having a simple, plastic density was shared by the craftsmen.

CYLINDRICAL TRIPOD CUP.
The motif of the intersecting volutes, engraved in relief, recalls similar forms and motifs common around Veracruz, which reached Teotihuacan through trade and cultural exchange. Although the cup reflects established decorative devices, the engraving is executed with an original freshness and freedom of movement.

Cylindrical Tripod Cup
A.D. 400–600
Terracotta; height 7 7/8″.
From Teotihuacan.

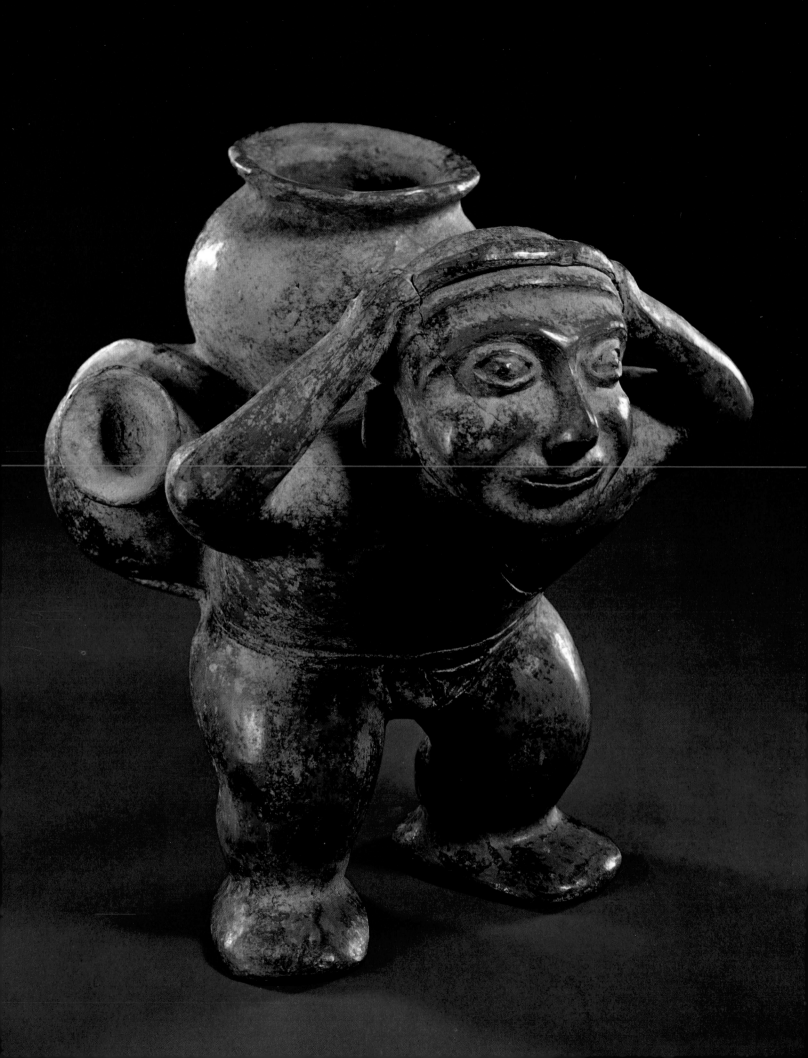

VASE IN THE FORM OF A WATER BEARER.

In the state of Colima — as at Nayarit and Michoacan in western Mexico — during a period of rural civilization, major cultures arose, which continued throughout the Pre-Columbian era but flourished particularly in the so-called Classic period. Solid and polished, Colima terracottas represent animals, the produce of the earth and scenes from everyday life. Representations of the divinities, except for Huehueteotl, the god of fire, are rare, despite finds of tomb offerings that indicate the existence of strong religious feelings. Religious sensibility evidently had a magical character, in which spiritualized natural forces predominated. What has come down to us from the so-called Tarascans is a series of works, such as this one, that were produced mainly for funerary purposes. They are not sober and "categorical" like those of the Egyptians, but more like the exuberant interpretations of aspects of life found in Etruscan art.

NUDE WOMAN KNEELING. *p. 70*

This is one of the purest of the large carved and painted figures produced by the Tarascan artists of Nayarit. The prevailing preference for distortion, disproportion and physical description bordering on the caricatural is kept within bounds. Such elements as the pathetically small arms, the impertinent nose and the unequal breasts help to individualize the figure and enliven its solidly composed and unified forms.

SEATED NUDE WOMAN OFFERING A PLATE. *p. 71*

Captured in a spontaneous pose, the figure is seated on a three-legged bench and pro-offers a plate. On her shoulders are the signs of scarification that appear often on such Tarascan figures. Although polished and volumetric, the figure has more expressive deformation and a more complex balance of rhythms and weights than do earlier Tarascan statues. These elements, which seem to go back to Jalisco, are typical of the Late Classic period of Colima. The deep parallel striations of the hair, the contrast between the long flat body and the swelling limbs, and the finely characterized but composed face, probably indicate a moment of transition between the balanced terracottas of the First Classic period and the exquisite sculptures that came after A.D. 500.

VASE IN THE SHAPE OF A PARROT. *p. 72*

This and the following vases belong to a large number of such works that were found in tombs in the territory of Colima. They represent a form of Tarascan art produced in specialized "studios." The plastic modeling is mainly in terms of spherical or tubular masses related in such a way as to maintain the purity of their volumes. The strong stylization does not lead

Vase in the Form of a Water Bearer
A.D. 300–500
Terracotta with green varnish;
height 9".
From Colima.

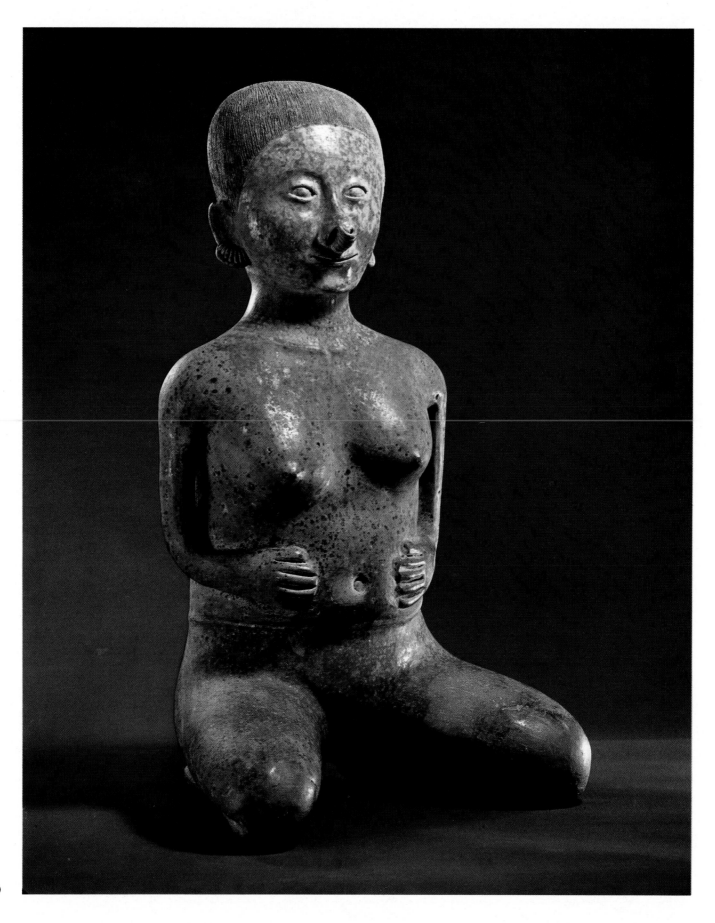

Nude Woman Kneeling
A.D. 300–500
Terracotta varnished in green and red;
height 28″.
From Nayarit.

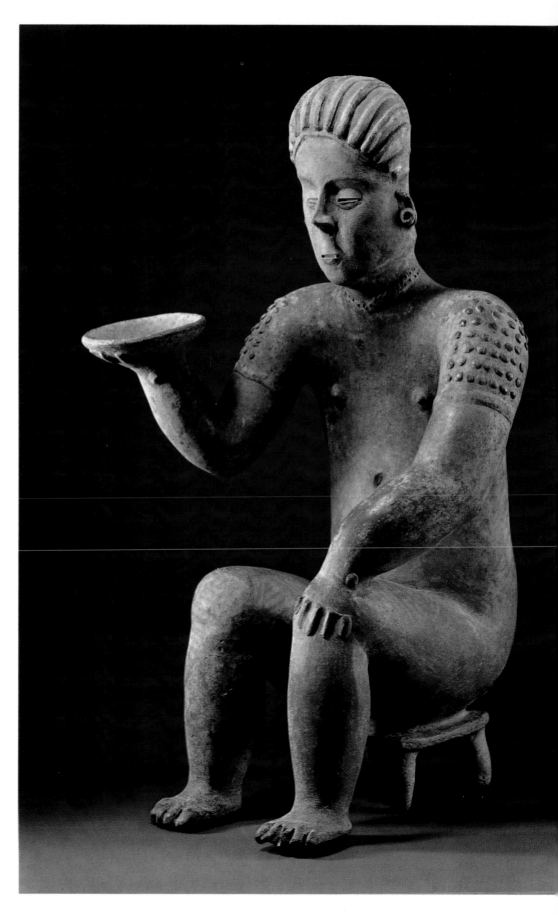

Seated Nude Woman Offering a Plate
A.D. 400–700
Terracotta varnished in red and green;
height 18 7/8″.
From Colima.

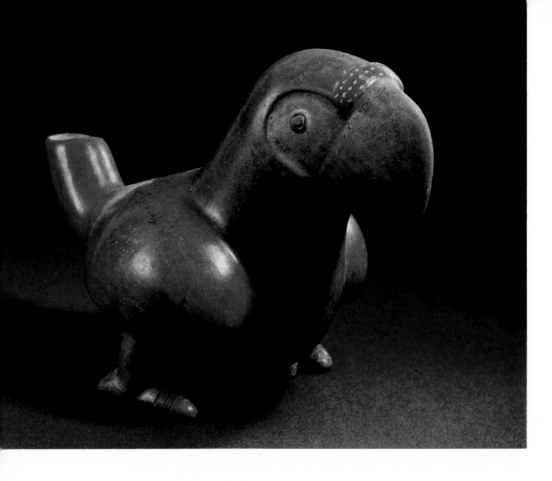

Vase in the Shape of a Parrot
A.D. 400–600
Painted terracotta; height 7 7/8".
From Colima.

to repetition. Objects and themes are the same, and material, technique and color are shared, but each example has its own individuality and the stamp of a lively originality.

FATTENED DOG.
The *Fattened Dog* is one of the numerous *itchuinchi* represented by the potters of Colima. Fattened dogs were associated with the cult of the dead and were supposed to accompany the souls of the dead on the difficult journey through the region "of the nine rivers" that divides heaven from the world of the shadows.

VASE IN THE SHAPE OF A DOG.
Another example of a subject that is common in Colima ceramics from the beginning of the Classic age to the thirteenth century, this vase shows a smooth-haired dog that has been fattened for the table. Dogs like these, in reality and in effigy, were supplied as part of the tomb furniture for the dead.

OLD HUNCHBACK LEANING ON A CANE. *p. 74*
The old hunchback is wearing a loincloth and a necklace with two huge canine teeth as pendants. He stands on a two-headed snake or fish. The figure's age and deformity are vividly characterized by the concentric wrinkles on the face and by his unsteady stance as he supports himself with a cane. The other attributes of the figure suggest that it represents a mythical or magical personage. The composition builds up vertically in a sequence of compact, rounded masses. In style, this masterpiece is close to the subsequent sculptures of Colima.

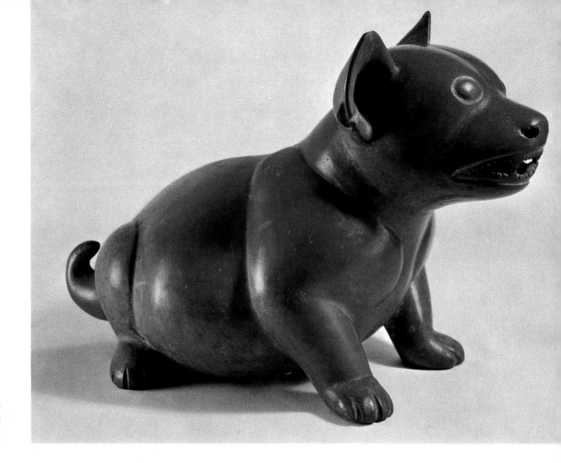

Fattened Dog
A.D. 400–600
Terracotta; height 7 1/8".
From Colima.

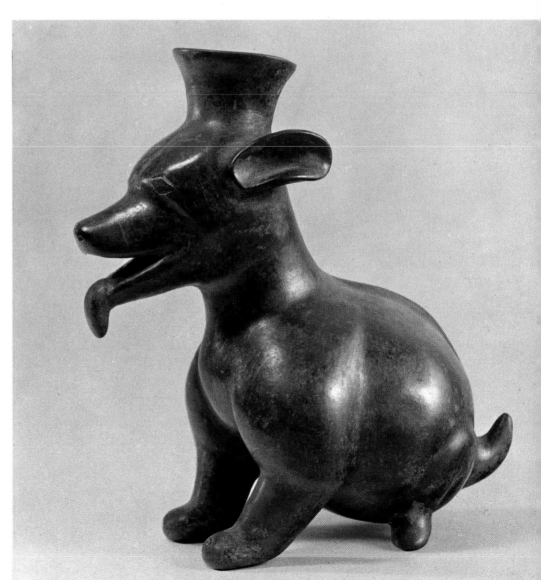

Vase in the Shape of a Dog
A.D. 400–600
Varnished terracotta; height 9".
From Colima.

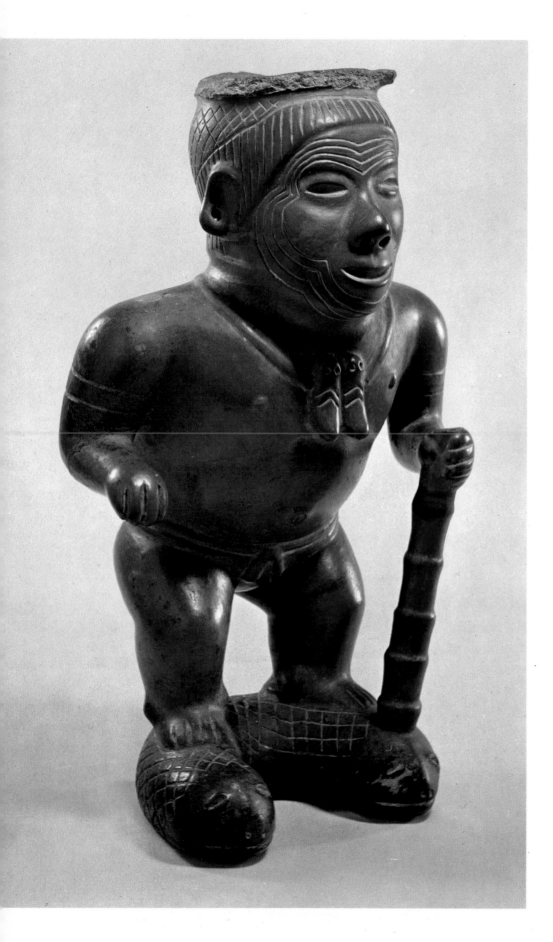

Old Hunchback Leaning on a Cane
A.D. 400–600
Painted terracotta;
height 16 1/2".
From Jalisco.

Seated Hunchback
Circa A.D. 500
Painted terracotta; height 10 5/8".
From Colima.

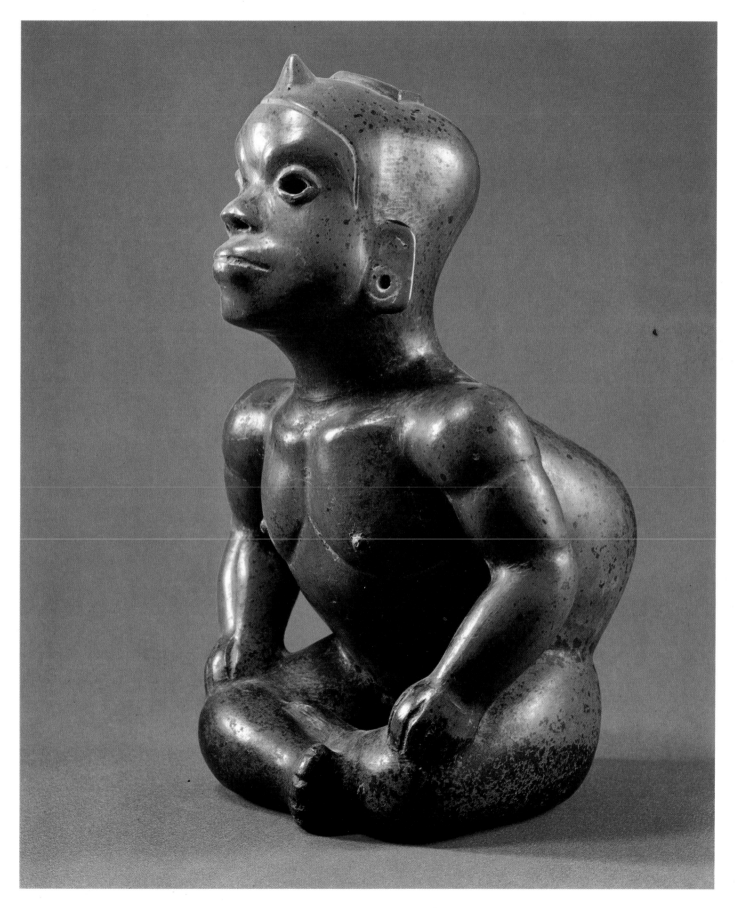

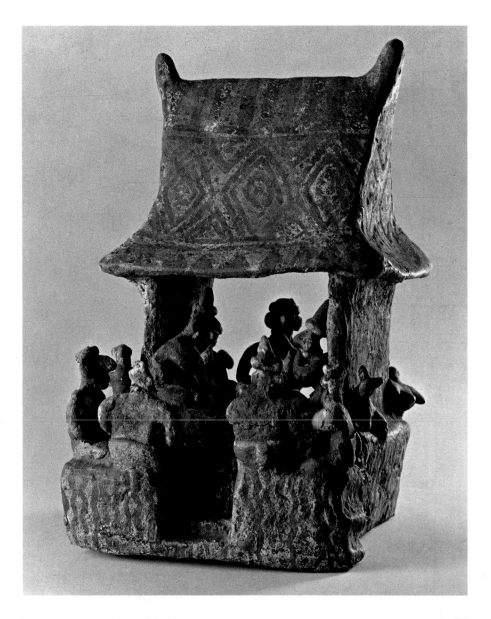

SEATED HUNCHBACK. *p. 75*

A typical product of the period around A.D. 500, this figure shows all of the formal and decorative features of the handiwork of the master potters of Colima. Despite the many different subjects represented in Colima pottery, each figure has its own individuality. Faces and bodies are penetratingly rendered, while the figure's profession — dancer, ball player, musician or warrior — is indicated by pose and attributes. Hunchbacks — who were believed to have magic powers, and who were often members of the courts of the caciques — are often shown. Here the artist appears to have taken pleasure in stressing the swelling spherical and tubular forms. The composition is worked out in a frontal six-part construction.

MODEL OF A HOUSE.

This lively sketch represents a house built of logs and covered with a straw roof, which is decorated with a two-color design. It is approached by a flight of steps, and inside and around it are numerous figures and animals

Model of a House
A.D. 400–600
Painted terracotta; height 12".
From Ixtlan (Nayarit).

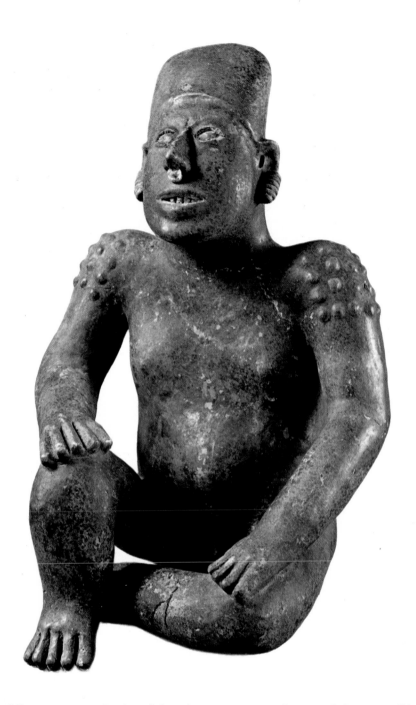

in different poses. A cheerful and spontaneous picture of domestic life is evoked. The work is characterized by the renewal of the Pre-Classic taste for improvisation in modeled terracotta.

CROSS-LEGGED SEATED WOMAN.

This female figure, with the signs of scarification on her shoulders, comes from Nayarit but shows greater affinity with the ceramics of Jalisco. In fact, many figures that are almost identical in detail and execution — except for smaller size, different position of the legs and the addition of armlets — have been found at Jalisco. The closed composition and the plastic correspondences of Olmec tradition are continued here, but in a freer and more humorous manner.

Cross-Legged Seated Woman
A.D. 400–600
Painted terracotta; height 27 1/2".
From Nayarit.

77

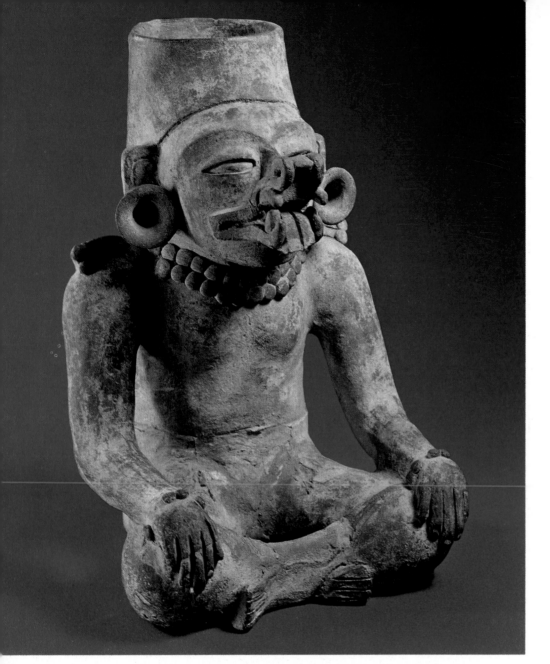

*Funerary Urn Representing the
God Cocijo*
A.D. 200–350
Painted terracotta; height 11 3/4".
From Oaxaca.

FUNERARY URN REPRESENTING THE GOD COCIJO.

In the numerous Zapotec tombs discovered in the state of Oaxaca, many of the funerary urns represent animals and human or divine beings. The figures are usually seated, with their legs crossed, and originally were set on rectangular bases. This figure represents Cocijo, the god of rain, and is perfectly in keeping with other works from Monte Alban showing identical taste, forms and technique, though different in subject. These vases are attributed to the so-called *loma larga* period in Zapotec art, which was one of transition between the preceding links to Olmec tradition in the mode of composition, and the subsequent affinities with Teotihuacan.

THE GODDESS OF THE THIRTEEN SERPENTS.

This funerary urn represents the Goddess of the Thirteen Serpents, who was the patron of the earth, agriculture and food. It is akin to the preced-

*The Goddess of the
Thirteen Serpents*
A.D. 400–600
Painted terracotta; height 10 5/8".
From Oaxaca.

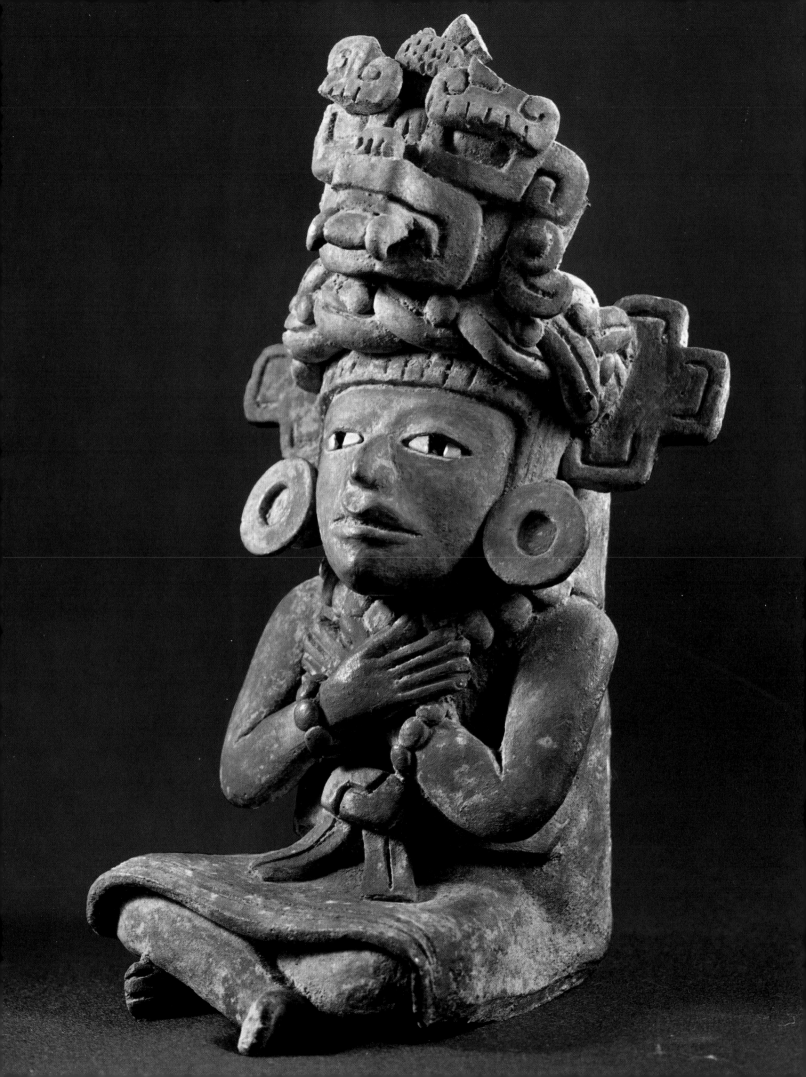

ing work, but has a pronounced decorative linear quality, which is brought out in the frontality and symmetry, and in the enormous, intricate headdress. This heavy ornamental style is similar to some of the magnificent Teotihuacan masks and sculptures.

THE RAIN-GOD COCIJO SEATED.

Decorative and linear stylization clearly prevail over the plastic structure in this Zapotec work from Monte Alban. The ornamental play is emphasized by the mask and attributes, as in another example, with seven corn cobs on its turban, in the Berlin museum.

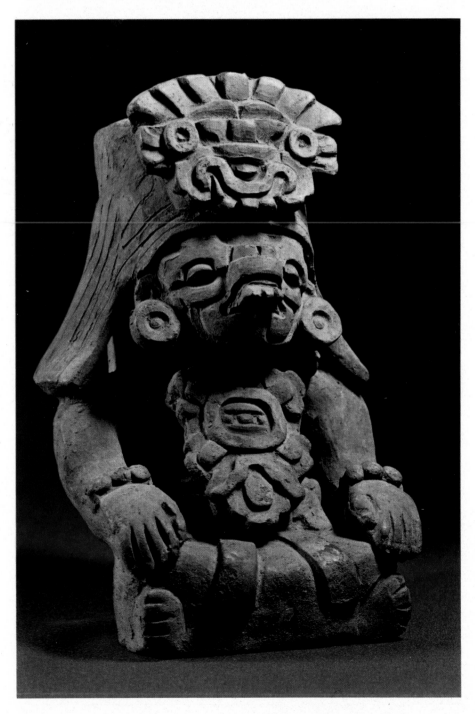

The Rain-God Cocijo Seated
A.D. 400–600
Terracotta painted with cinabar; height 7 1/2″.
From Tomb 77 at Monte Alban.

"THE OLD GOD."

This small but splendid funerary urn represents "The Old God," who was patron of fire. His attributes include the unusual blinders that the figure is wearing. The Zapotec artist subscribed to the decorative and graphic taste that has been observed in various interpretations in the preceding works; but he clearly had a more original personality, as seen in the multiplication and intensification of the elements and the organization of the interlaces into a star-shaped composition.

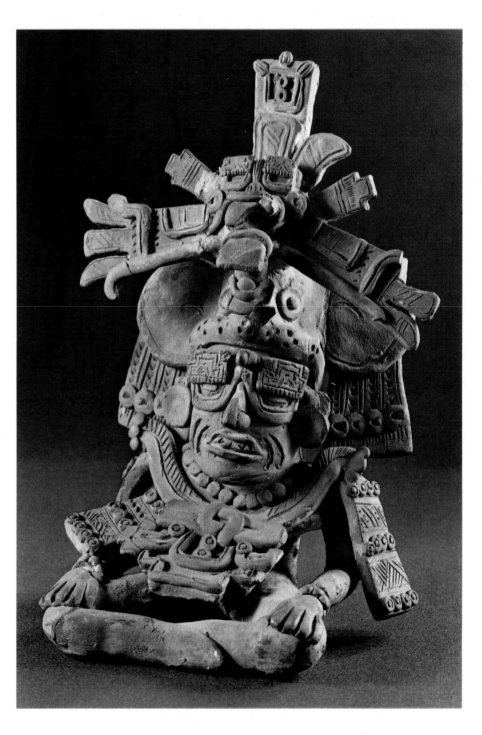

"The Old God"
A.D. 400–600
Painted terracotta funerary urn; height 11″.
From Monte Alban.
On page 82: detail.

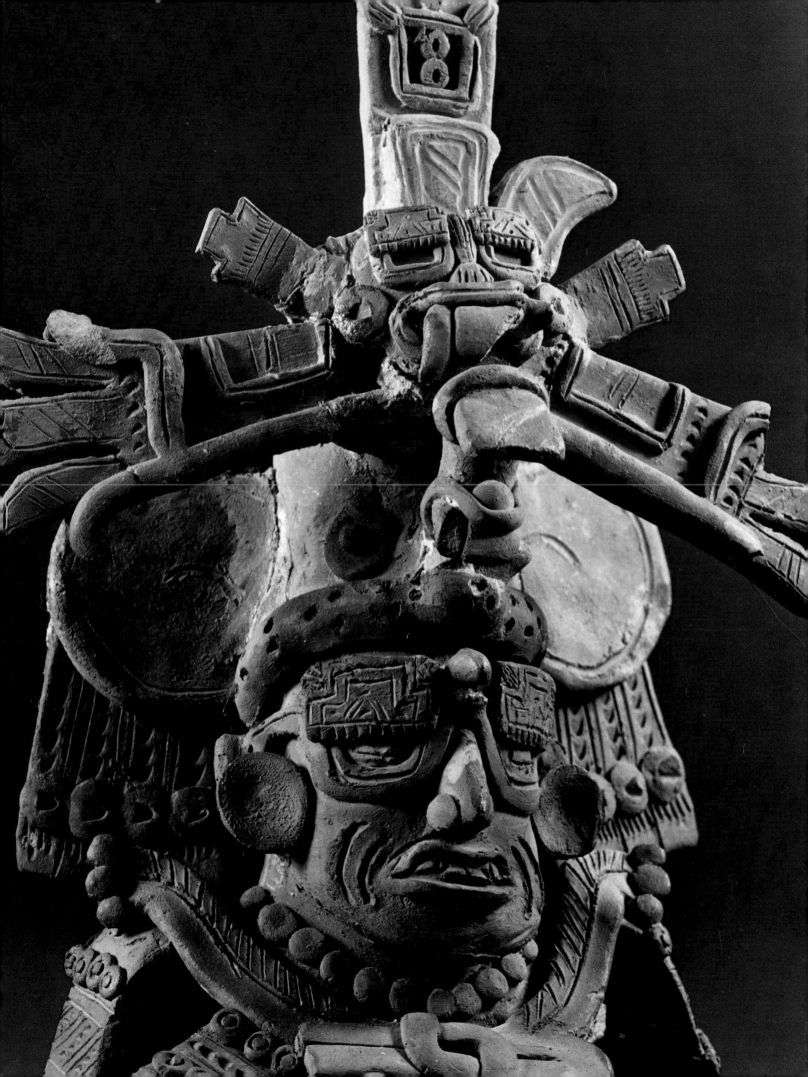

A.D. 600—1250
ZAPOTEC CULTURE
TEOTIHUACAN CULTURE
MAYAN CULTURE
TOLTEC CULTURE
HUASTEC CULTURE

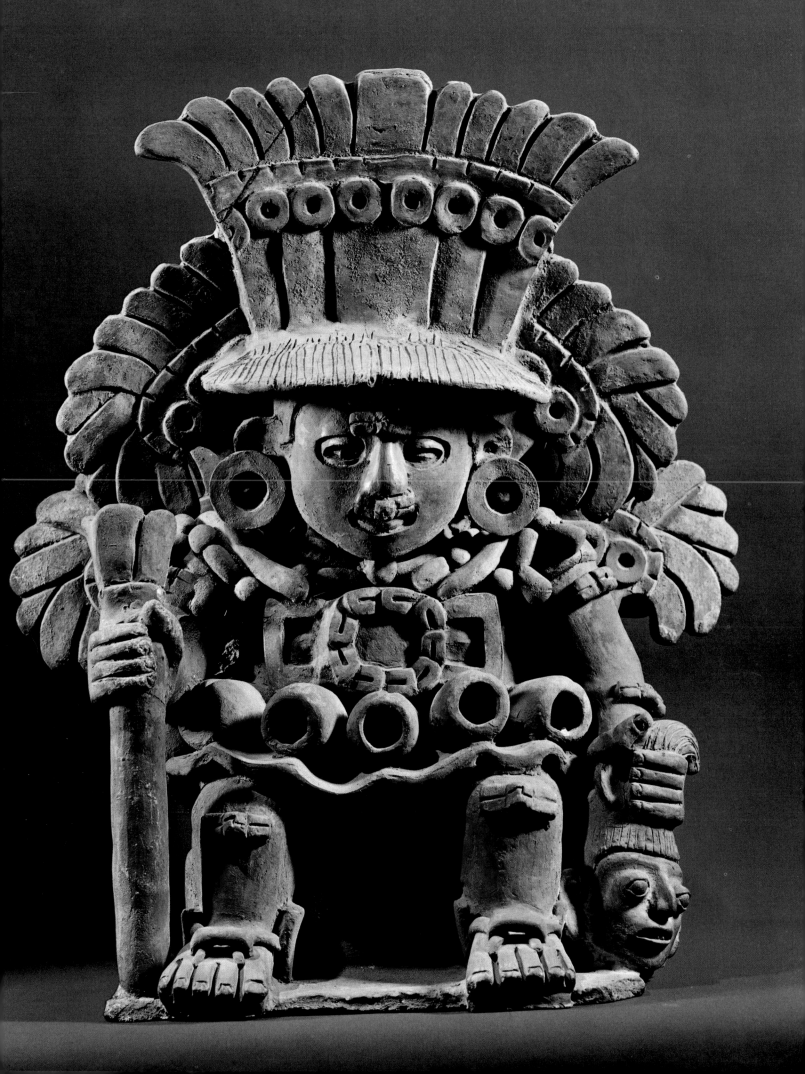

Xipe-Totec, God of Renewal
A.D. 600–1000
Painted terracotta funerary urn;
height 20".
From Monte Alban.

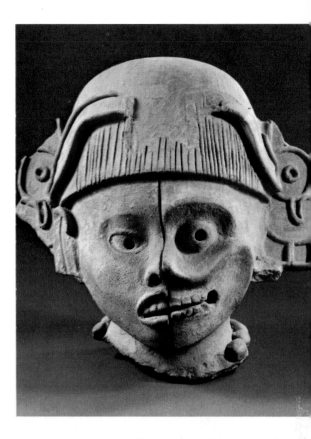

Fragment of a Head
A.D. 600–900
Varnished terracotta; height 13".
From a funerary urn found at Soyaltepec,
in the state of Oaxaca.

XIPE-TOTEC, GOD OF RENEWAL.

As at Teotihuacan, the great Zapotec religious center of Monte Alban had an important cult devoted to Xipe-Totec, "Our-Lord-Who-Was-Flayed," the god of spring, fertility and the renewal of the earth. This funerary urn of the Monte Alban IIIB type shows the god seated, with the typical flayed skin over his face and the head of a sacrificed victim in his hand. Headdress, ornaments and staff all allude to the cultivation of the earth and its produce. The work itself may not have been mass produced, but the symbolic attributes are probably repetitions. The sculptor's masterful modeling enlivens the surface of an expanding, centralized composition that is firmly anchored to the ground.

FRAGMENT OF A HEAD.

Associated with Pitao Bezelao, god of death, this fragmentary head shows the eternal vicissitudes of human destiny — from birth to death, from face to skull. In merging the two images, which are different at the sides and in profile, the artist emphasized the frontal unity of the work. This is heightened by the strict bilateral symmetry of the decorated helmet and its plastic compactness.

WOMAN WITH ELABORATE HEADDRESS, PONCHO AND NECKLACE. *p. 86*

The figure provides valuable evidence of the mode of dress adopted by Zapotec women: full garments with a cape or poncho and elaborate coiffures wound to form a sort of turban. The statue is attributed to the period of Monte Alban IIIB but its form and features would place it close to the statues from Monte Alban IIIA. Linear cadences and a massive, static structure have been carefully developed.

MASK. *p. 87*

Numerous examples of this kind of sculpture in hard stone have been found, including some from the region of Teotihuacan. In the severe simplicity of the forms and in their sophisticated execution, the Guerrero sculptors were inspired by Olmec art. The rectangular "face" of this mask is divided into measured, symmetrical and corresponding areas. An intense, contemplative repose is created by the underlying rhythm and geometry.

XIPE-TOTEC. *p. 88*

The standing figure is made up of three parts, and shows "Our-Lord-Who-Was-Flayed" wearing a human skin. The god represented the renewal of living things, and was also the patron of goldsmiths and the divinity of warriors offered in sacrifice. In one hand Xipe-Totec holds a small vase, and on his other forearm he wears a small square shield. Solidly planted

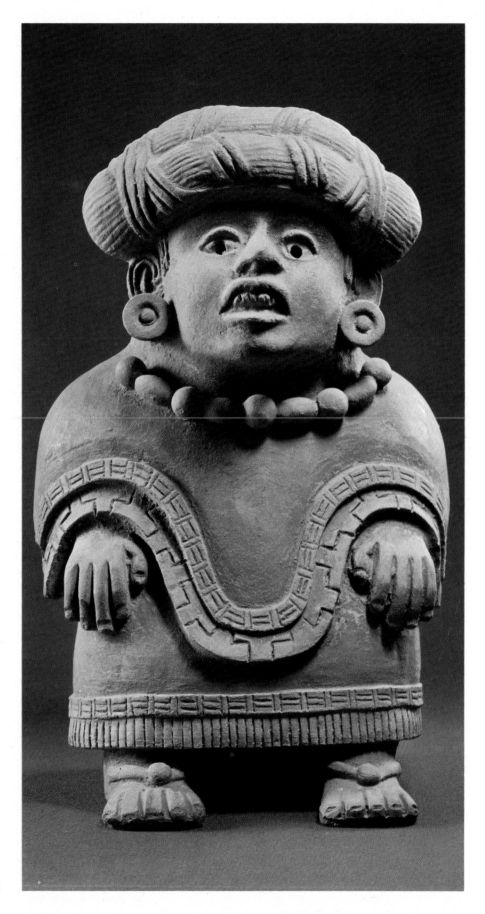

*Woman with Elaborate Headdress,
Poncho and Necklace*
A.D. 600–1000
Terracotta; height 13 3/8″.
Zapotec culture.

86

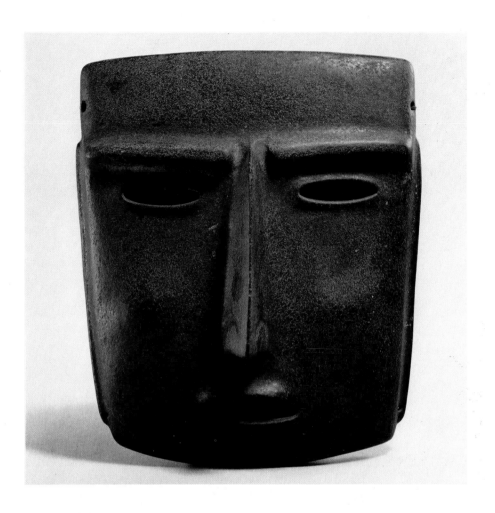

on columnar legs, the figure is substantially cylindrical and composed with a balanced correspondence of its parts. A decided taste for simplified form is seen in the head and in the splendid diadem with laminated rays. A similar example in the regional museum of Teotihuacan shows Toltec influence. There is also a similarity between this figure and an approximately life-sized Aztec terracotta figure found at Coatlinchàn (Mexico), now in the Museum of Natural History, New York.

CEREMONIAL BRAZIER. *p. 89*

This object represents a temple decorated for a festive ceremony with feathers, hoops and shells. In the center is a sanctuary of Quetzalcoatl, the god of water and agriculture in the Teotihuacan pantheon. In the strict symmetry of the surface elements and the marked taste for ornamentation, the work is related to earlier terracottas made for decorative purposes. Its opulent splendor is heightened by lively touches of red, yellow and green on the blue of the reliefs.

VASE WITH QUETZALCOATL DECORATION. *p. 90*

Quetzalcoatl was a feathered serpent associated with the cult of a goddess corresponding to Venus. The planet Venus disappears as a morning star and reappears as the evening star; thus, it vanishes into the land of the dead, from which it is triumphantly resurrected. The figure is modeled in

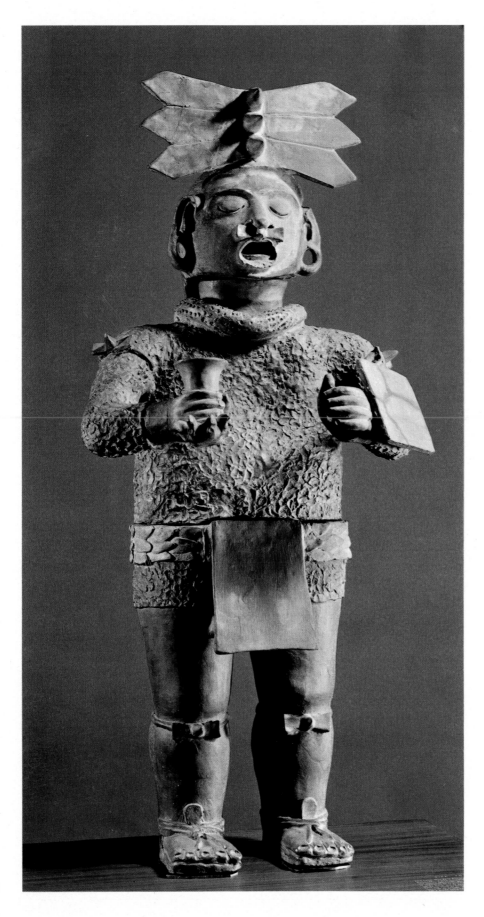

Xipe-Totec
A.D. 600–900
Polychrome terracotta;
height 22 1/2″.
From Teotihuacan.

Ceremonial Brazier
A.D. 600–800
Painted terracotta;
height 22 1/2″.
From Teotihuacan.

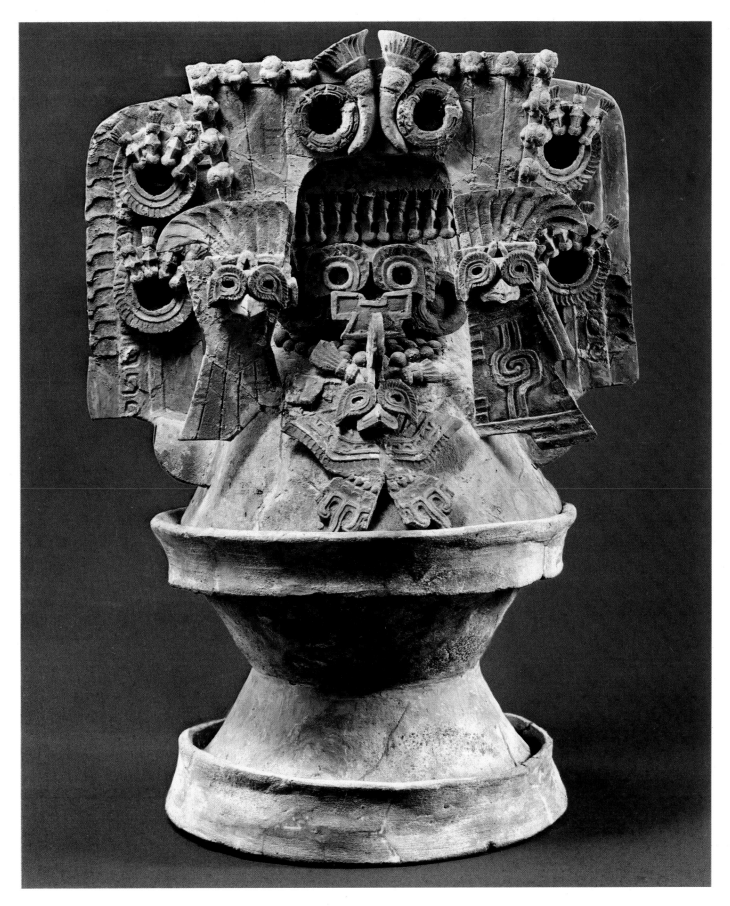

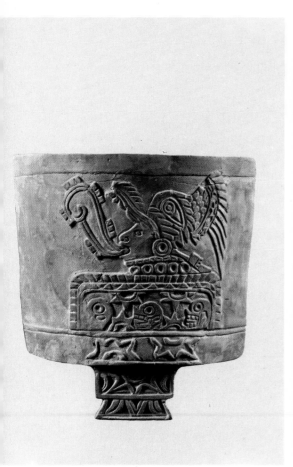

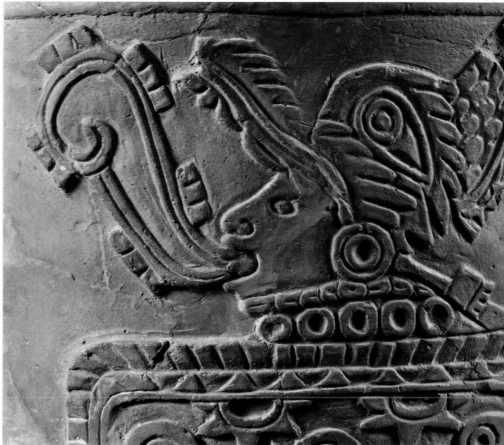

low relief on the front of a cylindrical and conical vase. It was carved and incised with a modeling stick, following an iconographic and compositional model. This is evident in the two-handled distribution of the form above and in the alternating series of stars and skulls below, but the execution shows a marked freshness and liveliness.

TRIPOD DISH.

The artist drew his design on the surface of the plaster coating, then filled in the various colors, as in the technique called *cloisonné*. Three animals with long tails and gaping jaws are seen pursuing one another around the plate. The point of view is in part from above and in part in profile. A complex, dislocated movement is created, which is intensified by the varied coloring on the red ground.

PLAQUE OR PECTORAL WITH A MAYAN PRIEST
SEATED CROSS-LEGGED. *p. 93*

The Maya were masters at carving hard stone, especially jade — the symbol of green things, such as water and vegetation. Jade was even used for such common purposes as dental inlays and ornaments for the dead. This very hard material was worked with obsidian tools, while damp quartz sand was used to polish it.

The pectoral or plaque represents a priest with his complicated rod of office. It is datable around 600, and shows the great precision and skill of

90

Vase with Quetzalcoatl Decoration
A.D. 600–800
Restored terracotta; height 12 1/4".
From Teotihuacan.
Above, right: detail.

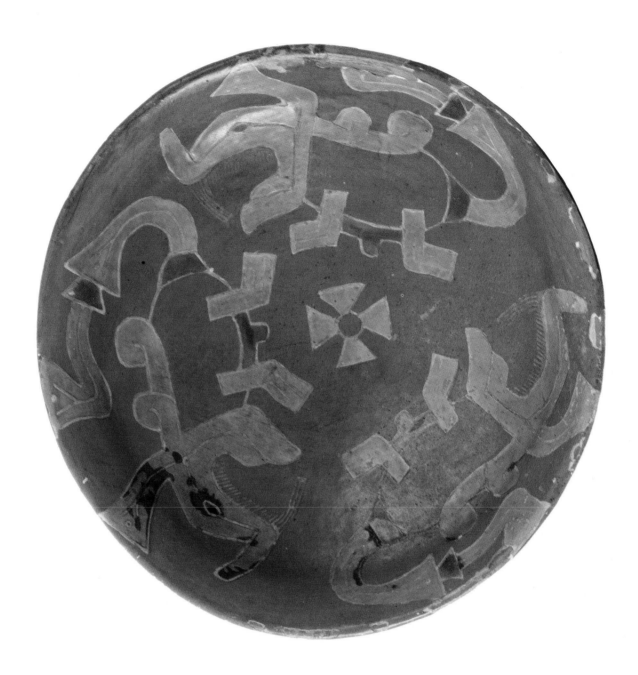

the sculptor, as well as his originality as a designer. Apparently simple, it has a fluid, undulating rhythm in keeping with the soft contours. The unstable balance of the composition is exceptional in the stone sculpture of the period. This flexibility of form is seen again in the reliefs of the *Jaguar* (also on page 93). Similar rhythmical, curving forms are seen in the Esperanza phase (Kaminaljuyu, Guatemala, A.D. 200–500), but also to be considered are the elegance and inventive liveliness of the wood carvings on some of the twelve doors of the temples of Tikal, one of which is dated 741.

Tripod Dish
A.D. 600–900
Terracotta with *cloisonné* pattern;
10 1/4″ × 4 1/8″.
From Buenavista de Cuellar,
in the state of Guerrero.

The Maya were the most homogeneous linguistic family of Central America, comprising the population of the states of Campeche, Yucatan, Chiapas and Tabasco in Mexico, all of Guatemala, and parts of Honduras and El Salvador. Not much is known about the primitive period of the Mayan

people, from 1000 B.C. to A.D. 300. There are only the remains of the temple at Naxantun (Peten) and ceramics from Fanom, Chikanel and Matzanel. The centuries from A.D. 300 to 600, when the calendar and writing were introduced, are known through Tzacol ceramics, with their round forms and incised lines, and dated works such as the 328 steles from Uaxactún and the 474 doors of Oxkintok. From 600 to 900 there is the art of Tepeu and Uaxactún, with overlays of Chiama (623 steles from Copan, 692 temples of Panque). After 700 comes the art of Tepeu III, the "orange" reliefs of Uaxactún, the wood carvings of Tikal, the jades of Pedras Negras, and the statuettes of Campeche. Among the dated works are 770 large heads of Copan, 800 large steles of Copan, 810 steles of Quiraga, 869 steles of Tikal and 879 temples of Chichén Itzá. The year 975 marks the invasion of the Toltec Itzá, who brought with them their own art, which is exemplified by the statuettes of Chipal and Jaina.

From the foundation of Mayapan in 987 to the destruction of Tula in 1108, and from the fall of Chichén Itzá to the rebellion of the Maya, the art of this culture continued in various centers, influenced by the conquest of the Mexica and the penetration of Aztec art forms. There were three distinct geographical areas: Yucatan, Campeche, Uxmal, Chichén Itzá and Mayapan in the north; Tabasco on the Honduras side, Palenque, Bonampak, Yaxchilàn, Uaxactún, Tikal and Pedras Negras in the center; and Chiapas and Guatemala in the south. Chronologically, archaeologists distinguish an Early Classic to Classic and a Late Classic period, from 200 to 900, and a Post-Classic phase from 900 to 1521. The Pre-Classic period, which is not represented in this museum, had its major expressions at Kaminaljuyu in Guatemala.

Mayan innovations include vaults and steles (rare and summarily executed after 900) and polychrome pottery, often with representations of figures. Mayan art, before its decadence in the tenth century, was highly original in form and full of creative vitality, as the examples illustrated here demonstrate.

JAGUAR WITH CALENDAR (?) ON REVERSE.

It is thought that the representation on the back of this work represents a calendar, with the heads or glyphs in the squares corresponding to numbers of days and years. According to their "long count," or calculation by twenties, the *tun* or years were grouped in *katun,* or periods of twenty years, which formed by geometrical progression the *baktun, pictun, calabtun* and *kinchiltun* (twenty-three billion and forty million days). With their vigesimal system and the use of the zero, Mayan mathematicians were able to make amazing astronomical calculations. One inscription records a time calculation of ninety years; another, 400 million years. They were astonishingly exact: their calculation of the planet Venus' synodical revolution shows an error of only .08 part of a day in fifty 365-day years. These skills were improvements on Olmec discoveries, as was Mayan writing. Their writing system has not been entirely deciphered as yet, but was certainly based on simple phonetic signs or pictograms in combination with ideographic glyphs that could be modified by adding prefixes and suffixes. Unfortunately, all of the Mayan codices — except for the *Popol Vuh,* a sort

*Plaque or Pectoral with a
Mayan Priest Seated Cross-Legged*
A.D. 600
Carved jade;
height 3 1/2".

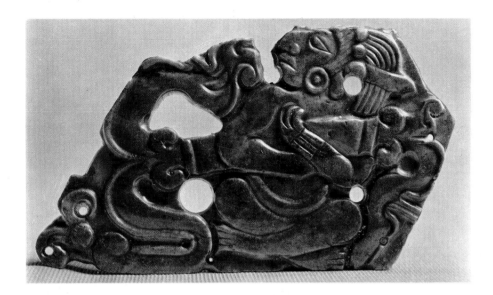

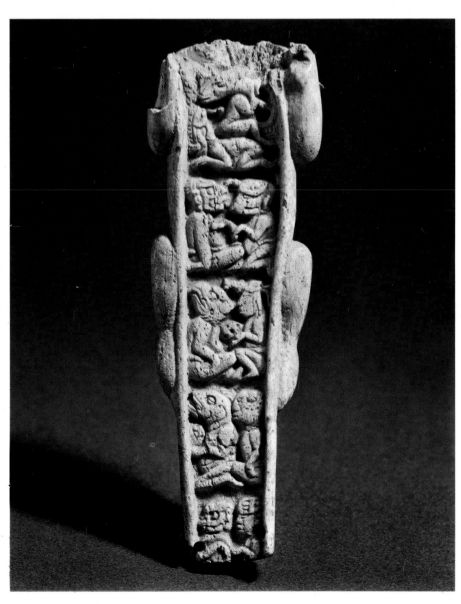

*Jaguar with
Calendar (?) on Reverse*
A.D. 600–900
Carved stone;
height 5 1/2".

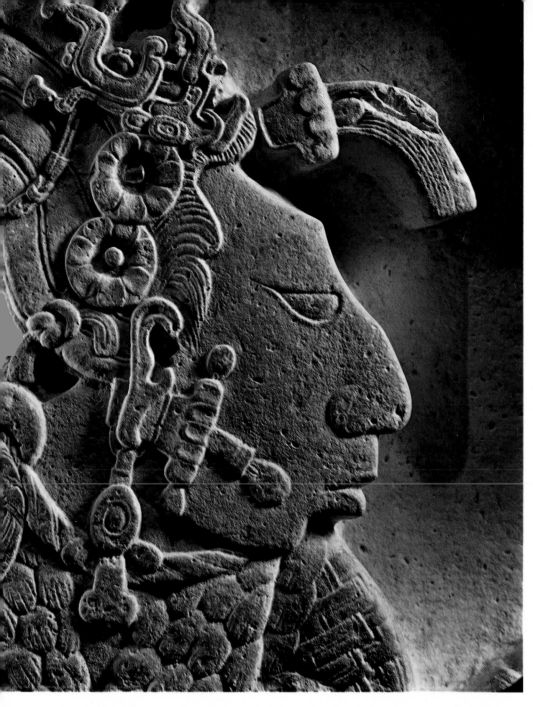

of Genesis, and the *Chilam Balam,* a book of prophecies and riddles —
were destroyed in the sixteenth century by Bishop Landa.

The alignment of the reliefs on this *Jaguar* recalls that of Stele A (A.D.
731) and Stele M (A.D. 756) of Copan. Separated by the deep shadow
of the horizontal division, the partitions contain correlated figures, as are
later found in Indian and Romanesque sculpture.

PROFILE OF A MAN.
Steles, altars, reliefs and panels served as calendars for the Maya. They
were carved to record historical events and exalt the hero of the occasion
— a great leader, warrior or priest. This profile, and the following one, are
from the rich relief decoration of the ceremonial center of Yaxchilàn (or
"God of the Green Stones"), which was created by the Maya after 514 and
flourished until the early eighth century. By the same artist as the *Profile of*

94

Profile of a Man
A.D. 726
Stone; 7'3/5" × 33 1/2".
Detail of a relief from
Yaxchilàn (Chiapas).

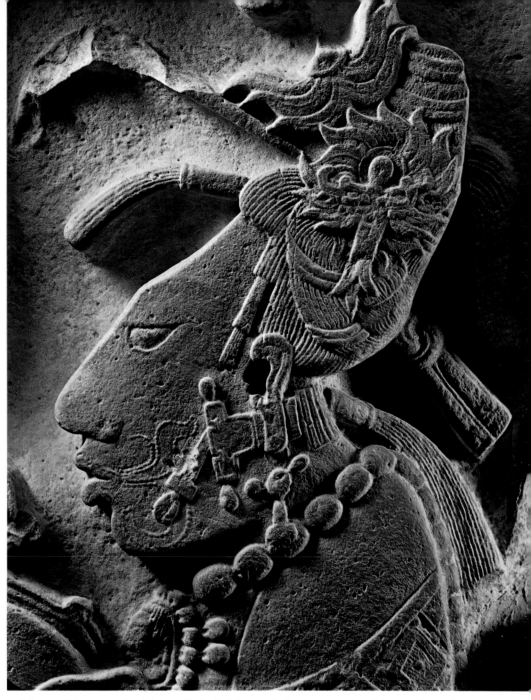

a Mayan Woman, the high relief of this work is characterized by a play of light that creates moving shadows in the deep ground and sharply defines the profile. It is subtle, sensitive and refined in drawing, and bears a sumptuous amount of decoration in low relief, but the whole effect is careful and controlled. Along with the finds from Palenque and Bonampak, such works are among the great masterpieces of art.

PROFILE OF A MAYAN WOMAN.

A minutely observed and imaginative rendering of Mayan practices and adornment make this piece a rare find. Among the fascinating details are the tattoos on the cheeks and chin, the flattening of the forehead, the hair drawn up into a complicated and ornate coiffure, the heavy earrings, the thick necklaces and the voluminous, decorated pectorals. This exceptional relief has affinities with the more prosaic sculptures of the Master of the Palenque Cross, which were executed around 716–720. According to

Profile of a Mayan Woman
A.D. 726
Stone; 7'3/5" × 33 1/2".
Detail of a relief from
Yaxchilàn (Chiapas).

95

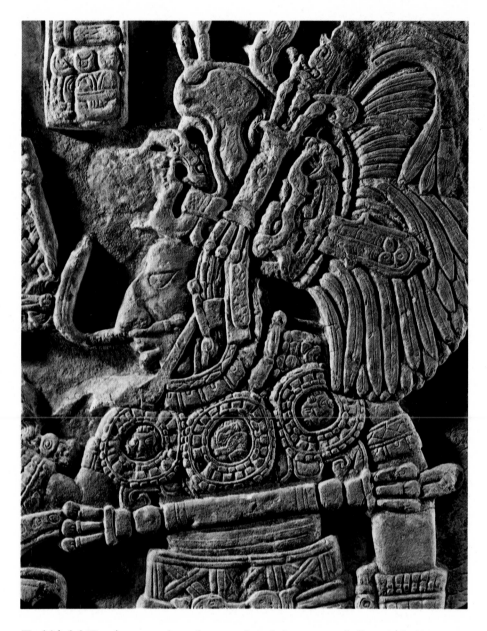

*Bust of a Cacique
or Halach Uinic*
A.D. 600–900
Stone; 47 1/4″ × 37 3/8″.
From Yaxchilàn.

Trebbi del Trevignano, these late works of the master influenced this panel from Yaxchilàn and the bas-relief of Bonampak.

BUST OF A CACIQUE OR HALACH UINIC.

Like the relief on page 97, this bust is very close in style to Stele 10 of Yaxchilàn, dated 766. According to archaeologists, it was around that time that the decline of the ceremonial center began. Although the stylistic approach is substantially the same as in the preceding reliefs, the shape that stands out against the shadowy ground does not have the same exquisitely nuanced plastic passages and the soft effects of light and dark. There is an interlocking of areas of forms with a multiple play of depths, animated by a vibrant pictorial movement.

LADY MAKING AN OFFERING TO A CHIEF OR CACIQUE.

Apart from the lesser degree of symmetry in the scene, this bas-relief shows

*Lady Making an Offering to a
Chief or Cacique*
A.D. 600–900
Stone; 64 1/2″ × 35″.
From Yaxchilàn.

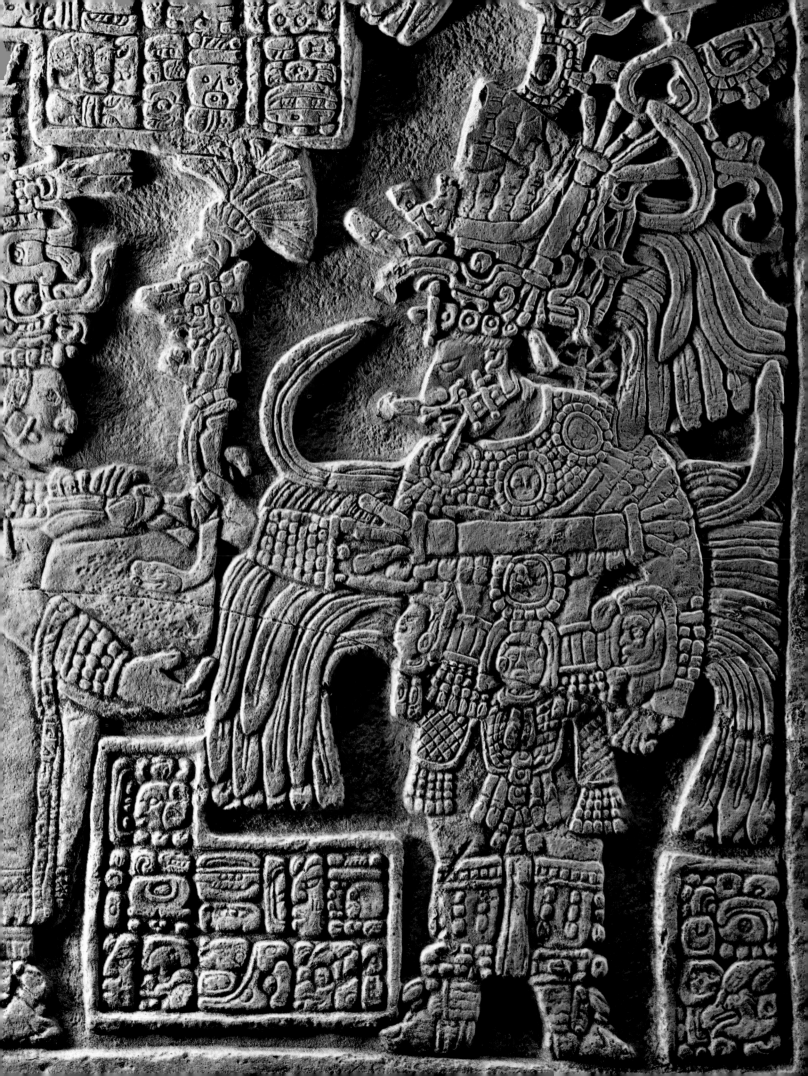

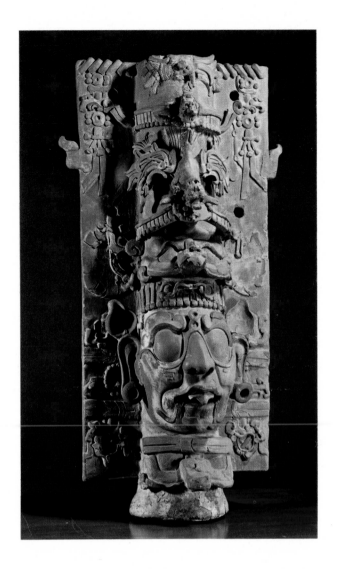

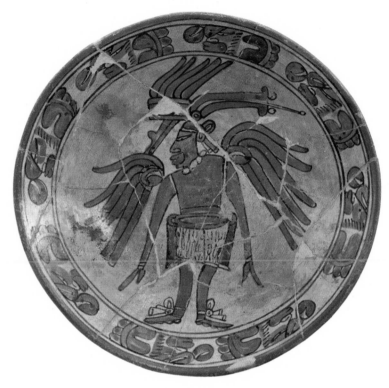

affinities with the reliefs of the Master of the Palenque Cross. The alignment of the surfaces carved in relief against the ground is even more sensitive than in the preceding work. The artist treated the planes as areas in which the multiple, geometricized carving that spreads in every direction create a movement of light and dark. The effect is more pictorial than sculptural. With this aim, he fanned out his forms on the two sides of the central horizontal axis. Along with the areas of crowded hieroglyphs, this creates an intense movement of light and shade.

FLANGED CYLINDRICAL VESSEL FOR OFFERINGS TO THE SUN GOD.

This work has been interpreted as a representation of the sun god (Kinich Ahau, Ninich Kakmò, or simply Kin or Ik, meaning "breath" and "life"), seen emerging from the jaws of the personification of Earth — a symbol of the process of creation. The form of a vertical half-cylinder against lateral flanges, with superimposed motifs, is also found at Chama, Guatemala, between A.D. 600 and 800. The tall elaborate arrangement interweaves marine motifs, various figures, birds, and symbols of the sun, earth and water. Similar vases have been discovered in the Temple of the Cross at Palenque.

Above, left:
Flanged Cylindrical Vessel for Offerings to the Sun God
A.D. 600–900
Terracotta with traces of polychromy;
44 7/8" × 24".
From Palenque (Chiapas).
It was used as a base for ceremonial dishes or braziers.

Above, right:
Dish with Figure of a Dancer Dressed as a Bat
A.D. 600–900
Polychrome terracotta; diameter 13 3/4".
From Uaxactún.

98

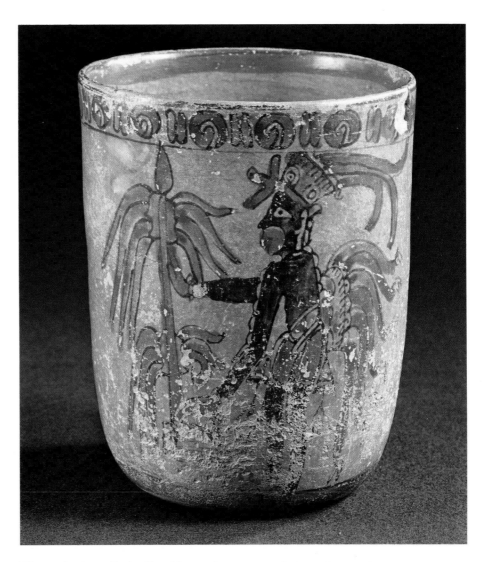

The artist is stylistically akin to the master of the palace reliefs (circa 750), whose formal effects he translated into a mannered artificiality, stressing a decorative linearity.

DISH WITH FIGURE OF A DANCER DRESSED AS A BAT.
The central figure, enclosed in a border of hieroglyphics, is typical of Tepeu I ceramics, which flourished at Uaxactún (A.D. 600–675). It also recalls the freer "orange" ware of Chama III (Guatemala, A.D. 600–900). The figure, with its swarming motion and ornaments, revolves within the circle. Line and decoration have a freshness of touch. The refinements of composition and movement imply a subtlety of invention in balance and rhythm (of which there is an extraordinarily fine example in the disk of Chinkultic, dated 590).

FLAT-BOTTOMED CYLINDRICAL VASE WITH RICHLY ADORNED PERSONAGE.
An example of Tepeu ceramics, this vase is similar to those found in contemporary codices. In style of drawing and color, it is very close to the preceding dish.

Flat-Bottomed Cylindrical Vase with Richly Adorned Personage
A.D. 600–900
Incised and painted ochre terracotta; height 6 1/2".
From Yucatan.

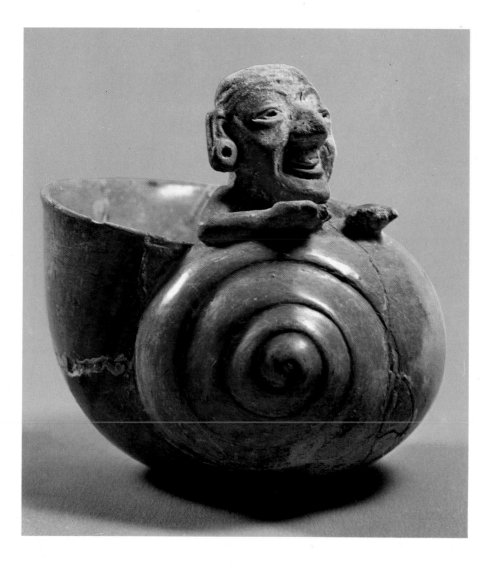

SHELL-SHAPED VASE WITH HUMAN FIGURE.

This exceptional vase in the form of a sea shell, from which the bust of a man protrudes, had a religious significance. It alludes to the spirit of Ik, god of the wind, or to Quetzalcoatl in his aspect of Ehecatl, also a god of the wind, whose symbol was the sea shell. This slightly caricatural human figure with a sarcastic grin is also seen in fifth-century sculpture from Tikal. In its anthropomorphic motif, the vase is related to the seventh-century ceramics classified as Tepeu I, which flourished at Uaxactún, near Tikal. This example shows an exceptional synthesis of form and an intense vitality.

STUCCO HEAD WITH BEADED HEADDRESS. *p. 102*

In this and other works from Palenque (such as the *Portrait of a Sovereign, Portrait of an Escort* and *Portrait from the Palace Courtyard,* also in the museum), there is a departure from the typological, sacred and ritual canons, and from a predominantly decorative vein. Instead, they show a lively interest in the immediacies of everyday life, and are imbued with a new humanism. The artists maintained a feeling for synthesis, and avoided stylistic exercises, estheticism and accidental effects. A Palenque artist of the early eighth century, called the Master of the Faces, must have had as powerful

Shell-Shaped Vase with Human Figure
A.D. 600–900
Painted terracotta; height 7 1/8″.
From Uaxactún.
Right: detail.

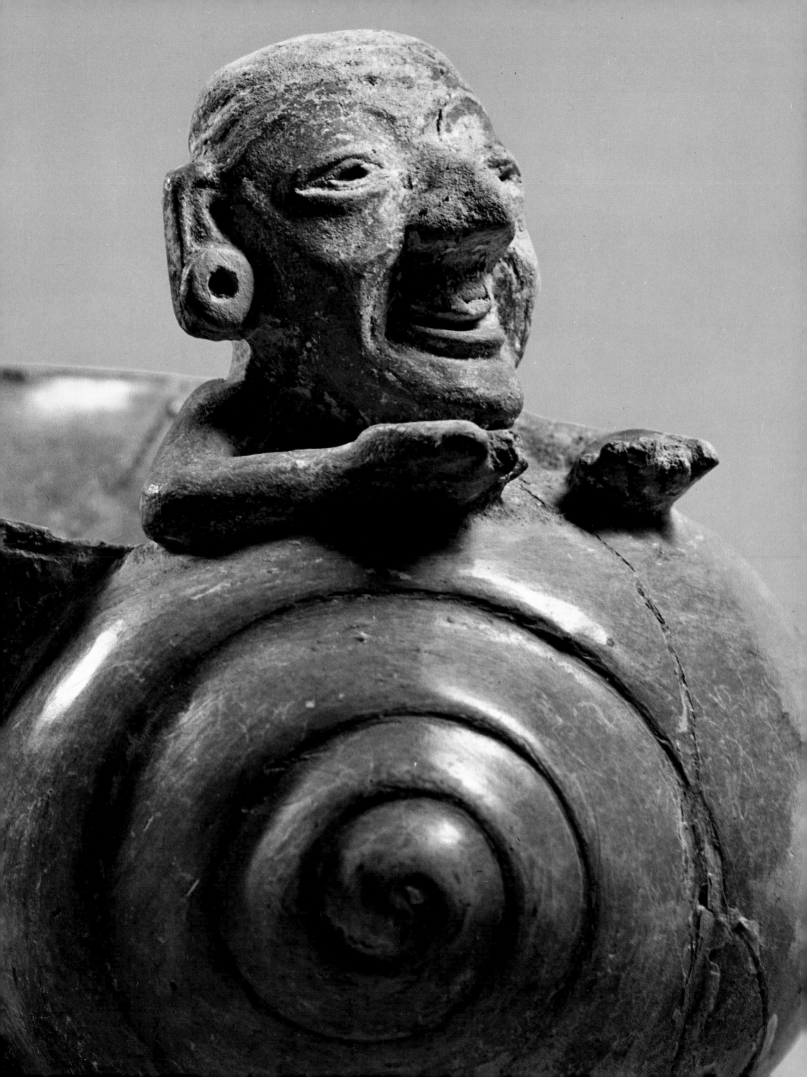

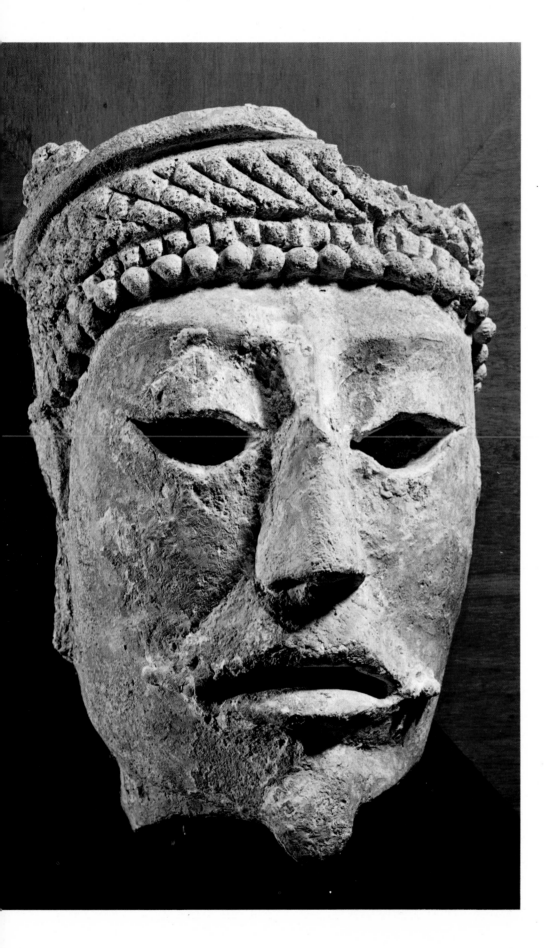

Stucco Head with Beaded Headdress
A.D. 600–800
Painted plaster; height 17 3/4".
Artists in Comalcalco, ceremonial center of
the Maya, made extensive use of stucco,
along with baked brick, as a building mate-
rial. The modeled figures of the bases of the
temples were also made of stucco, which was
then painted, as at Palenque.
From Comalcalco (Tabasco).

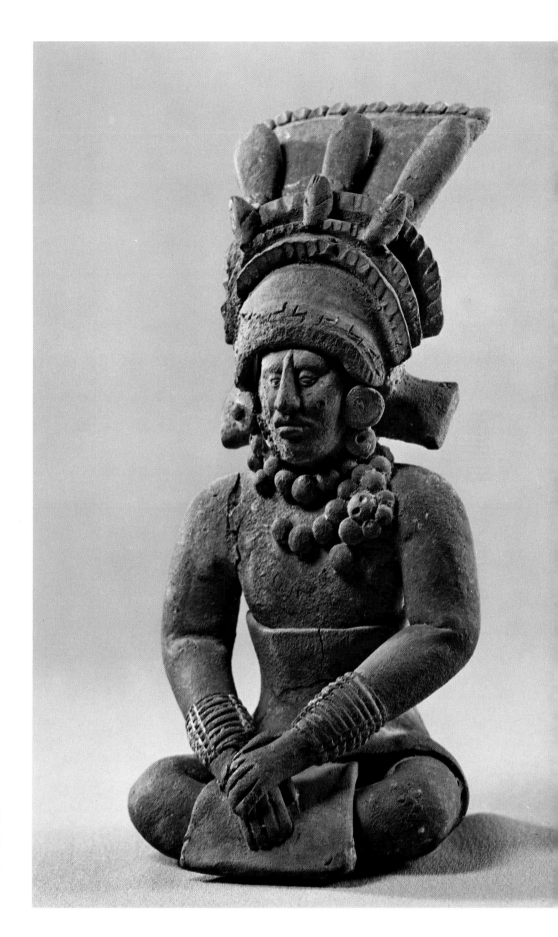

Seated Mayan Chief
A.D. 600–900
Terracotta; height 4 3/4".
The Mayan chiefs, or caciques, ruled the
people in religion, trade and war. Their posi-
tion was usually hereditary. They were
assisted by noble lords, who were respon-
sible for administrative duties, and by priests,
who performed religious functions.
From Jaina (Campeche).

an impact on the development of painting as Masaccio was to have on the art of fifteenth-century Florence. The sculpture of Palenque strongly influenced the masters of the stucco sculptures of Piedra Negras, Tabasco.

SEATED MAYAN CHIEF. *p. 103*
This statuette and the one on page 104 were both discovered in the tombs of Jaina, an island off the coast of Campeche. It was an important ceremonial center and had a cemetery where the dead of the neighborhood and surrounding areas were buried directly in the ground. The chronology of Campeche art is still disputed; most scholars assign it to the period from A.D. 600 to 800, while others date it from 700 to 900, and still others from 987 to 1194. These brightly painted little terracotta vases, whistles and bells are not found in any other area of Mayan art. They take the form of men and women, chiefs, priests, warriors and ladies, represented in all the variety of their colorful costumes and sumptuous ornaments. With an extraordinary intensity of life and an immediacy of presence, they are shown carrying out everyday activities or performing ceremonies. Each sculpture is a unique work which the artist has infused with an individual character. The result is a vast repertory of original expressions. The style is clear, integrated, composed in balanced rhythms, and free of naturalistic distractions. Although the works are small in size, the composition and massing of the forms give them a monumental scale.

LADY OF RANK WITH A FAN.
The hair of this figure is braided with broad ribbons and ornamental buttons. The open dress, called *huipil,* is the same as in the *Zapotec Woman* (A.D. 400–600), which is also in the museum. She is wearing heavy earrings and a necklace. The immobile, ceremonial pose is expressed by the predominantly cylindrical forms and the pure volumetric feeling of the whole.

SEATED WOMAN WITH TATTOOED FACE.
The figure is adorned with rich jewels at the neck, ears and arms, and is wearing the shirt known as *quechquemitl.* Numerous examples of similar female figures (such as in the Museum of Primitive Art in New York) have survived. They vary to some degree in their headdresses, which in these Pre-Columbian "Tanagra" figures are always minutely detailed. In fact, they are a mine of information concerning the customs, practices and social relations of the time, and express a feeling for civilized values through the almost austere density of the plastic medium.

"THE WEAVER." *p. 106*
The weaver sits at a loom tied to a tree trunk, on which a little dog has been placed. This is a representation of the typical method of weaving among the Maya, for whom the manufacture of cloth had great importance. The material for priests' vestments, for instance, was made by trained women who were under the protection of the goddess Ix Asal Uoh. There are other surviving examples of "weavers," almost always shown with the single loom. A subject from daily life is expressed without recourse to the anecdotal or the picturesque. Although alive and incisive in mood, the sculpture has a lofty solemnity that elevates the activity to the level of a rite.

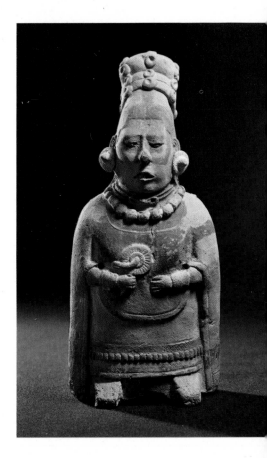

Lady of Rank with a Fan
A.D. 600–800
Painted terracotta; height 8 1/4".
From Jaina (Campeche).

104

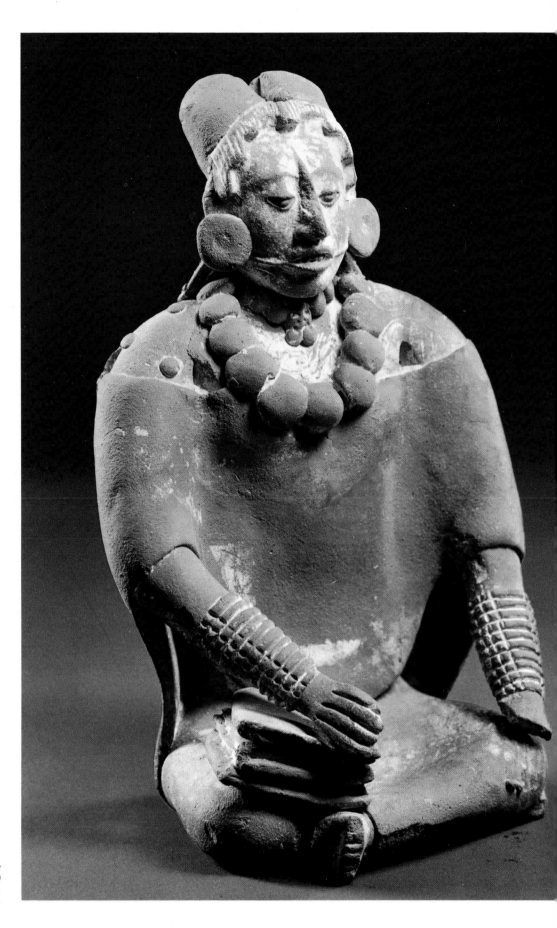

Seated Woman with Tattooed Face
A.D. 600–800
Terracotta; height 6 1/4″.
From Jaina.

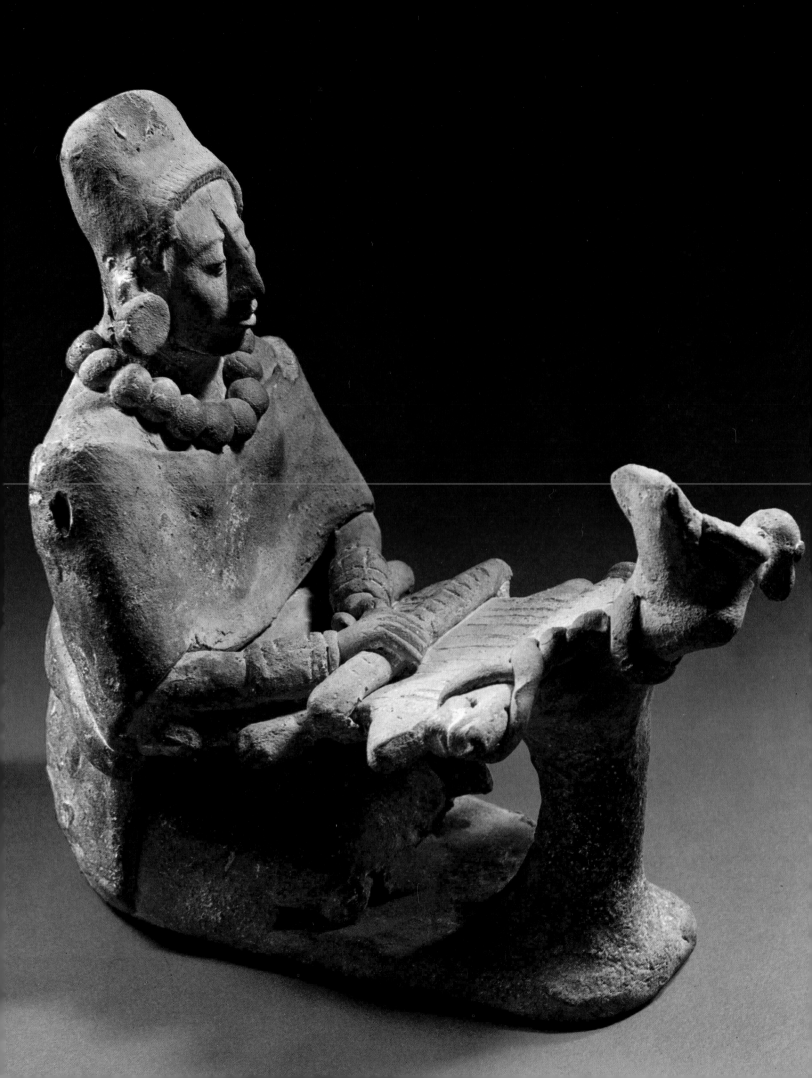

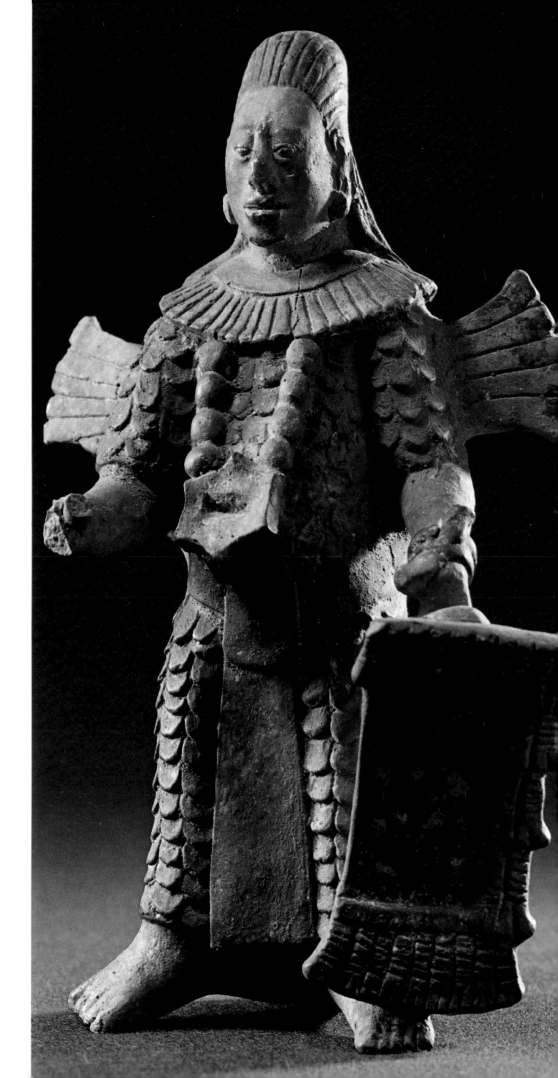

"The Weaver"
A.D. 600–800
Terracotta; height 6 1/2".
From Jaina.

Warrior with a Shield
A.D. 600–800
Painted terracotta;
height 8 5/8".
From Jaina.

WARRIOR WITH A SHIELD. *p. 107*

The warrior wears a scaly costume, feather ornaments, a radiating collar and a hexagonal pendant. His hair is arranged like a helmet. All these elements are rendered in a manner complementary to the formal discipline of the work. At the same time, it is evident that the modeling was freely improvised by the sculptor.

LADY WITH ELABORATE COIFFURE.

A lady of rank is dressed in a sumptuous ceremonial costume, with an appropriately elaborate coiffure in which the coils of hair are decorated with heavy jewels. There are many examples of such figures, but a comparison with the *Warrior with a Shield* (page 107) shows that within a common pattern the artist has achieved originality and firmness.

Left:
Lady with Elaborate Coiffure
A.D. 600–800
Painted terracotta; height 8 1/4".
From Jaina.

A PRIEST.

The mask on the face and the pectoral indicate that this figure is a priest, shown while performing a ritual. The geometricizing, tubular forms and the carefully balanced composition are features peculiar to Campeche sculpture, but here an unusual degree of articulation is apparent.

Right:
A Priest
A.D. 600–800
Painted terracotta; height 7 1/2".
From Jaina.

SEATED WOMAN WITH FEATHERED HEADDRESS. *p. 110*

Notable differences distinguish this figure from the preceding work: there is less simplification of the forms; a pronounced asymmetry despite the parallels set up by the opening of the dress, the objects in the hands and the setting of the feet; and a greater taste for elaborate ornamentation. The artist established his originality in the flowing *huipil,* or dress, which opens at the breast. Scholars usually assign sculptures such as this one to a later and presumably "decadent" phase of Campeche production, around A.D. 900.

"THE ORATOR." *p. 111*

The unusual head covering, the costume with the leather belt and the large earrings indicate that here is an important official. The pose is usually interpreted as that of an orator, but the extended right arm may have held a staff. If so, it would have been parallel to the falling end of the belt, thus making a quadrangular frontal composition.

The artist's inclination toward geometrical composition is confirmed by the triangular forms repeated rhythmically in the figure. These are made by the left arm, the open costume and the spread of the knees and the feet. This feature, present in other Pre-Columbian works, is particularly strong in this sculpture.

VASE WITH TATTOOED HUMAN FACE AND HEADDRESS IN THE FORM OF A BIRD. *p. 112*

This vase is a typical example of the trade goods that the Maya utilized in their flourishing commerce throughout Central America. The merchants were organized in corporations, each with its own gods and regulations. Traveling with an escort of porters and warriors, they often undertook

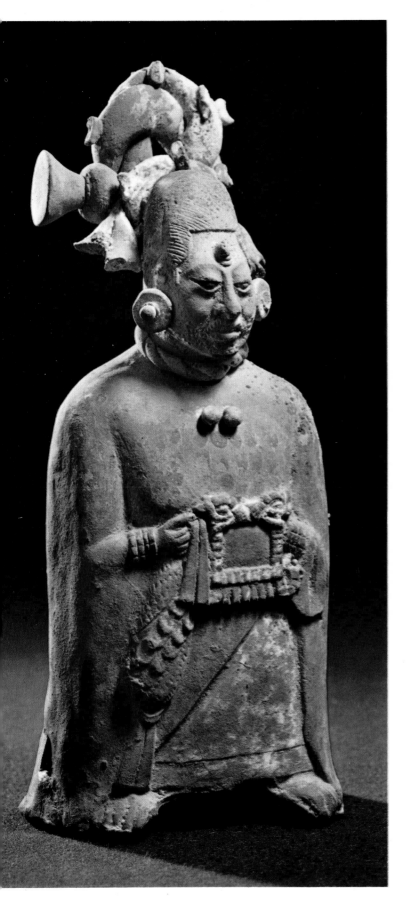
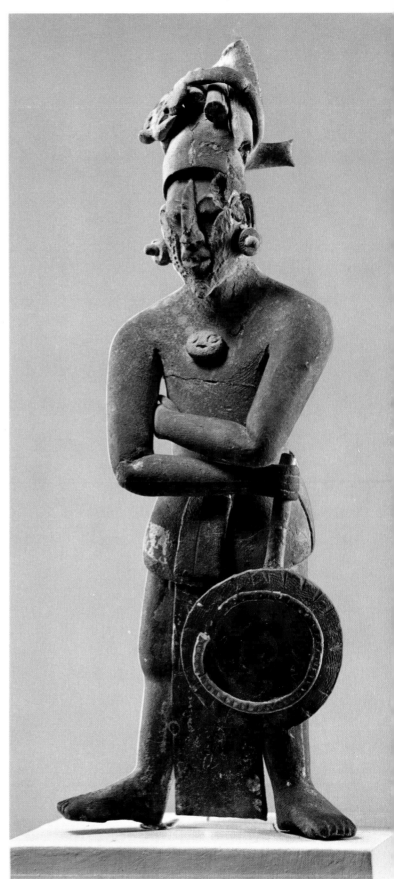

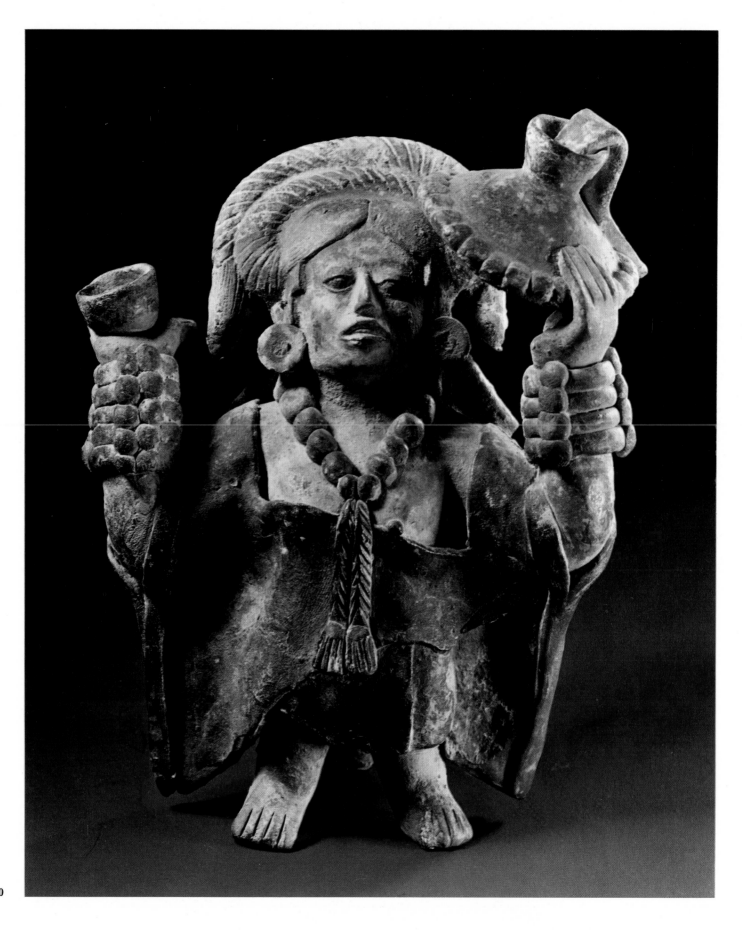

*Seated Woman with
Feathered Headdress*
A.D. 600–800
Terracotta;
height 7 1/2"
From Jaina.

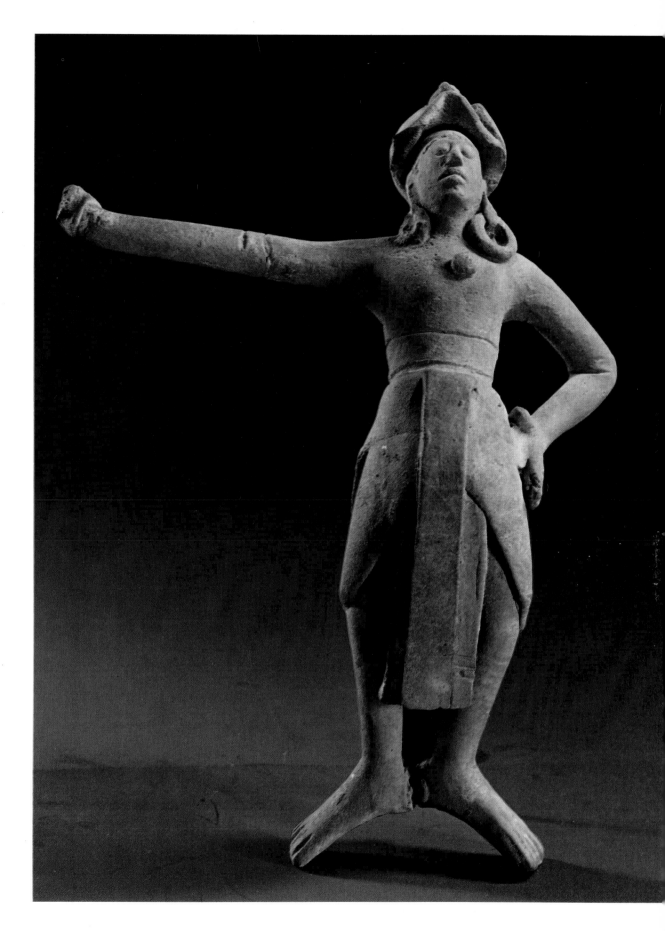

"The Orator"
A.D. 600–800
Painted terracotta;
height 7 5/8".
From Jaina.

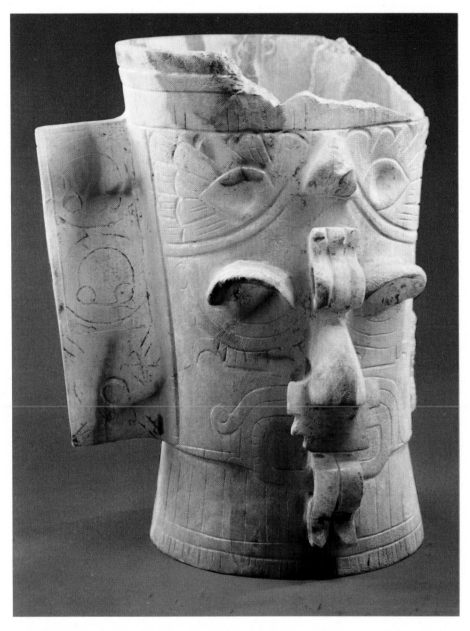

Vase with Tattooed Human Face and Headdress in the Form of a Bird
A.D. 1000–1200
Carved alabaster; height 8 5/8″.
From the Central Plateau.

spying missions for their caciques, sending back reports on the conditions and intentions of the peoples they visited.

This sculpture belongs to the production on the Mexican Plateau after A.D. 1000. Other incense burners in the form of heads with side-plates or stylized ears are found at Chimuxan and at Chipal. In this vase, the features of the face have been reduced to structural or decorative forms, in harmony with the volutes incised on the cylindrical face.

CHAC-MOOL.

Many sculptures have been found of the god of the rains — lord of lightning and floods. Typically, they show him as a reclining man who is about to rise, with rectangular ornaments in his ears and on his breast, armlets, and rings of feathers at the ankles and sandals. Such figures were placed in front of the ceremonial altars of the temples at Tula, Cempoala and

Chac-Mool
A.D. 1000–1200
Detail.
Limestone; 61 1/2″ × 31 1/2″.
From Chichén-Itzá.

112

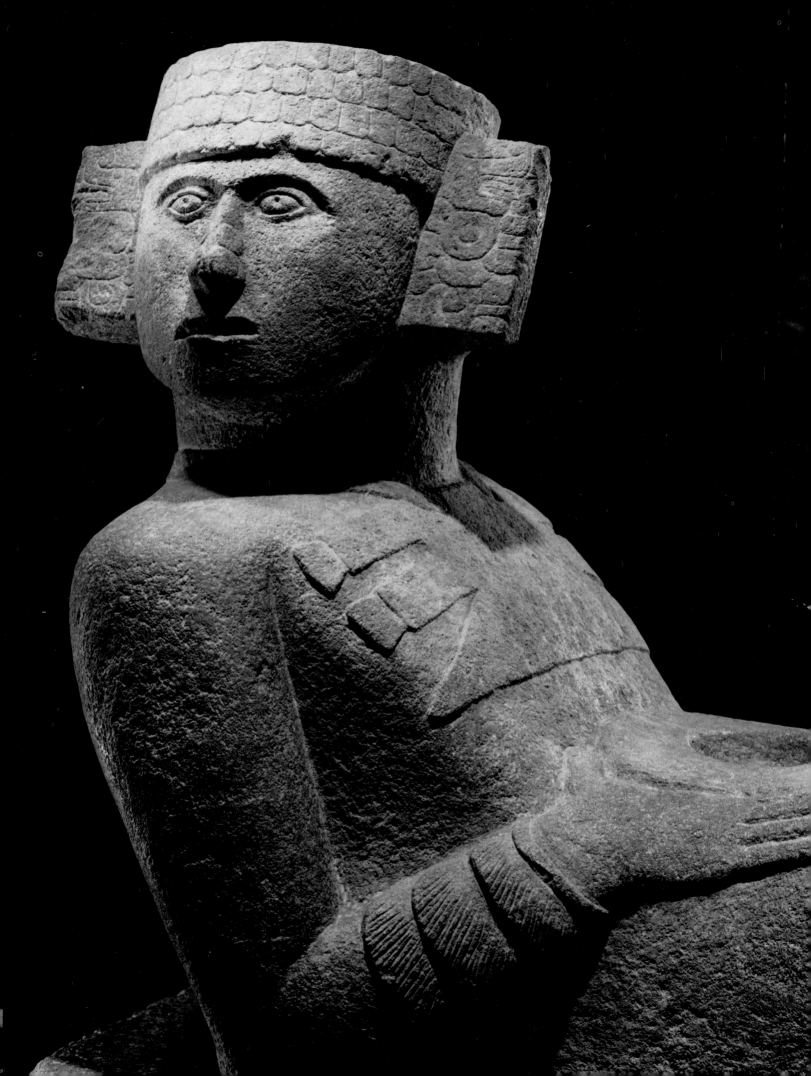

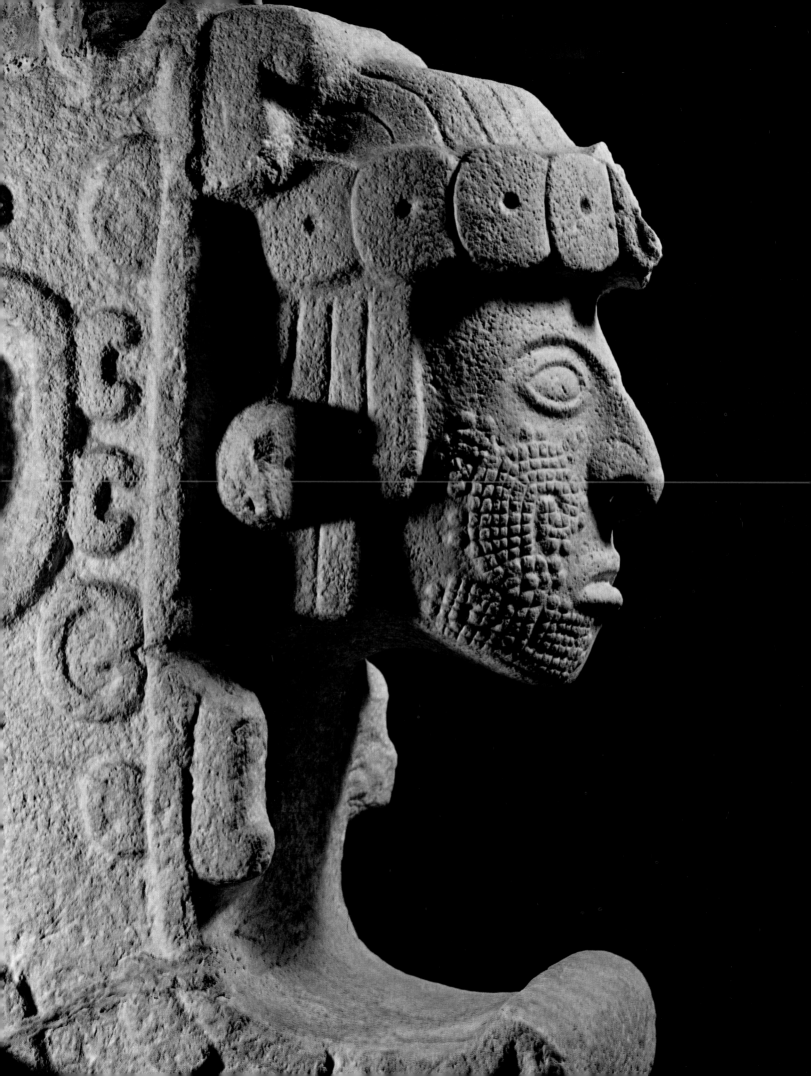

Ihuatzio, throughout western Mexico and as far as Yucatan. Considered evocations of Quetzalcoatl, the absent god, as he awakes from sleep to resume his reign, these sculptures served as vessels for offerings — including human hearts — made to the god of the sun. This example from Chichén-Itzá combines Mayan forms with those of the Toltec invaders and overlords.

"THE QUEEN OF UXMAL."

The staring head of *"The Queen of Uxmal,"* elaborately modeled and ornamented with tattoos, emerges from the jaws of a serpent. It was part of the decoration of the pyramid of the Temple of the Dwarf at Uxmal, which was one of the magnificent buildings erected after A.D. 1000. The appellation of "Queen" is a nineteenth-century invention, since there were in fact no male or female sovereigns in Mayan society — only the caciques. It is not even certain that a woman's face is portrayed. According to one theory, the statue is the portrait of a priest of Kukulkàn, the founder of Mayapan and the hero-god who led the Itza tribes during their migration toward the northeast and their settlement at Chichén Itzá. The broad planes and compact masses of this sculpture are in keeping with a hieratic or ceremonial purpose.

DISK ASSOCIATED WITH THE CULT OF THE SUN.

Found at the top of El Castillo, this disk is an example of the technical mastery of Mayan artisans in the period before the fall of Chichén Itzá in

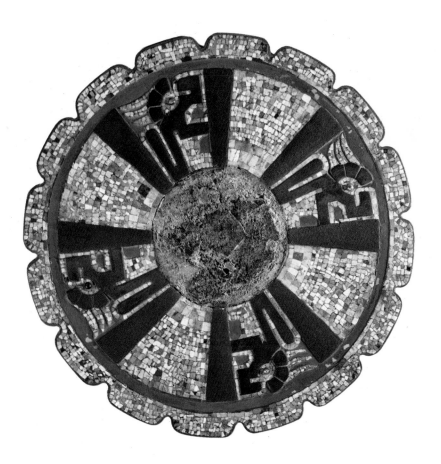

Disk Associated with the Cult of the Sun
A.D. 1000–1191
Mosaic of turquoise, shells and pyrite on wood; diameter 9 1/2".
From Chichén Itzá.

1194. El Castillo, or the Temple of Kukulkàn, is a pyramid erected over another smaller temple, which in turn was built over a sacrificial altar. With its nine setbacks, it is the most important monument of Chichén Itzá. Four stairways of ninety-one steps each give access to the rectangular temple at the top. This disk is divided into four fields with variegated colored grounds. Each field contains a feathered profile with a metallic eye that follows the same pattern.

WHISTLE IN THE FORM OF A RECLINING JAGUAR.

Music and the dance had great importance in the ceremonies and life of the Maya. Many types of musical instruments were used, including wooden trumpets, sea shells, bells, flutes, wooden or terracotta drums with strips of leather and tortoise-shell kettledrums. This small whistle appears to have been mass produced from a mold, but the soft agility of the resting animal with his open jaws has been rendered with lively feeling.

URN OR BRAZIER IN THE SHAPE OF A PRIEST.

The vessel represents a priest, richly costumed with feather ornaments, who is making an offering of incense. A typical example of Mayan pottery after A.D. 1200, it is evidence of the historical and cultural importance of the city of Mayapan, which was founded in 987 and was the capital until its destruction in 1441. The terracotta is painted in watercolor. The figure, with its traditional static composition, is covered with superimposed carved ornamentation. The priest appears dehumanized, an apparition as complicated as a jungle flower.

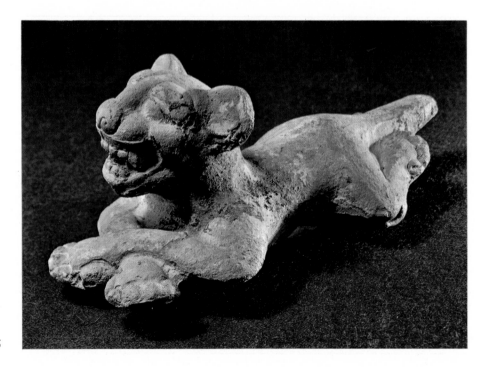

Whistle in the Form of a Reclining Jaguar
A.D. 600–800
Ochre terracotta; 3 1/2″ × 8″.
From the cemetery of Jaina.

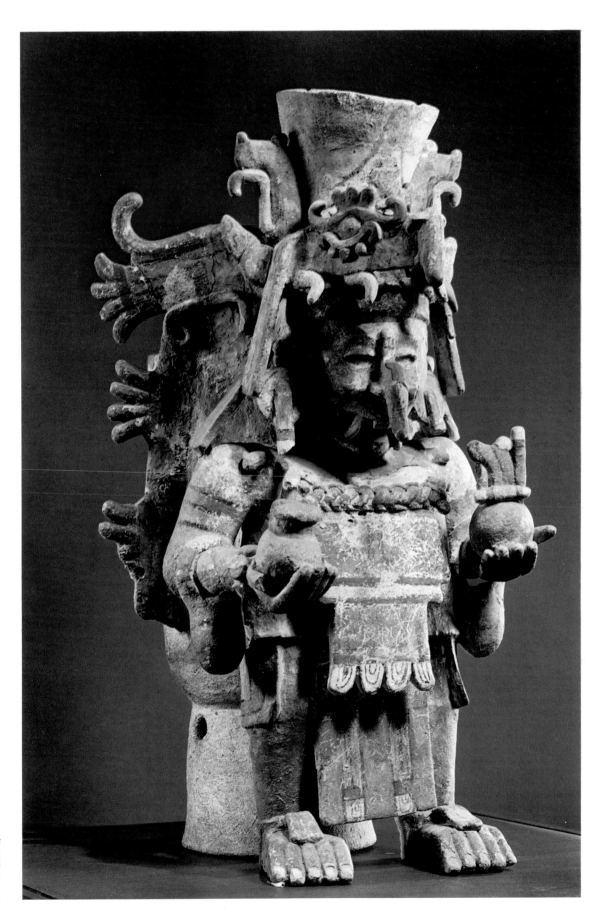

*Urn or Brazier in
the Shape of
a Priest*
A.D. 1200–1400
Polychrome terracotta;
height 22″.
From Mayapan, in Yucatan.

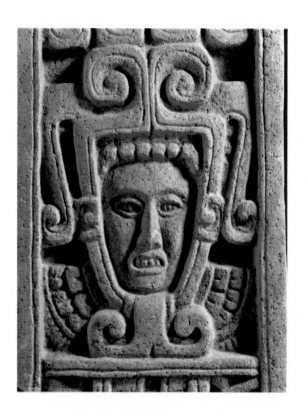

Stele of Quetzalcoatl
A.D. 600–900
Stone; 17 3/4″ × 15″.
From Xochicalco (Morelos).

STELE OF QUETZALCOATL.

Xochicalco, the "City of Flowers," was a cultural center during the last phase of the Teotihuacan period and the early years of the Toltec capital of Tula. An important, independent center, Xochicalco is generally considered an integral part of the Toltec culture, but there were also influences from Teotihuacan, Maya and Veracruz. The area in which the Toltecs settled includes the present states of Hidalgo, Morelos, Puebla and the Maya territories of Chiapas and Yucatan. The Toltecs arrived in central Mexico around 900, under the leadership of Mixcoatl, father of Quetzalcoatl, the "Feathered Serpent," and established their capital at Tula, which was sacked in 1186 and finally occupied by the Mexicas in 1254.

The Toltecs were long thought to be the creators of the Teotihuacan civilization. But the discovery a few decades ago of the ruins of Tula revealed that their hegemony came later and was significantly different.

Unlike the people of the classical centers of Teotihuacan, Monte Alban and El Tajin, the Toltecs were ruled by a military rather than a priestly caste. In the tenth century they penetrated into Maya territory; appreciable traces of their domination are clearly seen in the civilizations of Chichén Itzá, Uxmal and elsewhere.

This relief is a detail of one of the three steles discovered at Xochicalco. It represents the god issuing from the jaws of a forked-tongue serpent, and symbolizes Venus emerging from the dark. From the planet Venus — also seen in works from Teotihuacan — derive the divinities of Xolotl, the "evening star," the "precious twin," and Tlahuizcalpantcuhtli, the "light of dawn." Toltec sculptures, which served as architectural decorations, have a slightly eclectic character, combining Zapotec, Totonac and Teotihuacan decorative elements.

HUEHUETEOTL, GOD OF FIRE.

The intense play of light and dark, and the teeming intricacy of fantastic motifs that characterized Totonac art up to A.D. 600, were more subdued in the final phase of Remojadas II (seventh and eighth centuries). The forms became full and solidly geometric, accentuated, animated and sometimes contradicted by the prominent linearity of incised patterns and superimposed motifs. These elements are exemplified in this extraordinary statue of the god of fire, from Veracruz.

HEAD OF A GUACAMAYA. *p. 120*

The guacamaya or macaw is a rare bird associated with the cult of the sun, and was often represented in the markers set into the walls of pelota courts. Dated between 856 and 1168, this Toltec statue is remarkable for its stylized forms, tending toward the abstract and the emblematic.

Huehueteotl, God of Fire
A.D. 600–900
Painted terracotta; height 33″.
From Cerro de las Mesas (Veracruz).

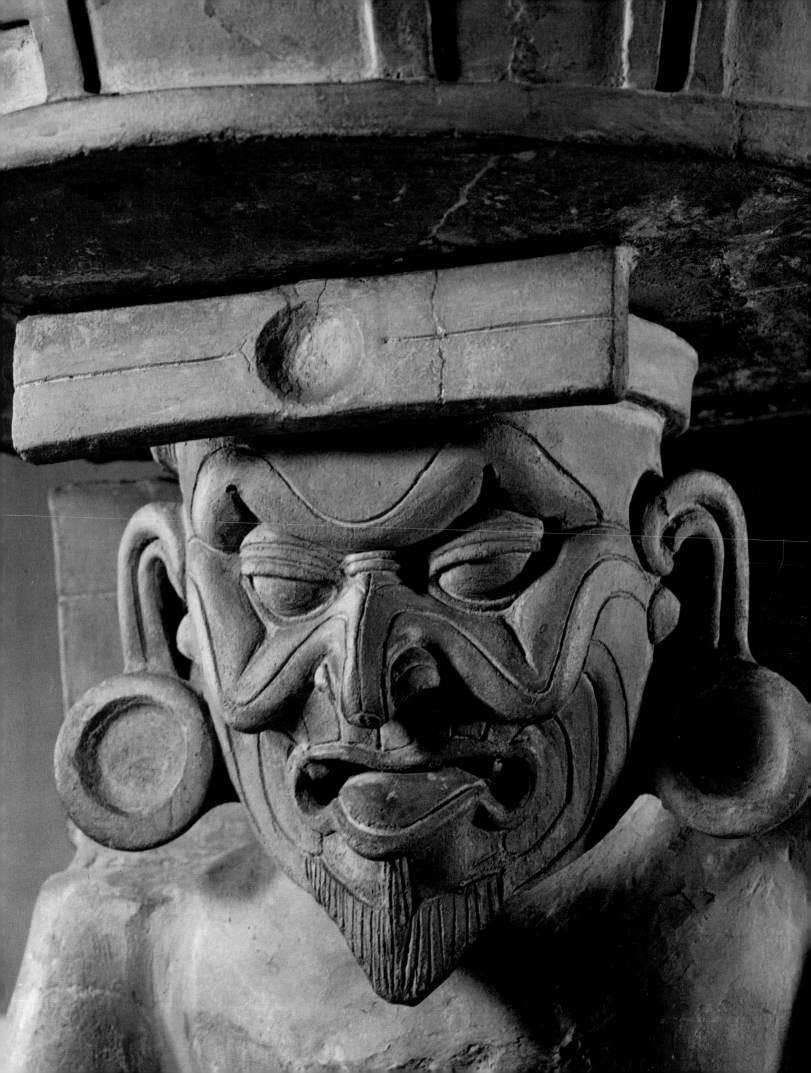

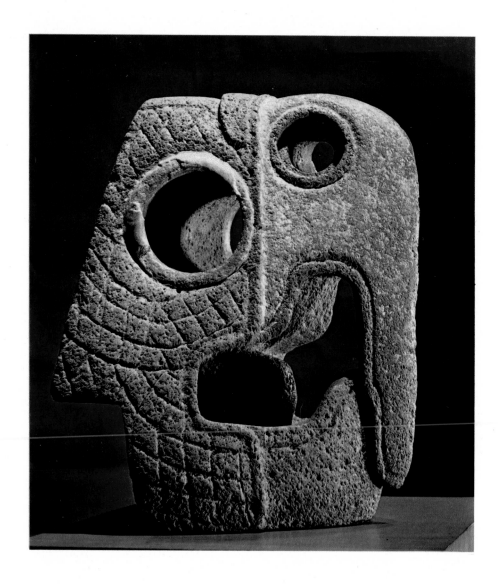

Head of a Guacamaya
A.D. 856–1168
Basalt; height 21 5/8″.
From Xochicalco.

TELAMON WITH RAISED ARMS.

With his tall helmet and diadem, feathered necklace and tunic, this statue probably represents Quetzalcoatl, the most important Toltec divinity. He was the son of the chief who led the Toltecs to central Mexico, and from living hero, he became a legendary god. He is shown in the typical attitude of a telamon, which was used in Toltec architecture as a support for friezes or architraves. Probably executed before 1168, the work shows the typical Toltec symmetrical disposition and accentuated cylindrical volumes.

WILD BOAR WITH A MAN'S HEAD IN ITS JAWS. *p. 122*

This unusual head was probably used as an architectural decoration. Inlaid work of this sort, sometimes with a variety of materials, was not uncommon. The underlying sculptural form is solid and compact, and on it the irrides-

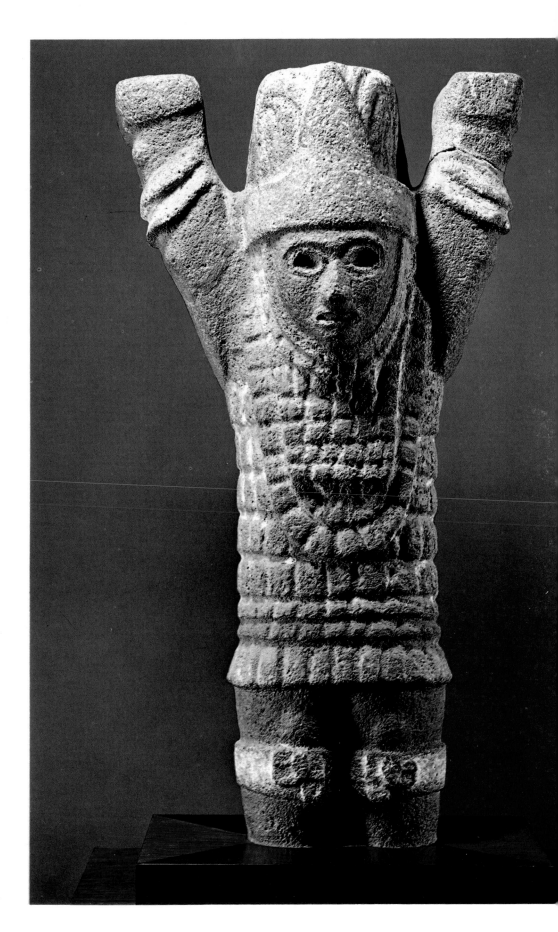

Telamon with Raised Arms
Circa A.D. 1168
Basalt with traces of paint; height 32 5/8".
From Tula (Hidalgo).

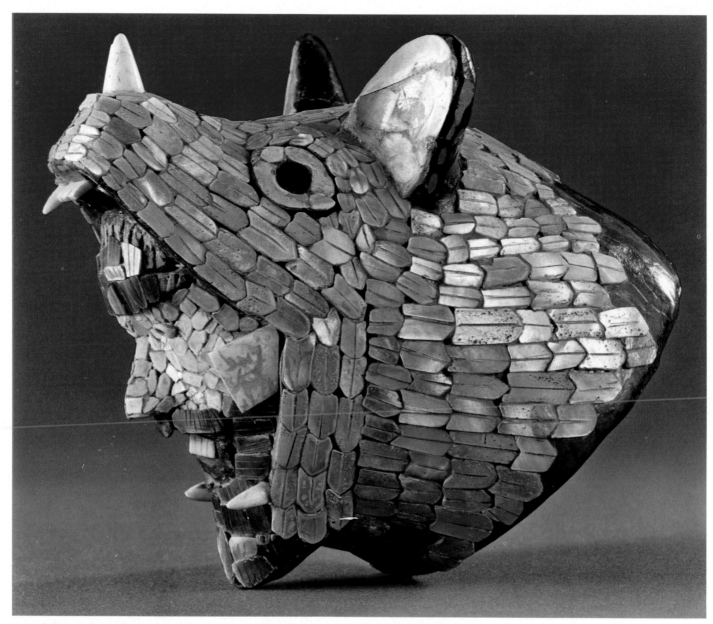

cent inlays of mother-of-pearl create a shimmering variation of light and dark. The unreal glitter is in keeping with the fabulous nature of this combined human and animal image.

COLOSSAL TELAMON WARRIOR.

With three other telamons of the same size, and four square pillars, this warrior supported the roof of the main temple of Tula, which stood on top of a pyramid dedicated to the planet Venus. The statue represents Venus, as one of the manifestations of Quetzalcoatl, in the form of a warrior fighting against the shadows. The sumptuous costume shows traces of the original paint. It is composed of four parts, three of which are joined with tenons. Hieratic and majestic, the divinity has been represented architectonically, with feet like a plinth and head like a capital, in a combination of frontal and profile views. Every element of the work is contained within the abstract geometry of the composition.

Wild Boar with a Man's Head in its Jaws
A.D. 900–1250
Terracotta covered with mother-of-pearl scales; height 5 1/2".
From Tula.

122

Colossal Telamon Warrior
A.D. 900–1250
Basalt with traces of red paint;
height 15′1″.
From Tula.

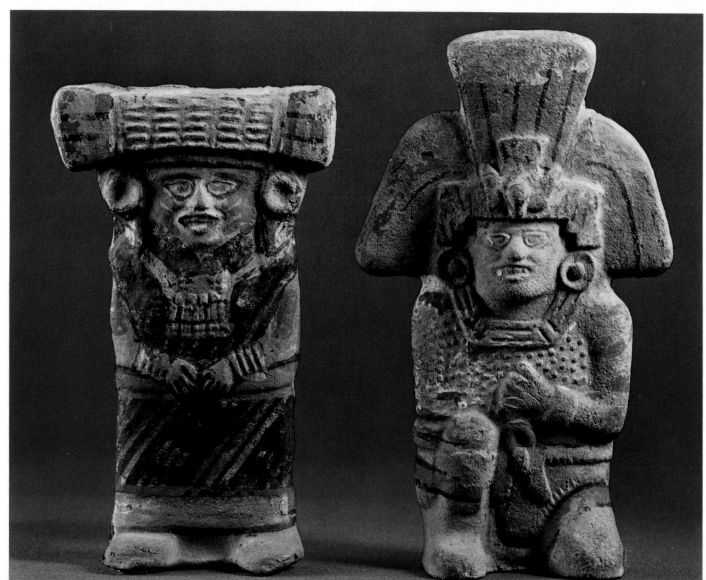

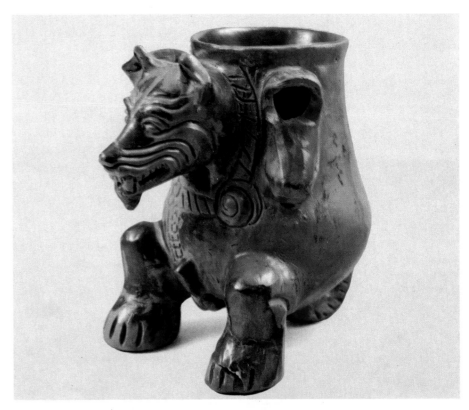

Vase with Handle in the Form of a Bird
A.D. 900–1250
Plumbate terracotta; height 6 1/4".
From Tula.

Double-Necked Vase
A.D. 900–1250
Terracotta; height 6 3/4".
From Tenayuca (Mexico).

Vase with the Figure of a Coyote
A.D. 900–1250
Plumbate terracotta, glazed in two
colors; height 6 1/2".
From Tula.

Female Figure in a Skirt and
Kneeling Figure with a Tall Headdress
A.D. 900–1250
Terracotta with traces of applied fresco;
heights 5 1/8" and 5 7/8".
From Ecatepec.

VASE WITH HANDLE IN THE FORM OF A BIRD.
Probably imported from the region dominated by the Huastecs, numerous examples of this type of polished ware have been found among the remains of Toltec culture. The modeling creates clear plastic volumes in the lightly streaked ridged body and in the neck. The handle, more animated in feeling, was made by applying pellets of clay to the curved cylindrical form.

DOUBLE-NECKED VASE.
This vase is typical of the "orange ware" ceramics produced by the Chichimec groups that settled at the same time as the Toltecs in central Mexico, making their capital at Tenayuca. The spherical body and the two necks joined by a curved handle give this splendid example of a mixing vessel an elegant, rhythmic balance.

FEMALE FIGURE IN A SKIRT, AND KNEELING FIGURE WITH A TALL HEADDRESS.
These two striking figures are typical examples of the wide production of statuettes reflecting the style and forms of contemporary monumental architectural sculpture. They were probably cast in molds and then painted with bright colors.

VASE WITH THE FIGURE OF A COYOTE.
Either imported into Tula or made in imitation of Huastec ceramics, this vase has the typical feature of an animal figure grafted onto a volumetric form. The hybrid forms of this kind of ware were often highly inventive, highlighted by imaginative linear motifs incised with a stick and colors that intensify the unusual effects.

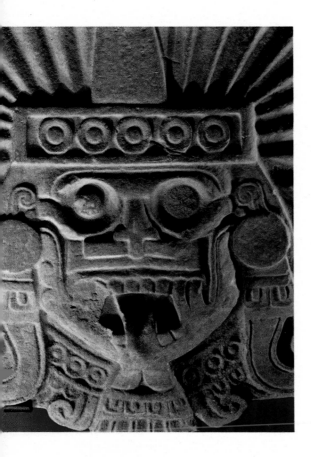

Above:
*Stele of Tlahuizcalpantecuhtli,
"Our Lord of the Dawn"*
A.D. 1000–1200
Detail.
Limestone; 67″ × 43 1/4″.
From Teptzintla.

Opposite:
Xilonen, Goddess of the Young Corn
A.D. 1000–1200
Limestone; height 33 1/8″.
From Tuxpan (Veracruz).

On page 128:
Huastec Adolescent
A.D. 1000–1200
Detail.
Stone; height 46″.
From El Consuelo de Tamuín
(San Luis de Potosí).

STELE OF TLAHUIZCALPANTECUHTLI, "OUR LORD OF THE DAWN."

The Huastecs, an ancient people related to the Maya, settled on the northern coast of the Gulf and infiltrated as far as San Luis de Potosí. Although there is no evidence of an interrelationship with the Maya in the arts, contacts existed with the Olmecs, Teotihuacan and the Aztecs, by whom they were later conquered. In architecture and town planning, Huastec civilization was especially close to Teotihuacan. An abundance of steles have been found, which were executed from plaster models and are two-dimensional in feeling.

As in this example, Tlahuizcalpantecuhtli, "Our Lord of the Dawn," was usually represented by the Huastecs with a mask over his face, earrings in the form of hooks, and decorations of folded paper. In the mask, planes and elements are superimposed and organized for ornamental effect within a strictly symmetrical, balanced scheme.

XILONEN, GODDESS OF THE YOUNG CORN.

The headdress and ornamentation of bands, pendants, ears of corn, heavy earrings, sun's rays and jade necklace that symbolize the fertility of the crops — all worn by this statue — are the attributes of the Goddess of the Young Corn, who was venerated by the Huastecs. The work is datable after 1000, in the period known as Panuco V, or at the earliest in Panuco IV (700–1000). The artist's sensitivity is seen in the individualized and lifelike head, while the rest of the composition, with its contained monumentality, shows a harmonious balance of the parts.

HUASTEC ADOLESCENT. p. 128

A young priest of the god Quetzalcoatl, this youth carries on his back an infant symbolizing the sun. His right hand is held close to the breast with the fingers arranged so as to leave space for offerings of flowers and branches. The slender body is beautifully tattooed with motifs of flowers, ears of corn and Mayan glyphs and hieroglyphs representing the years, the sun, etc. In addition to its esthetic qualities, this magnificent sculpture contains a repertory of Huastec knowledge in writing, the calendar and astronomical observations. A masterpiece of Huastec art, the figure forms a closed, blocky composition, built up in a rhythmic succession of planes. On these planes, all the plastic movements of the work are developed, whether in high relief, such as the representation of the infant on the back, or in incised linear decorations as profuse and orderly as a complex musical score.

The Olmec heritage is seen in the rigorous geometric and volumetric composition, and in the separate frontal and profile points of view. The horizontal cylindrical object formerly held in the left hand created an element of spatial projection. With vibrant sensitivity, the artist has enlivened the surface of the work with an exquisitely modulated play of light.

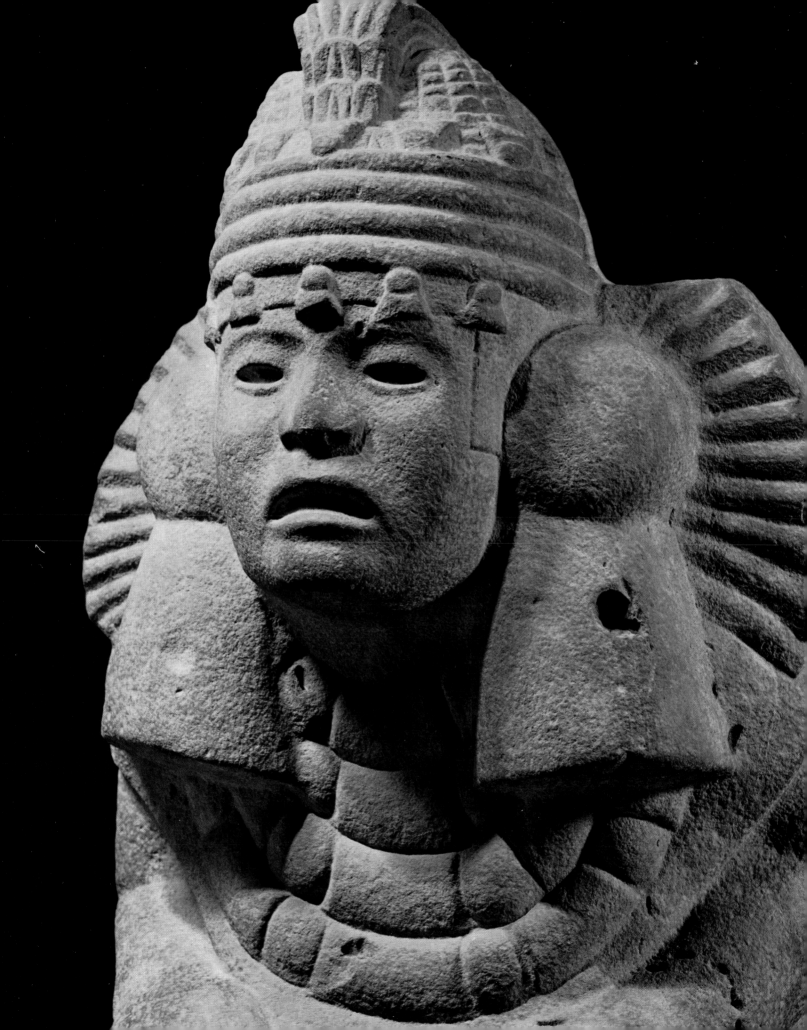

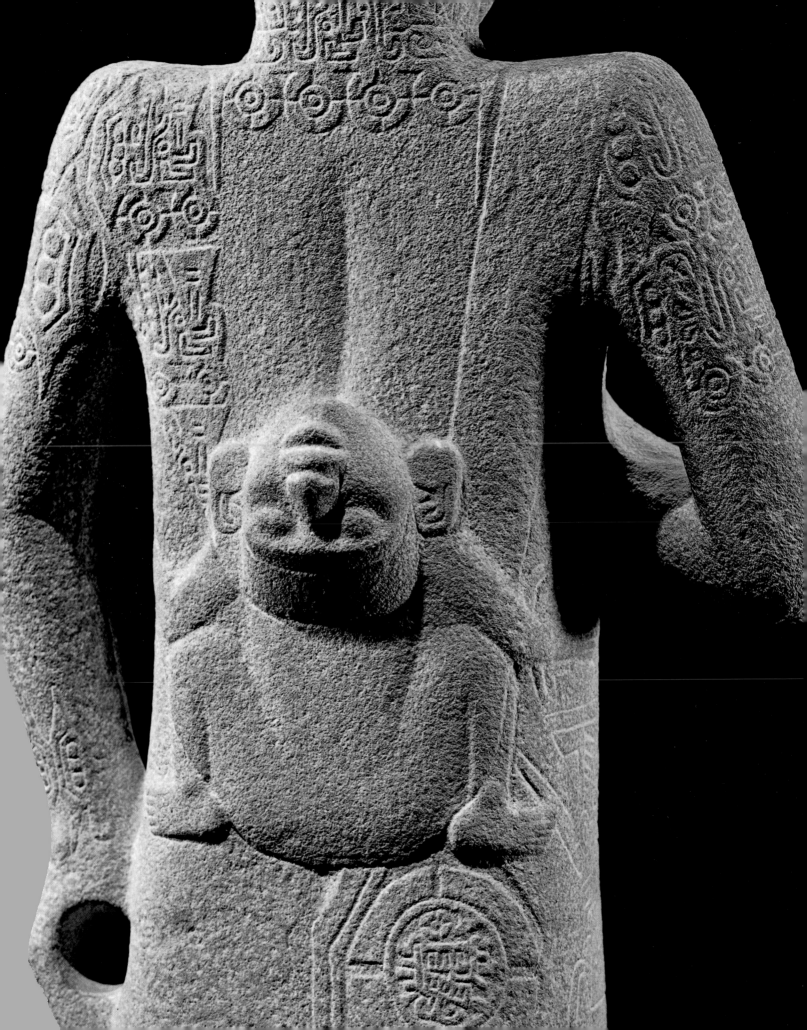

A.D. 1250—1521
AZTEC CULTURE
MIZTEC CULTURE
HUASTEC CULTURE
CASAS GRANDES CULTURE

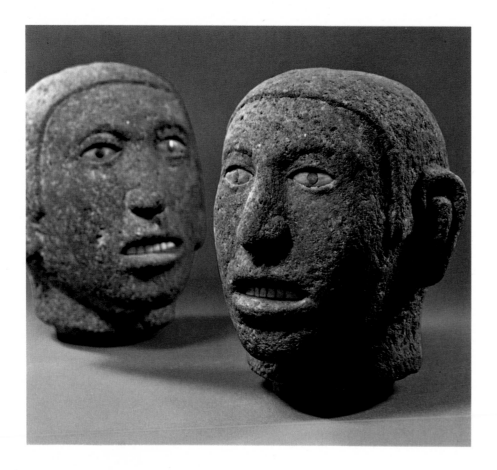

TWO MALE HEADS.

These Aztec heads are fragments of statues made of volcanic stone. Their mother-of-pearl eyes and teeth accentuate the "realism" of the naturalistic trend represented by these works — a trend that coexisted with others of different inspiration. The simplification of form in pure, closed volumes has analogies in Olmec art.

Aztec civilization is better known than any other in Mexico, because of the large number of surviving artifacts. Originally "Chichimec" nomads, the Mexica or Aztecs emigrated from a legendary place (perhaps Guanajuato) to Tula. When Toltec civilization was declining in the early thirteenth century, they entered the surrounding regions of the Valley of Mexico. After destroying the power of the Lords of Culhuacán, they founded an empire in 1325 with its capital at Tenochtitlan (the present Mexico City). The city, which was built on an island connected to the mainland by raised highways that also served as dikes, survived until the Spanish Conquest in 1519. Aztec civilization was based on a military and religious establishment in which the nobility were responsible for government, the priesthood, trade and war, while the "burghers" and artisans practiced the arts. The population was divided into castes; outside the castes were servants and slaves, who supplied the labor for economic production. Power was exercised by a chief, who was assisted by a council of state composed of noblemen, a general and a high priest — often these functions were performed by the same person.

130

Two Male Heads
A.D. 1324–1521
Basalt, with eyes and teeth incrusted with mother-of-pearl, and pupils with pyrite; 7" × 6".
From Mexico City.

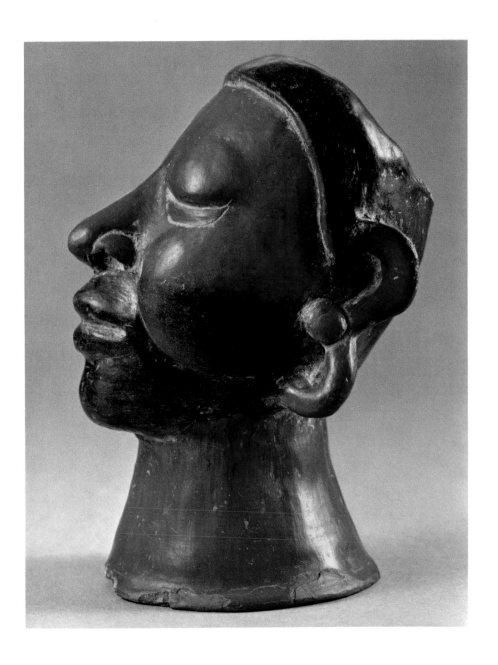

Anthropomorphic Vase
A.D. 1250–1521
Terracotta with black paint on a polished
red ground; 6″ × 3 1/2″.
From the Valley of Mexico.

This highly centralized society achieved a high standard of civic life. It had ceremonial centers, palaces, gardens, schools, arsenals, workshops and a sophisticated system of irrigation canals and aqueducts. Trade flourished, and public administration was sustained by tribute collected from a host of subject peoples. Religion was polytheistic, with the gods appropriated from conquered neighbors. Huehueteotl was the god of fire; Coatlicue, of earth; Tlaloc, rain; Xilonen, corn; Ehecatl, wind; Quetzalcoatl, the planet Venus; Tlazolteotl, fertility; Tezcatlipoca, night; Huitzilopochtli, Lord of the Universe. A fundamental belief was that everything had its origin in a single principle of duality: the invisible and the visible, masculine and feminine, destroyer and creator, sun and moon, unity and opposition. The cosmos

was divided horizontally in accordance with the cardinal points, which were associated with life and death; and vertically, into thirteen planes or worlds, which did not, however, correspond to a hierarchy of moral values. Asceticism was an essential element in this framework. Time was not an abstract entity nor space a simple extension. The gods were time itself, the rhythm of the seasons and the course of the planets. Nothing was permanent; everything was in movement. The sacred year of 260 days was a cosmic repetition; every fifty-two years the rites of the new fire were celebrated. The ritual required by the religious system strongly colored the lives of the community, with dancing and ceremonies laid down for every social activity, including war. Human sacrifice was performed to guarantee the cycles of perennial rebirth and to avoid catastrophe. Unlike the Mayan culture, much of Aztec literature, science, religion and even poetry has survived. Continuing the strictures of the missionaries who came in the wake of the Spanish conquerors, archaeologists usually stress the monstrous, macabre and inhuman aspects of the Aztec liturgy of human sacrifice. This view is reflected in their estimates of Aztec art, which is seen as fearful, vainglorious and savage; however, human sacrifice was also common to such ancient civilizations as the Hebrew, Indian, Greek, Roman and Druid, whose arts are not usually interpreted so invidiously.

ANTHROPOMORPHIC VASE. *p. 131*
Archaeologists assume that the animistic conception of the cult of the dead among the Mexicans led not only to the making of masks of the dead, but also to their portrayal on vases, which thus became objects of commemoration and devotion. But the Aztec artist who created this work was primarily interested in form and the problem of associating and articulating abstract volumes.

HEAD OF AN "EAGLE KNIGHT."
This statue, with a headdress or helmet in the shape of an eagle's head, represents a knight from one of the two Aztec military orders reserved for nobles and great army leaders. This masterpiece has been conceived in rigorously sculptural terms, with the forms reduced to their essential values. Such simplification accentuates the vitality that springs from the double image.

XOCHIPILLI, THE "FLOWER PRINCE." *p. 134*
Xochipilli was the Aztec god of spring, love, the dance and poetry. On his head he wears a diadem of heron feathers; on his face, an actor's mask; on his neck, ornaments in the form of jaguar claws; and on his body, symbols of flowers and the sun. His throne is decorated with hieroglyphs symbolizing the beating of wings and the petals of flowers, as well as the "thunder" motif of four grouped disks. The god was also called "Lord of Souls," and his significance was both spiritual and material. In accordance with Aztec liturgy, the symbolic motifs scattered over his body had double and triple meanings. The sacred purpose of the figure has been transformed into a fanciful though rhythmic and orderly arrangement of floral elements. In their geometrical simplification, they do not disturb the clean-cut,

Head of an "Eagle Knight"
A.D. 1324–1521
Andesite; 15″ × 12 1/4″.
From Mexico City.

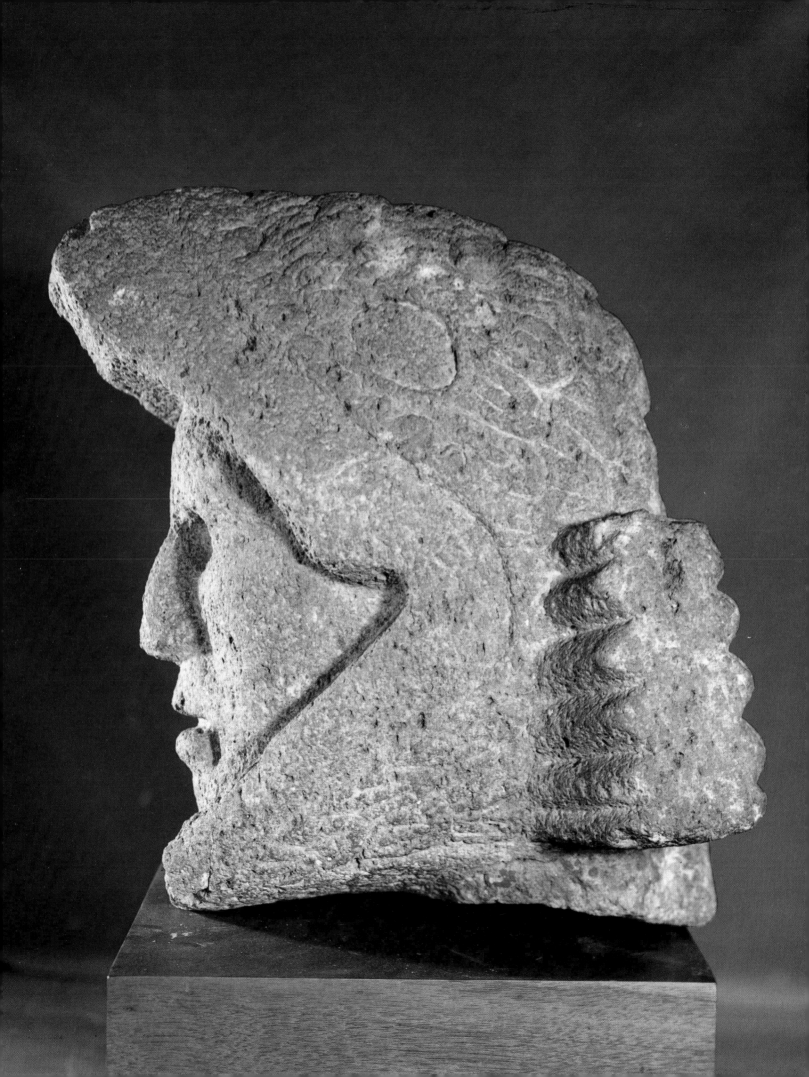

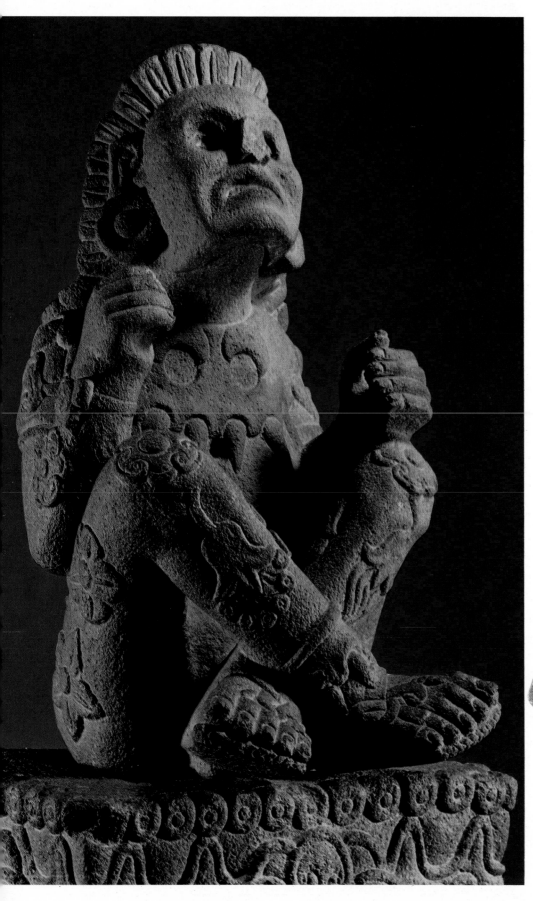

Xochipilli, the "Flower Prince"
A.D. 1324–1521
Volcanic stone; height 30 1/4".
From Tlalmanalco (Mexico).

*Coatlicue, Goddess of the Earth,
Life and Death*
A.D. 1324–1521
Basalt; 47 1/4" × 15 3/4".
From Coxcatlan (Tehuacan).

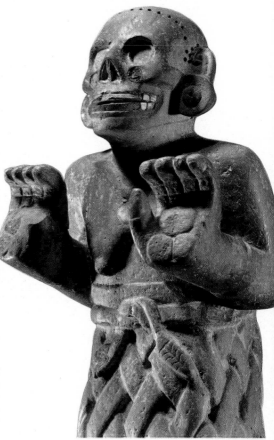

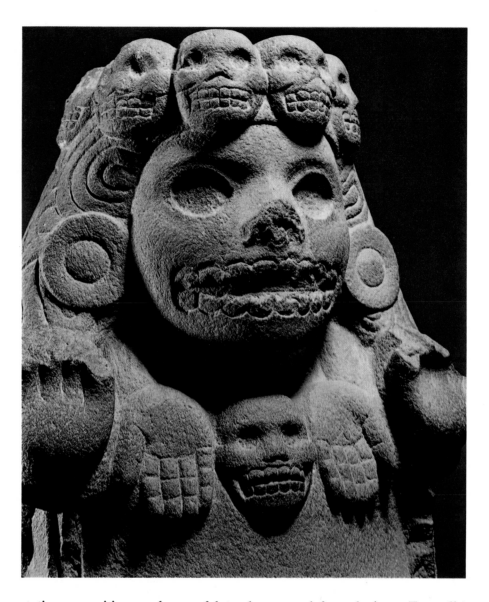

The Goddess Coatlicue
A.D. 1324–1521
Detail of the bust.
Basalt; 43 1/4″ × 15″.
From Calixtlahuaca (Mexico).

static composition made up of lateral, rear and frontal views. Frontally, the figure shows the chiasma of the legs — a splendid supporting form for the arms, torso and head of the god.

COATLICUE, GODDESS OF THE EARTH, LIFE AND DEATH.
This statue is one of the most "humanized" of the extant representations of the "Goddess of the Serpent Skirt." Shown with the physical features of a very old woman, she wears the mask of an emaciated face with turquoise inlays on the cheeks and mother-of-pearl teeth. The figure wears a skirt and belt of snakes and jaguar claws on its hands and feet. The pectoral is composed of a precious stone. The stylization in modeling and composition is similar to that of the works already discussed, despite the emphasis here on sacred symbols aimed at creating a psychological and religious effect.

THE GODDESS COATLICUE.
In this detail of a large statue, the goddess Coatlicue is shown as a youthful woman wearing the symbolic ornaments of skulls on her hair and at **135**

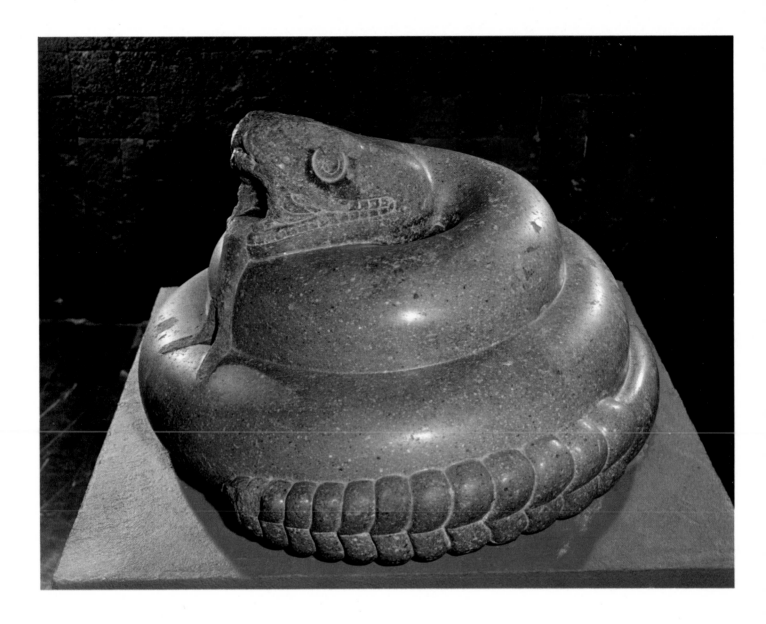

her neck (between two open hands that symbolize life and death). Her *huipil,* or shirt, is decorated with hearts and feathers. The character of the mask and the attributes was dictated by the religious function of the work.

COILED SMOOTH-SKINNED SERPENT.
The serpent, with its open mouth and forked tongue, represents the forces of the earth. Its spiral shape, from the triangular head to the rattles of the tail, is an architectonic form. This technique of creating an image in structural forms is a constant feature of Aztec art.

COILED FEATHERED SERPENT.
The feathered serpent represents the union of heaven and earth. While the feathers signify the sky, life and light, the serpent itself stands for the earth, darkness and death. It is also identified with the planet Venus in its

Coiled Smooth-Skinned Serpent
A.D. 1324–1521
Green granite; 29 1/2″ × 39 3/8″.
From the Valley of Mexico.

diurnal and nocturnal phases, and assumes the name of Quetzalcoatl, the redeemer. The cult of the serpent probably originated with the Huastecs, and subsequently became highly important, as myth and history, to the Toltecs. (At Teotihuacan, he was the god of rain.) It was believed that Quetzalcoatl was an old priest of Tula who immolated himself on a pyre in order to purify his people and was resurrected in the form of the planet Venus, promising to return from the East to redeem his people. Cortez received a friendly welcome from the Aztecs because of their belief that he was the resurrected savior.

Like the *Coiled Smooth-Skinned Serpent* (page 136), this sculpture is built on a conical architectonic scheme. But the ruffled plumage and the stylization of the head show a more graphic and decorative bent which is also seen in other, more heraldic, works of the period.

Coiled Feathered Serpent
A.D. 1324–1521
Basalt; 11 3/4″ × 15 3/4″.
From the Valley of Mexico.

137

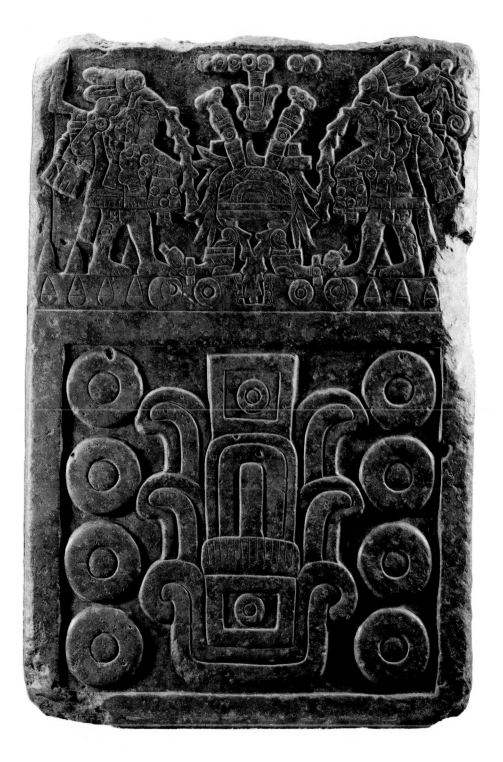

Stele Commemorating the Inauguration of the Great Temple of Tenochtitlàn
Volcanic stone; 35 1/2″ × 23 5/8″.
From Tenochtitlàn.

STELE COMMEMORATING THE INAUGURATION OF THE GREAT TEMPLE OF TENOCHTITLÀN.

The commemoration of the Great Temple took place in 1487, at the beginning of the reign of Ahuizotl. This date is indicated in the lower panel. In the upper panel, Tizoc (Seventh Lord, 1481–1486) and his successor Ahuizotl (1486–1502) sacrifice themselves, pouring their blood on the earth to make it fertile. Both the upper part and the large lower frieze of

Sun Stone (or Aztec Calendar)
A.D. 1324–1521
Stone; diameter 10′2 3/4″.
From Tenochtitlàn.

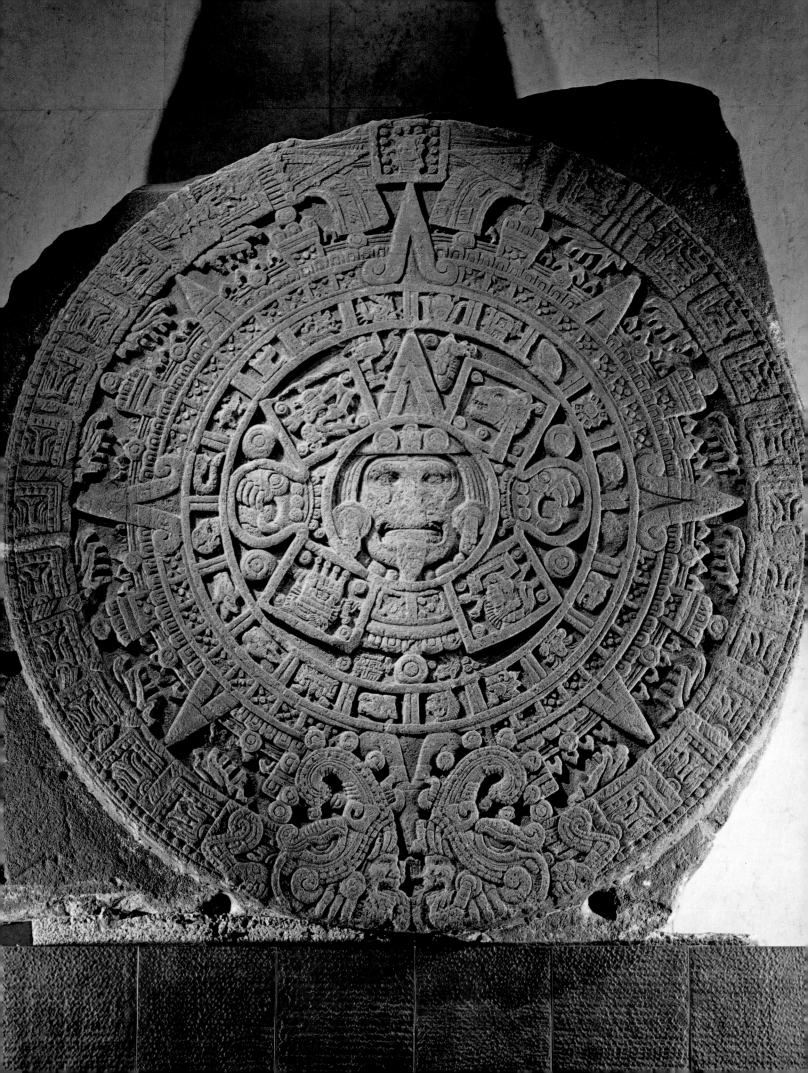

this stele were inspired by the same concept of symmetrical arrangement, following a closed rhythm that has a ritual character.

SUN STONE (OR AZTEC CALENDAR). *p. 139*
With its hieroglyphs for the days, months and suns — or cosmic cycles — this stone calendar represents the history of the world according to Aztec cosmology. In the center is the sun (Tonatiuh), surrounded by symbols of movement and the four suns or cosmogonic worlds preceding the time of the Aztecs: Tiger, Water, Wind and Rain of Fire. Around the center is a band with hieroglyphs of the twenty days of the Aztec month; other bands depict the sun's rays, precious stones, symbols of blood and flowers, elements of the solar cult and the two fiery serpents that indicate the cyclical order and the cosmic order.

The *Sun Stone* was discovered in 1790 during repair work on the cathedral of Mexico City, which was built on the site of an ancient temple of Tenochtitlàn. The extreme stylization is in keeping with the hieroglyphs and abstract symbols — the whole composition making up an extraordinarily refined image. In the low-relief, flat-ground sculpture associated with Tenochtitlàn, there is a notable connection with the graphic and pictorial style that was current in Mayan and later Toltec art.

THE TIZOC STONE.
This detail of a monolithic stone dedicated to the sun is decorated with scenes from the life of Tizoc, Seventh Lord of Tenochtitlàn. The hero's victories are represented in fifteen scenes, each containing two figures. Here he is dressed as Huitzilopochtli, god of the universe, and is shown seizing an enemy chief by the hair. The chief bears the hieroglyph of Acolman, one of the Mexican states subjugated by the Aztecs. As in Mayan reliefs, all realism has been excluded. The artist's main interest was in transforming each scene or event into a fabulous elaboration of shapes and lines that are densely incised and create an incessant play of light.

TEPONAZTLI. *p. 142*
The drum was in wide use among the Aztecs, for whom music was very important. They provided schooling in music in the *cuicacalli* or "House of Song." The god Macuilwochitl, one of the manifestations of Xochipilli, god of music and the dance, is represented on this detail from a stone drum. The figure is made up of metamorphic elements: wounded hands form the eyes; hearts, transfixed by knives, the ears. A flowering branch goes around the mouth, a larger one starts at the nose and defines the contours of the head at the back. In line with liturgical sculpture, the artist has used traditional stylistic elements for the rendering of a cryptic subject.

POLYCHROME CUP. *p. 142*
In the later phases of their empire, the Aztecs favored Mixtec potters for the production of wares for civil and religious uses. This polychrome cup was found at Tenayuca, which gave its name to a type of ceramics with

The Tizoc Stone
1481–1486
Detail.
Stone; diameter 8'4 2/5".
From Tenochtitlàn.

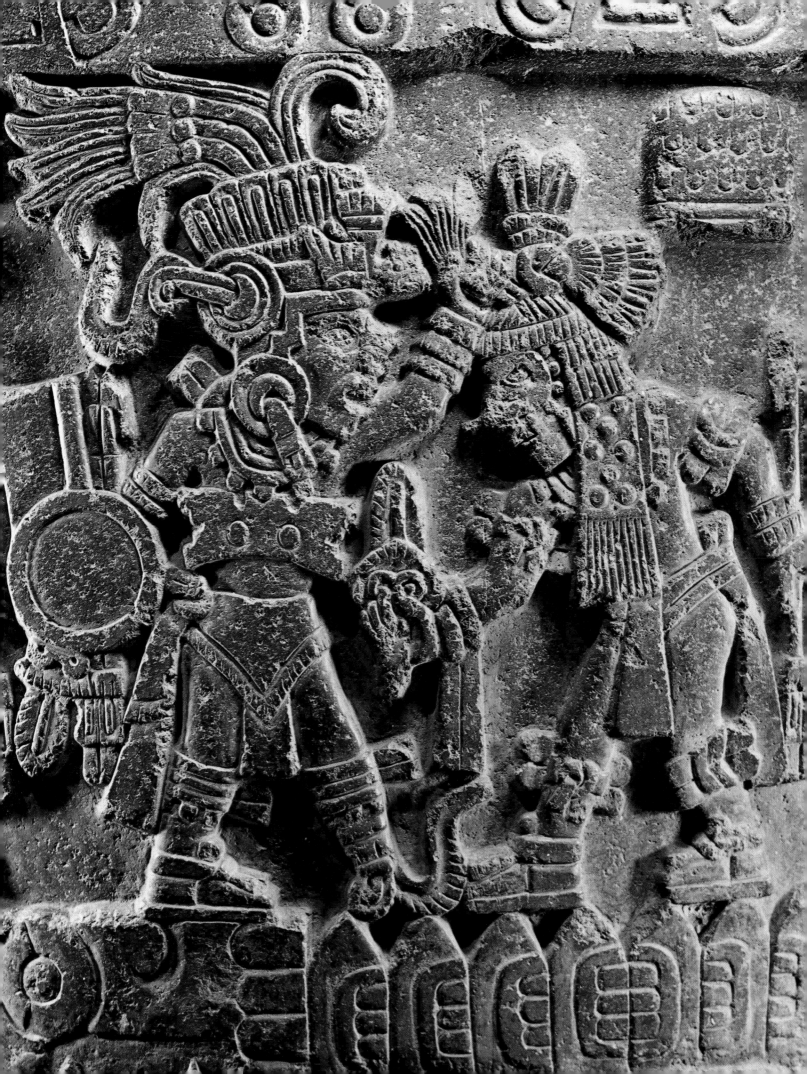

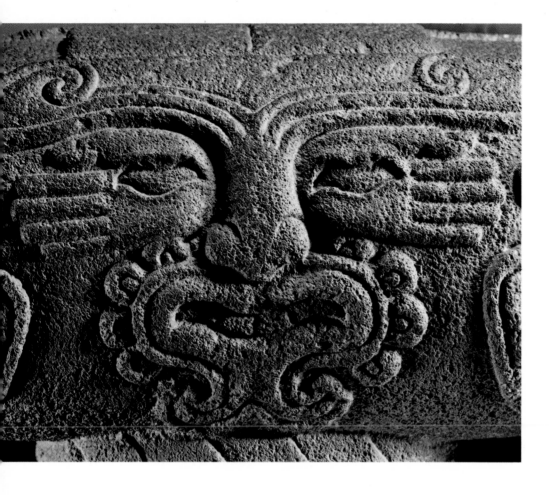

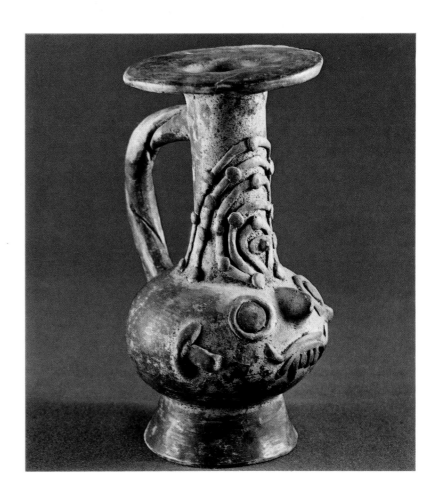

inventive and complex registers of geometric designs. The black and red friezes and red lining of this cup show clear affinities with Mixtec art.

SMALL TRIPOD BRAZIER.
This Mixtec brazier, richly decorated with perforations and incised symbols alluding to the planet Venus, comes from Tenayuca. Probably one of the objects that made up the tribute paid by the peoples subjugated by the Aztecs, it exemplifies the elegance and inventiveness of this type of ceramic-ware production.

SPHERICAL FUNERARY BRAZIER.
Less elaborate in workmanship than the *Small Tripod Brazier,* this vessel shows pierced-work motifs on its simple body and has three bell-supports in the shape of eagles' heads. Even popular ware such as this brazier exhibit imagination and skill.

VASE WITH EFFIGY OF THE GOD TLALOC.

An example of the pottery called *volcanes,* this vase is clearly distinguished from the preceding one in type of form and decoration. The figure was not molded but modeled freehand with fingers and stick. The rather caricatural head wears a diadem of ribbons and little balls.

143

SHIELD DECORATED WITH FEATHER MOSAIC.

This shield represents the head of a divinity associated with water. The featherwork was made by tying the exotic feathers with cotton thread and pasting them on cloth or paper. The various colors of the resulting mosaic had symbolic meaning: blue stood for sky or water; green, reinvigorated earth; red, the east, life and light; white; sunset; yellow, the north, cold and dark; black, the south. The contours of the highly stylized shield are edged by little gold plates, beaten to a thinness of four millimeters and laid on like the shingles of a roof.

OCHER JAR WITH BLACK DESIGNS.

This type of "Mexica" pottery was used for *pulque,* the fermented drink reserved for priests and elders. The black spirals, symbolizing the wind, make an exquisite decoration on the red ground of the body and neck of the vase.

CEREMONIAL BRAZIER. *p. 146*

Fundamentally a warrior people, the Mixtecs, "dwellers in the land of the clouds," occupied the highlands of Oaxaca around A.D. 1000. They took over such great ceremonial centers as Monte Alban and Teotitlan, and founded others such as Mitlà, Yanhuitlàn and Nochixtlaàn. In time, they

144

Shield Decorated with Feather Mosaic
1324–1521
Gold and feathers; diameter 10 1/4".
From Mexico City.

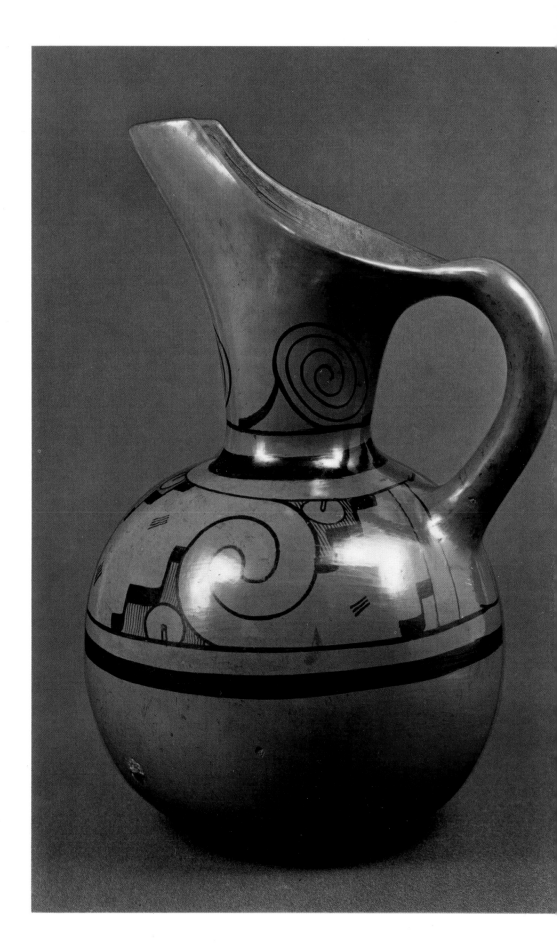

Ocher Jar with Black Designs
1324–1521
Polished terracotta; height 11″.

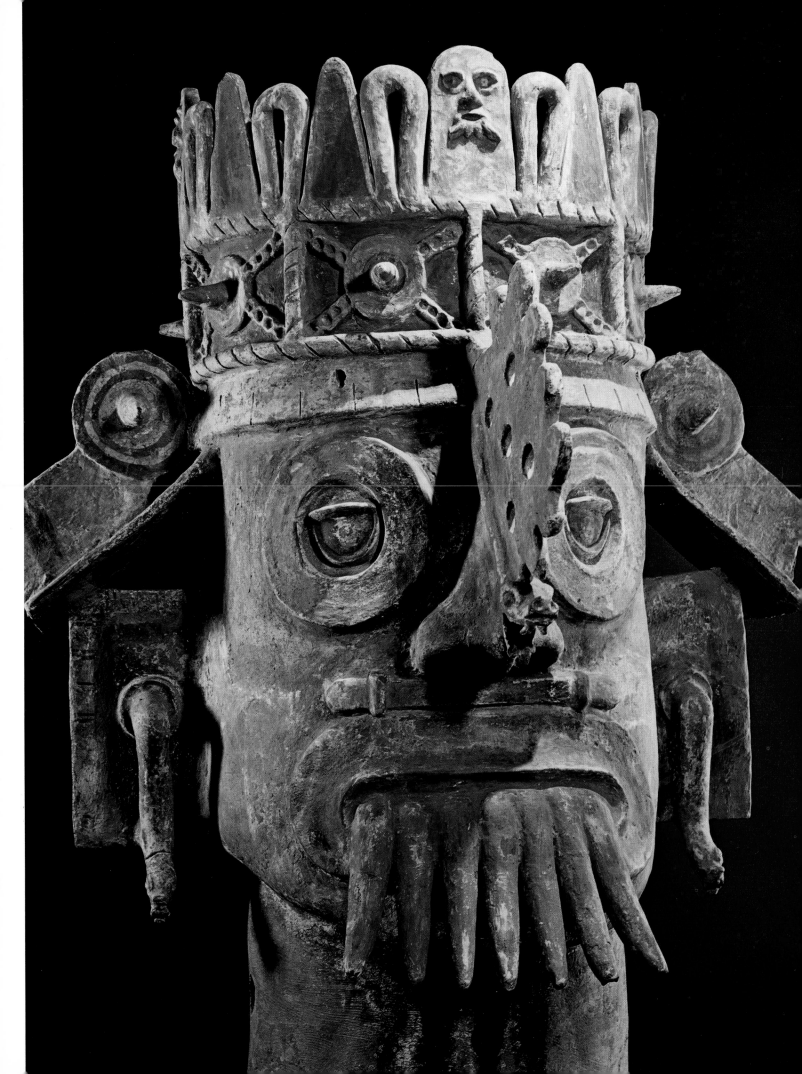

took control of many of the surrounding territories, reaching as far as Veracruz. Master craftsmen in metals, semiprecious stones and mosaic, the Mixtecs were also remarkable ceramists, codex painters and architects. This colossal brazier shows the typical Mixtec stylization, with compact masses balancing one another. These are decorated with fanciful pierced-work motifs, arranged in keeping with the artist's strong predilection for symmetry.

PECTORAL IN THE FORM OF A CEREMONIAL SHIELD. *p. 148*
This pectoral is a celebrated example of Mixtec goldsmiths' art. The "Greek fret" motif in the center is made up of bits of turquoise, while the darts and the pendants (formerly eleven, now eight) are gold, like the body of the pectoral. It was cast by the lost-wax process and enriched with the turquoise mosaic in a pattern that is typically Mixtec — the *xicalcoliutiqui,* which was probably derived from the stylization of a bird or serpent.

Metals and metalwork were introduced to Mexico by the Toltecs around A.D. 1000. A number of peoples assimilated their techniques of hammering, casting by the lost-wax process, soldering and filigree. Among these, the Mixtecs were outstanding, especially those groups that occupied the region of Oaxaca. They replaced the declining Zapotec culture with new forms, especially in goldsmiths' work, codex painting and terracotta. Some of the images for the masterly gold work were derived from the pictographs in the codices.

RING WITH BIRD'S HEAD, DISK AND PENDANTS. *p. 148*
The tomb of a Mixtec chief of Monte Alban has been partially reconstructed in the Mexican National Museum of Anthropology. It contained nine human skeletons and a considerable amount of funerary furnishings — especially jewels and bone objects. The tomb was discovered in 1932 by Alfonso Caso, and is datable at the end of the fifteenth century. This ring from the tomb consists of a broad band decorated in filigree. A bird's head, gold plaque — with place for a jade inset — and drop-shaped pendants are suspended from the ring. The same stylistic elements that prevail in other forms of Mixtec art are evident here.

PINS, PENDANT AND PECTORAL. *p. 148*
These objects, showing a predilection for pure geometric forms, are among the simpler examples of Meso-American goldsmiths' work. Jewelry such as this was common to the Mixtecs and Tarascans and was generally found throughout the Mexican territory, thanks also to the flourishing trade in this type of goods. The forms are derived from Colombian and Panamanian pieces, which were widely distributed, as these objects from Yucatan (Sagrado de Chichén-Itzá) demonstrate. The motif of the frog was popular with the Mixtecs, but is so typical of the preceding Panamanian gold work that its presence in Yucatan has even led to the hypothesis that artisans from Panama migrated to Chichén-Itzá.

Ceremonial Brazier
1300–1521
Terracotta; 59 7/8″ × 49 1/4″.
From Veracruz.

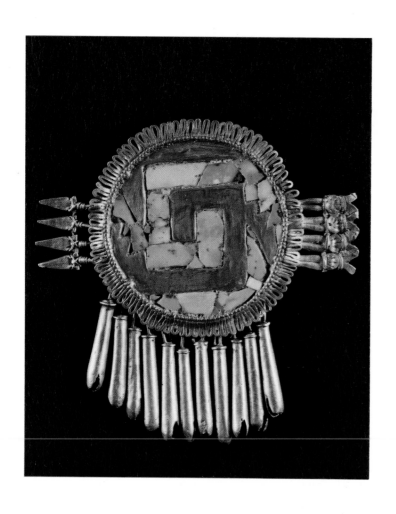
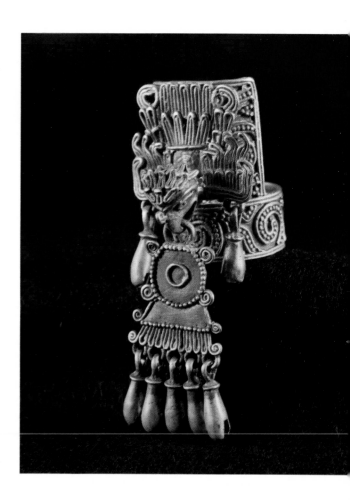
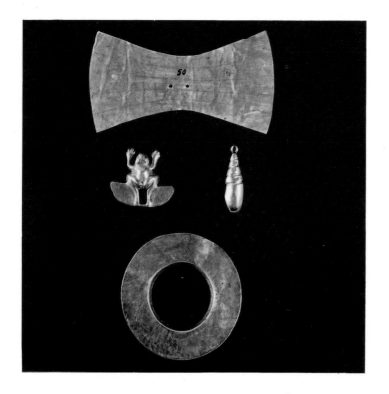
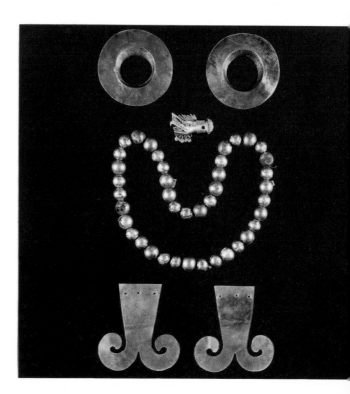

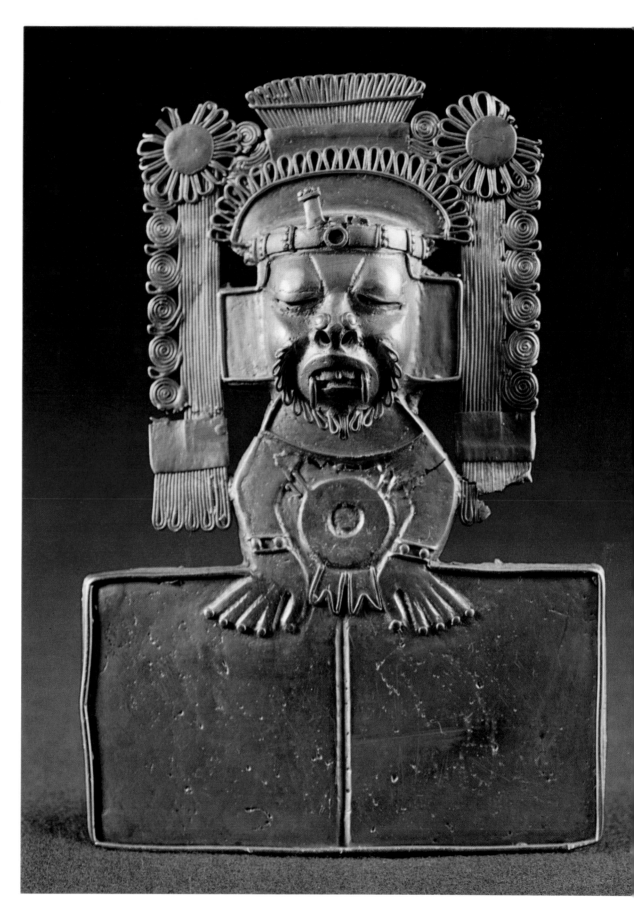

Opposite, left:
Pectoral in the Form of
a Ceremonial Shield
1300–1521
Gold and turquoise;
3 1/8″ × 3 1/8″.
From Yanhuitlàn (Oaxaca).

Opposite, right:
Ring with Bird's Head,
Disk and Pendants
1300–1521
Gold; 2 3/8″ × 3/4″.
From Tomb 7 of
Monte Alban.

Opposite, left:
Pins, Pendant and Pectoral
1300–1521
Gold.

Opposite, right:
Pins, Pendants, Necklace
and Earrings
1300–1521
Gold.

Pectoral with Effigy
of Xiuhtecuhtli
1300–1521
Gold.
From Tapantla
(Veracruz).

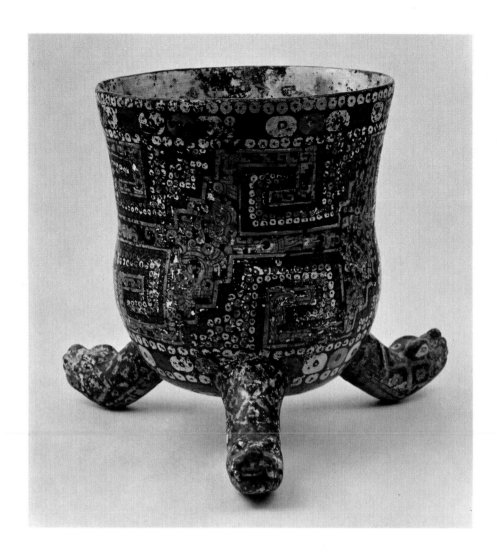

PINS, PENDANT, NECKLACE AND EARRINGS *p. 148*
The motif of this miniature pendant occurs very frequently. Necklaces of
round beads exist in all Pre-Columbian art and are found in numerous
sculptures and ceramics that show the female figure, beginning with the
Chavin Culture in Peru. Very often they are graphically represented in the
lists of tribute paid to the Aztecs by their subjects.

PECTORAL WITH EFFIGY OF XIUHTECUHTLI. *p. 149*
Cast by the lost-wax process and decorated with filigree, this pectoral rep-
resents Xiuhtecuhtli, a personification of one of the aspects of the old god
of fire. It is one of the finest and best-known examples of Mixtec gold work.
The two squares at the bottom often recur in such ornaments, as does the
large amount of masterly filigree.

PAINTED VASE WITH THREE SNAKE'S-HEAD FEET.
The major motif on this vase is the typical Greek fret pattern, into which
150 have been inserted representations of heads, figures and earth and cloud

Painted Vase with Three Snake's-Head Feet
1300–1521
Polychrome terracotta; height 6 1/4″.
From a tomb at Zaachila.

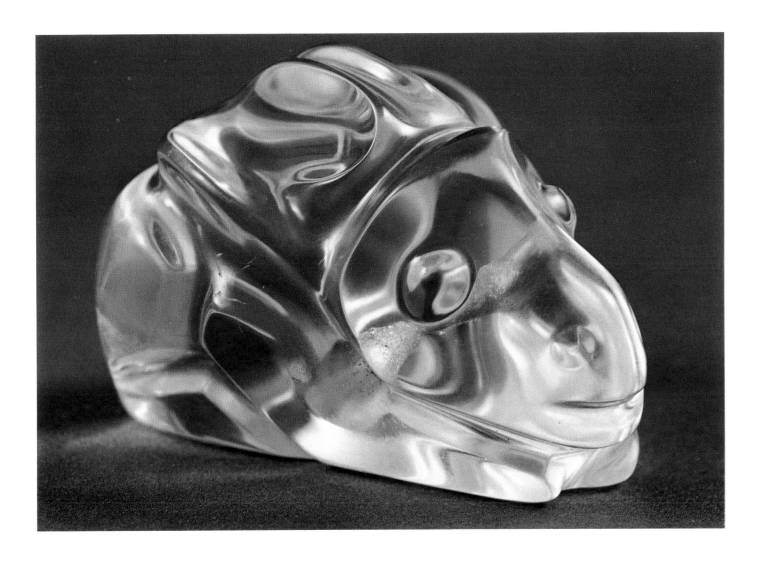

symbols. The result is a teeming, miniaturist decoration. This effect in Mixtec pottery derives from painting, especially from that of the codices.

CROUCHING RABBIT.
Just as they worked in all the semiprecious stones, the Mixtec craftsmen also carved rock-crystal figures, producing examples of the highest quality in form and technique. The compact stylization, in which the masses correspond and balance, is similar to that seen in large-scale Mixtec sculptures.

PITCHER WITH FLAT MOUTH. p. 152
A fine example of Mixtec-Puebla ceramics, this pitcher's pure volumes are made up of truncated cones and spherical forms. The painted panels are typical of the "codex type" of decoration, so named because of their resemblance to the miniatures in the manuscripts. The motifs, interlaced in various ways in the panels and bands, are also geometric in character.

Crouching Rabbit
1300–1521
Rock crystal; 2 3/8″ × 3 3/4″.
Provenance unknown.

151

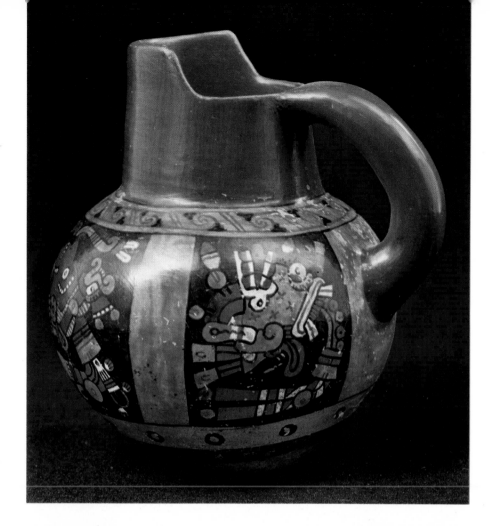

Pitcher with Flat Mouth
1350–1450
Polychrome terracotta; height 6 1/8″.
From Nochixtlan (Oaxaca).

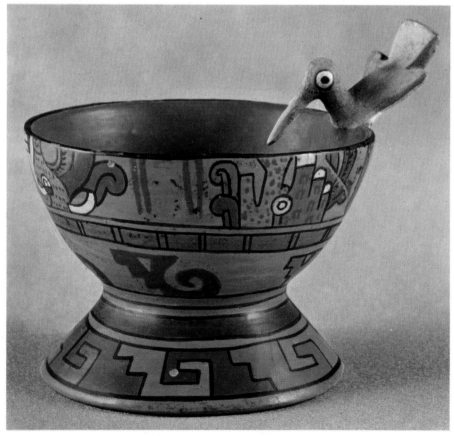

152

Painted Goblet with Hummingbird on Rim
1200–1521
Painted terracotta; height 2 3/4″.

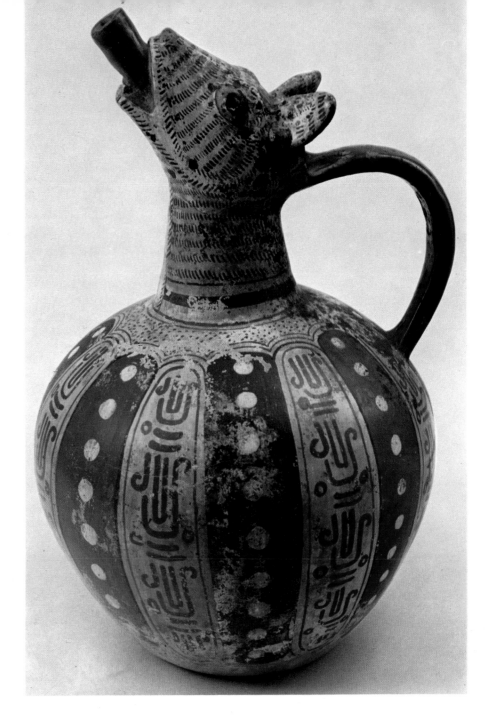

Pitcher with the Head of a Roe Buck
1300–1521
Painted terracotta; height 10 1/4".

PAINTED GOBLET WITH HUMMINGBIRD ON RIM.
The pure forms of the design, the graphic fantasy of the friezes and the technical mastery in this little Mixtec vase show the high level attained in this ware, which generally repeats a number of constant features but is very flexible in its solutions. This example is animated by the playful addition of a hummingbird poised on the rim.

PITCHER WITH THE HEAD OF A ROE BUCK.
The dashing elegance of the form, the painted decoration that is like a miniaturist's work and the fantasy of the zoömorphic image are typical of late Mixtec ceramics. On the body, a plain ground alternates with bands of the "codex" type. Neck and beak skillfully introduce the animal form which was frequently used, even in isolation, by the Mixtec potters.

153

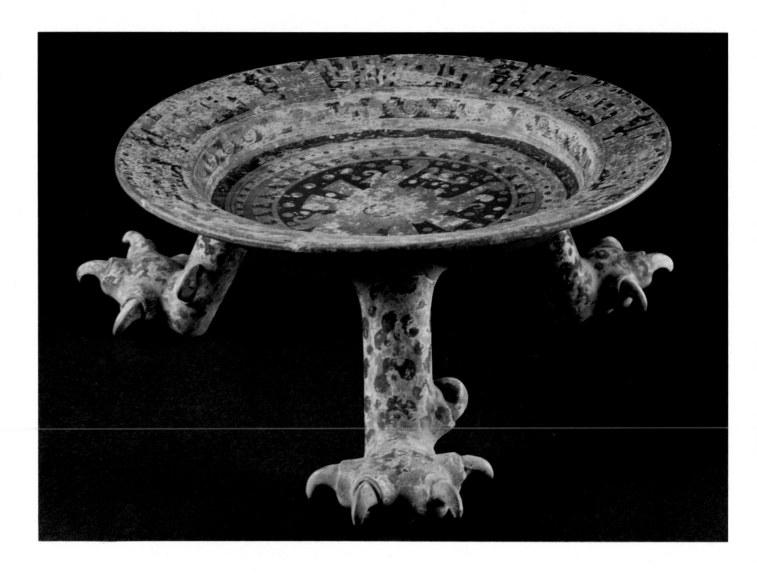

DISH WITH THREE TALL CLAW FEET.

In this ceramic dish, the dense, minute decoration recalls the painting in the codices and books in which the Mixtecs recounted their history, genealogy, religious precepts and daily life. The dish attests to the Mixtec potters' varied powers of plastic, graphic and chromatic invention.

LONG-HANDLED WATER-JUG.

The Tarascans established themselves in the lake district of Michoacan, with their capital at Tzintzuntzan, and subsequently enlarged their territory by the conquest of the states of Guanajuato, Colima and Jalisco. Very adroit in exploiting the agricultural resources of the occupied countries, they had a centralized political order akin to that of the Aztecs; they, too, were conquered at the peak of their civic and artistic flowering. Highly accomplished potters, the Tarascans were outstanding in the variety of their plastic ceramic forms, including the unusual arrangement of having the water flow through the handles to the spouts. The decoration of interlaces, lines, dots and zigzags, elegantly disposed over the surfaces of this water jug, is enlivened by ocher, purple-red and yellow polychromy.

Dish with Three Tall Claw Feet
1300–1521
Polychrome terracotta; 11 3/8″ × 5 1/2″.
From Zaachila (Oaxaca).

Long-Handled Water-Jug
1300–1521
Painted terracotta; height 8 1/16″.
From Tarasco.

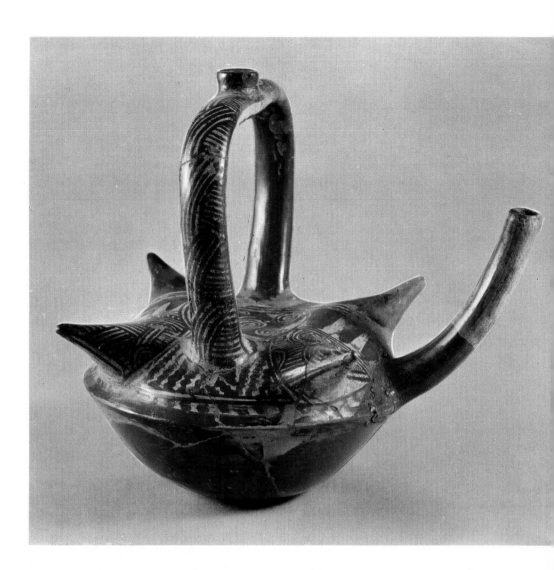

Water-Jug with Ring-Handle
1300–1521
Painted terracotta; height 8 5/8″.
From Tzintzuntzan (Michoacan).

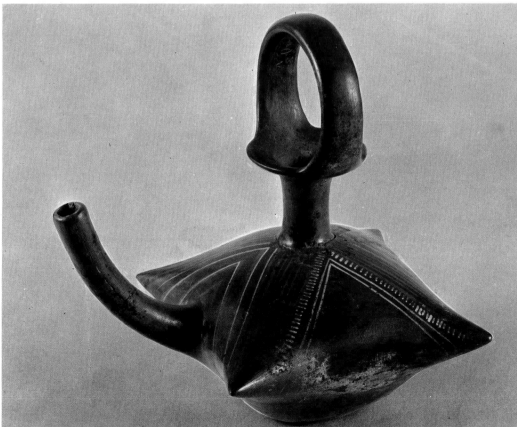

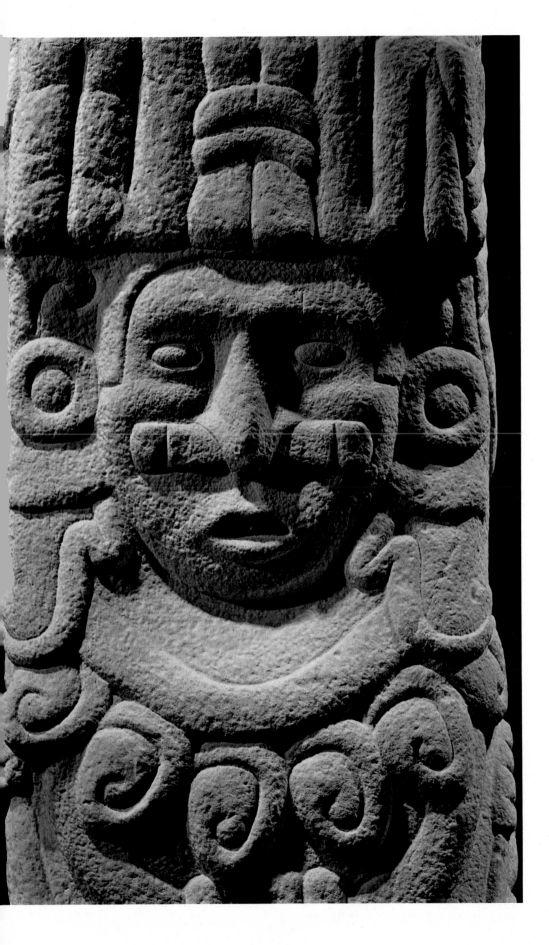

Quetzalcoatl in his Aspect of
God of the Wind
1300–1521
Detail.
Stone; height 10'1 1/8".

WATER-JUG WITH RING-HANDLE. *p. 155*

In the same style as the preceding example, this vessel comes from the ceremonial center of the Tarascan capital and was part of a funeral offering. The chief deity, Curicaveri, god of fire associated with the cult of the sun, was venerated by his priests through the maintenance of a perpetual sacred flame in the temples.

QUETZALCOATL IN HIS ASPECT OF GOD OF THE WIND.

This typical shell pectoral refers to Ehecatl, god of the wind. Even in late times, sculpture retained a two-dimensional tendency among the Huastecs. Volumes that are occasionally very soft in feeling are here framed in simple, sober geometric elements with occasional mannerisms.

PECTORAL WITH QUETZALCOATL AND A PRIEST SACRIFICING, ABOVE A FEATHERED SERPENT SYMBOLIZING THE EARTH.

Exquisite works of decorative art, mother-of-pearl pectorals and earrings were a specialty of the Huastecs. In the pectorals the curve of the shell was adapted to fit the contour of the wearer's chest. On the relatively small surfaces, mythological scenes with animated figures in engraved, pierced work stand out clearly, and show a knowledgeable organization of planes and rhythmic graphic and chiaroscuro contrasts. These works have rightly been called "codices in mother-of-pearl" because of their affinities to the miniatures. Here, as always in objects of this kind, the base is formed by two winding, interlaced serpents. On it is shown Quetzalcoatl, attended by another figure, drinking blood from the heart of a sacrificial victim.

SPHERICAL VASE INCORPORATING A BIRD. *p. 158*

Northern Mexico, the so-called "Marginal Meso-America," had few permanent, culturally important settlements. It is known that groups of Pueblo Indians arrived there from the Lago Salato region, introducing their own Hohokam culture. Another importation was the black and white terracotta forms with magnificent abstract decorations, created between A.D. 1100 and 1200 by the Anasazi civilization of Arizona. The region showing a more lasting culture was that of Chihuahua, which seems to have begun around A.D. 800 at Casas Grandes and reflects the forms of life and expression of the southern parts of the present United States. There is considerable documentation for domestic and funerary pottery, particularly of the time shortly before the Spanish Conquest. Such works are characterized by clearly defined areas with geometric and stylized decorations in bright colors. The simple, elegant forms were often varied by the inclusion of zoömorphic details, as in this vase which has a spout in the shape of a bird's head and, on the other side, a tail-shaped projection.

POLYCHROME JAR. *p. 158*

Like the *Vase with Dog's Muzzle* below, this work provides excellent documentation for Chihuahua ceramics during the period before the Spanish Conquest. Here there is a notable complexity of rhythms and directions in the apparently simple decorative motifs.

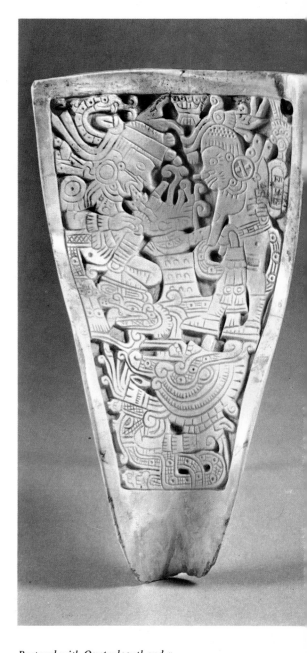

Pectoral with Quetzalcoatl and a Priest Sacrificing, Above a Feathered Serpent Symbolizing the Earth
1300–1521
Engraved mother-of-pearl;
6 1/4" × 1 9/16".

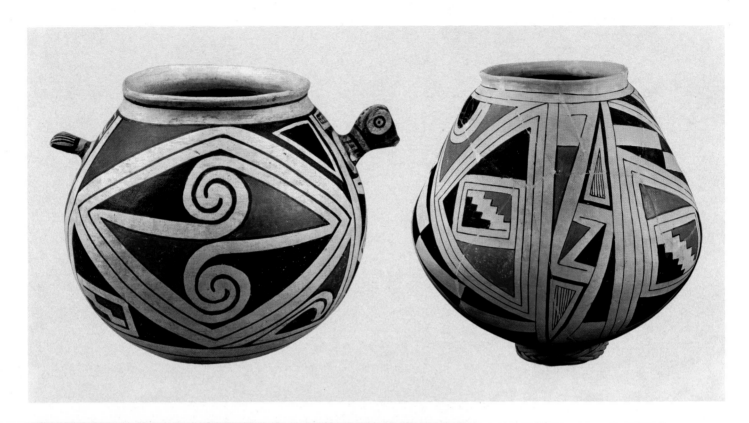

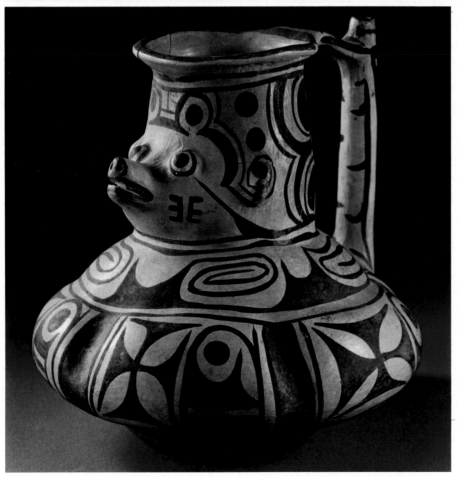

Above, left:
Spherical Vase Incorporating a Bird
1250–1521
Painted terracotta; height 6 1/4".
From Casas Grandes (Chihuahua).

Above, right:
Polychrome Jar
1200–1521
Painted terracotta; height 8 5/8".
From Casas Grandes.

Vase with Dog's Muzzle
1200–1521
Painted terracotta;
height 7 7/8".

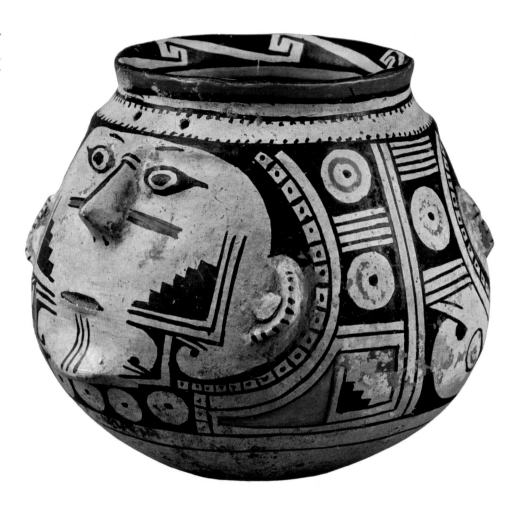

VASE WITH DOG'S MUZZLE.

This work is datable toward the last period of Huastec independence. It continues the high tradition of the local potters, who applied a great variety of decorations, with changing, inventive geometric motifs, to forms that were in part or entirely anthropomorphic or zoömorphic.

VASE WITH HUMAN EFFIGY.

The inclusion of the anthropomorphic motif both in the surface and the modeling of this vessel was achieved with careful and sensitive control. As with the polychrome bands that are in keeping with the shape of the vase, this presupposes a subtle degree of choice and a great awareness of form.

ANTHROPOMORPHIC VASE. *p. 160*

This vase is an even more significant example than the preceding one of the Chihuahua potters' exceptional command of their craft. The anthropomorphism of the whole object is achieved with such effective simplicity that it scarcely alters the rhythmic distribution of the ornamental motifs or the volumetric form of the vase. The facial features make up a composition of their own, which is distinct in technique from the decoration.

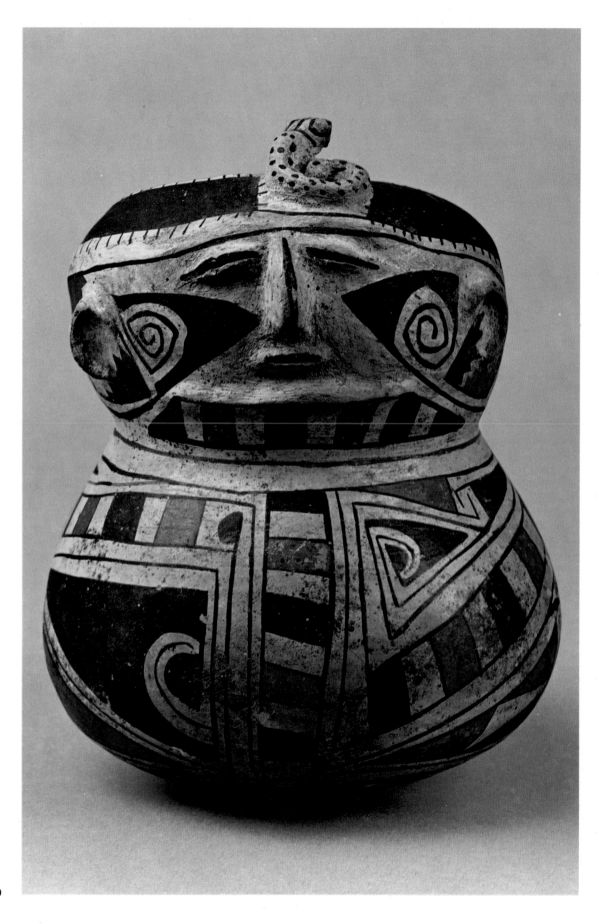

HISTORY OF THE MUSEUM
AND ITS BUILDING

HISTORY OF THE COLLECTIONS

The treasures of the National Museum of Anthropology are displayed on two large floors: the first contains thirteen magnificent rooms devoted to pre-Hispanic Mexico; the second, ten sections illustrating the ethnography of the various indigenous groups in the Republic. A visit to the museum begins with three introductory exhibitions: the first, situated in the large entrance hall, employs models, light and sound to describe the history of Mexico from its earliest beginnings to the Spanish Conquest; the second explains the four subjects that are fundamental to anthropology; and the third, on the upper floor, introduces the public to the field of Mexican ethnography. These three halls place the museum on the level of a study center and distinguish it from the majority of other collections, which generally tend to exhibit their works of art in a static manner.

On the lower floor, the exhibits are arranged around a large patio and can be visited either independently or in chronological order, starting from the right. The sequence begins with the most ancient human remains and corresponding cultural expressions. From there it passes on to the Pre-Classical period, which began around 5000 B.C., when man was no longer nomadic but tilled the soil and made pottery. It continues with the Classical period, which started around 200 B.C. and ended around A.D. 900. Finally, the sequence is completed with the Post-Classical period, or the arrival of the Spanish Conquistadores around 1519–1522. Other exhibits are devoted to geographical territories and cultural areas. The upper floor contains modern ethnographic material, often corresponding to the cultural and geographical areas shown on the floor below.

On each of the floors the best examples of extinct or living cultures are

shown. For that purpose, outdoor as well as indoor spaces are utilized, and there is a full use of display cases, dioramas, models and reproductions. The objects exhibited are almost always originals. All of the exhibits are subject to partial or total alteration, as new archaeological discoveries progressively change the perspective of their meaning or chronology. This dynamic quality is unquestionably one of the most interesting and unique aspects of the museum. For the organization of all matters concerning exhibitions and display, the museum has a staff of specialists in museum techniques, designers, painters, carpenters, metal workers, electricians and numerous assistants. Well-equipped workshops are attached to the various departments.

Another important aspect of the National Museum of Anthropology is represented by the exhibitions that have been organized every month since 1956, and by the other temporary shows that are put on periodically in rooms set aside for this purpose. The museum also sponsors traveling exhibitions that are sent throughout the country and abroad. Didactic and popular, they are intended to show Mexicans the antiquity and depth of their civilization. At the same time, they aim to tell foreigners that Mexico's antecedents go back to the most ancient times. The museum is thus an important cultural center for people of the most diverse social backgrounds. Its organization includes a Cultural Information Section, which arranges lecture series on pre-Hispanic Mexico and has the use of a comfortable auditorium that seats 355. It is filled three times a week by audiences listening to lectures by scholars on the indigenous past, or viewing films on the same subject. The museum also provides after-hours guided tours through the halls, led by archaeologists, anthropologists, linguists, ethnologists and pre-Columbian art historians. To publicize the cultural activities of the museum, the

Section prints and places on sale all the lectures that are given during the year.

A complete guide to the museum, compiled by the staff and containing a plan of the building, is available in Spanish and English. Another service is the rental of "guide phones" at a nominal charge. A more complete personal guide service is supplied at no extra charge by the museum. This service, the special reception of officials and important figures in science and the arts, as well as introductory lectures for groups of visitors, are the responsibility of the Public Relations Section. Blind people are accompanied through the museum by guides who have been specially trained for this purpose.

School children visiting the museum with their teachers are assisted by the Educational Section, whose staff is prepared to explain the various exhibits in terms suited to the different ages and grades of the students. The teaching methods are aimed at giving the children a balanced view of their heritage. They may thus begin to understand the importance of a civilization that in its day was not inferior to that of any other country, and had a far-reaching influence. The children may also practice modeling and drawing, put on theatricals and attend lectures. In addition, they have film showings, and during holidays special Children's Laboratories are organized in which they can learn more about their country's past.

The Educational Service publishes free or at low cost a series of booklets and recordings of music. Furthermore, the films it produces are very much in demand. All the public services offered by the museum could not exist without the work of the Research Sections in physical

anthropology, linguistics, archaeology and ethnography. The specialists of these Sections carry out all kinds of field work, and the results are then studied and classified in the research centers and laboratories of the museum. This institution, which is currently the only one of its kind in the world, has also set up a data processing center which will be able to do the work of dozens of office personnel in the future. The Research Sections also have photo archives, three photo laboratories, a photocopying section, biology and x-ray laboratories, a ceramics archive and two laboratories for restoring archaeological pieces. In addition there is a sound and recording studio, which is responsible for the maintenance of the tape recorders installed in each exhibition room to provide explanations and music. A Section devoted to film showings is responsible for the projectors in the three auditoriums.

The works of greatest artistic and intrinsic value are protected by specially constructed ceilings. In addition, there is an electronic alarm system. The building is air-conditioned, and is serviced by two large independent electric plants that automatically begin functioning if there is an outside power failure.

An organization on this large scale would not be complete without a school, a library and a film archive. Although these services do not come under the museum administration, they are housed in its building. The National School of Anthropology, which has an enrollment of 500 students, uses the laboratories and classrooms of the museum. The National Library of Anthropology, with its 300,000 volumes, is open to the public at large. During the year the Film Archive often has public showings in the museum's auditoriums.

THE BUILDING

A federal government institution, the Mexican National Museum of Anthropology has since 1939 been under the control of the National Institute of Anthropology and History which, in turn, is dependent on the Secretariat of Public Education. The building has been designed for easy access to its vast wealth of material. To make the visit comfortable, the building is equipped with gently sloping ramps, easily negotiable stairs, elevators, a wheel-chair service and numerous resting places where the visitor may sit and smoke while enjoying the view of distant white buildings blending

LEGEND

A Lobby
B Orientation Room
C Temporary Exhibits
D Auditorium
E Guided Tours
F Library and Educational Services

LOWER FLOOR
 I Introduction to Anthropology
 II Meso-America
 III New World Origins
 IV Preclassic Period in the Central Highlands
 V Teotihuacan Culture
 VI Toltec Culture
 VII Aztec Culture
 VIII Oaxaca Culture
 IX Culture of the Gulf of Mexico
 X Mayan Culture
 XI Culture of Northern Mexico
 XII Culture of Western Mexico

UPPER FLOOR
 XIII Introduction to Ethnography
 XIV Cora and Huichol Culture
 XV Tarascan Culture
 XVI Otomi Culture
 XVII Northern Puebla Culture
 XVIII Totonac Culture
 XIX Huastec Culture
 XX Mayan Culture
 XXI Culture of Northwestern Mexico
 XXII Autochthonous Modern Mexican Art

pleasantly with the exuberant greenery of the age-old Chapultepec woods. On the left of the large entrance hall is a bookstore that sells publications on anthropology, history and art, as well as postcards, transparencies and even cameras and film — for the taking of photographs is freely permitted in the museum. Next to the store are cloakrooms, coin telephones and stamp vending machines. The dining room offers visitors cafeteria service with coin-operated machines dispensing food and drink, or complete table service with an extensive menu.

SELECTED BIBLIOGRAPHY

BERNAL, I. *Mexico: Three Thousand Years of Art and Life.* (Abrams, New York).

BERNAL, I. *National Museum of Anthropology, Mexico.* (Abrams, New York).

BUSHNELL, G. H. S. *Ancient Arts of the Americas.* (Praeger, New York, 1965).

DRUCKER, P. *La Venta, Tabasco: A Study of Olmec Ceramics and Art.* (Washington, 1952).

EMMERICH, ANDRE. *Art Before Mexico.* (New York, Simon and Schuster, 1970).

KUBLER, G. *The Art and Architecture of Ancient America.* (Hammondsworth, 1962).

MORLEY, S. G. *The Ancient Maya.* (Stanford University Press, Stanford, 1956).

ROJAS, P. *The Art and Architecture of Mexico.* (London, 1967).

SPINDEN, H. J. *Ancient Civilizations of Mexico and Central America.* (New York, 1928).

VAILLANT, G. C. *Aztecs of Mexico: Origins, Rise and Fall of the Aztec Nation.* (New York, 1947).

VAILLANT, G. C. *Early Cultures of the Valley of Mexico.* (New York, 1935).

INDEX OF ILLUSTRATIONS

INDEX OF NAMES

Note: Italic numbers refer to names mentioned in captions.

GENERAL INDEX